PARTY SHIRT

Presents

NEXT-LEVEL EATS

XAVIER DI PETTA
AND
NICK IAVARONE
AND JENN GARBEE

THE
Party Shirt
COOKBOOK

100 Recipes for
Next-Level Eats

ABRAMS IMAGE, NEW YORK

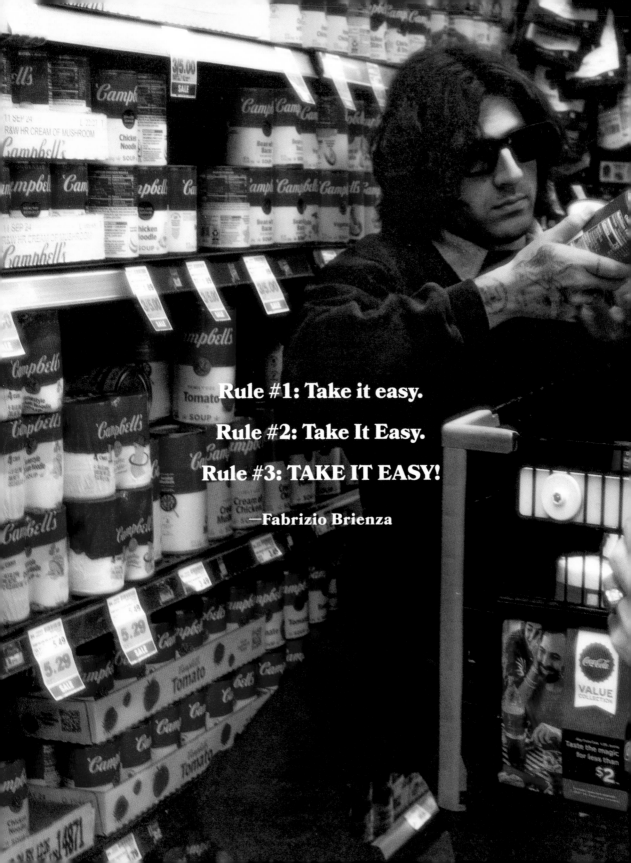

Rule #1: Take it easy.

Rule #2: Take It Easy.

Rule #3: TAKE IT EASY!

—Fabrizio Brienza

Table of Contents

How It All Dropped

I'm X. And I'm Ivy.
And welcome to the very best
of Snack or Yack?!

We can't believe we're actually here, taking the foods we've tasted on our TikTok series—to see if they're Incredible ... or Inedible!—to the Next Level. In these pages you'll find all new recipes for the very best and sometimes shocking, and shockingly delicious, Snacks.

If anybody had told us back in 2016 that we'd have a cookbook, we would have said you've got the wrong guys. That was the year we formed Party Shirt, our music partnership and the real reason we're here. We were just two college friends and passionate DJs living in Los Angeles, making music together that we loved then and are still proud of today.

We didn't even get on TikTok until several years later when the pandemic left us sitting at home looking for something more to do than stare at the popcorn ceilings in our crappy apartment. When we kicked off our @PartyShirt channel, we had no idea what we were gonna talk about, but one thing was for sure: music would always be our focus (why so many of our posts include our remixes). Along the way, we were looking for some good Snacks to keep us going—something there's no shortage of people talking about on the video-sharing platform.

The **Snack or Yack?** series actually evolved from an earlier series we still call **Fact or Cap?**, where we test trends to find out for ourselves whether they're real (Fact) or bullshit (Cap). We are both HUGE fans of the show **Myth-Busters**. If you've never seen that television series, each episode was dedicated to debunking or confirming whether certain urban legends were actually true. (Could a frozen chicken smash through the window of an in-flight airplane? Can an eel skin wallet erase the magnetic chip in a credit card?) In the years since the show's final episode, TikTok became the catch-all place for people to go who were testing out similar longstanding myths. They were also coming up with all kinds of new, "never before seen" hacks of

their own—only unlike the show, there was a LOT of bullshit that was being touted as true. We had to know for ourselves what was actually legit.

We spun off the **Snack or Yack?** segment into its own series when we started getting tons of food-related "You gotta try this!!" requests for **Fact or Cap?** from our followers. Things like: Can you make butter in a jar from heavy cream? (Definite Fact! See Gen Z Homemade Butter on page 33). It also meant we could make some stuff that sounded like it might possibly end up being a decent Snack, not just some food science trick. (Yeah, we now know you can submerge a raw egg underwater in the bathtub, crack it open, and the yolk and white will stay attached to each other even if you swirl it around pretty hard . . . but we're not gonna eat that shit!)

Our first video—and first actual certifiable meal—was an omelet with Flamin' Hot Cheetos (see page 49) that we made before we'd even figured out what to call the series. From there, a whole world of food and drink possibilities opened up that we'd never before considered. Whether it was combining ingredients that most people would never think to eat together (turns out Takis dunked in pickle juice are strangely addictive; see Hot Pickle Cereal on page 145 for a recipe), or trying out all kinds weird combos that were supposed to mimic the flavors in something like the Instant "McGriddle" (a series of shots you toss back that really does taste like the McDonald's breakfast sandwich; page 71). And look, we've made plenty of things for no other rea-son than we were hungry and they sounded Incredible (and equally important, incredibly easy to make), and maybe even too good to be true. The ones that exceeded the hype are definitely included in these pages. (You must try the easiest Italian beef roast ever on page 98!) The lesson: You never know when an Incredible drop—a track or a Snack!—is right around the corner.

Since we started the series and worked on this book, we've learned a lot of other useful cooking stuff, including that we got lucky on some of our initial video experiments. Things don't always work out as well the second or third time you make them as they do on the first go-round (cooking the perfect egg, for one, see Egg-in-a-Pocket on page 79). That's all part of the fun!

We hope you'll consider these expanded recipes full of crazy ideas for Incredible Snacks a starting point on your own ride, wherever you might be headed. And if that's all too much, just skip right past the particulars to the "In 60 seconds or less" quick-fire recipe summaries that are more the speed of our TikTok videos.

But mostly, don't take anything we say in these pages too seriously, conduct your own wild experiments, and make the recipes your own. Do that, and we promise that you'll never wonder whether something is Incredible, or Inedible, ever again!

Popcorn ceilings and a dream!
—X & Ivy

A SNACK-READY KITCHEN

Conveniently, pantry essentials are just minutes away from our apartment with the legendary Rock & Roll Ralphs right down the street. For decades, the Hollywood branch of the California grocery store chain has been THE place for Sunset Boulevard club partiers to go for Snacks (and booze) when the first "after" party is over so they're fueled for the "after after" party. Another music legend, the original Guitar Center, is also nearby. Since the 1960s, it's been THE spot every A-list rocker/jazz/funk artist hits to browse the merch when passing through town—and sometimes later the chip aisle at the Ralphs. (We're still holding out for Jay Kay of Jamiroquai!) Regardless, there is no shortage of packaged, bottled, jarred, frozen, and fresh ingredients to inspire new Snack combos on each trip.

Whether you're shopping at your local grocery, big box, or dollar store, or that Next Level convenience mart you spied off the highway (see Road Trip, page 66), you can make all the Snacks in this book with everyday ingredients. Get more on those pantry staples along with our favorite kitchen tools on the next few pages, should you care to spend the time. Or skip right past this commercial break to the reason we're all really here: the recipes so we can make some Snacks!

Ingredients

While we are by no means culinary experts, we have learned a few things from both the most basic and truly wild kitchen experiments we've tried out. The measurements we use in all of the recipes are written the way we like to cook: We grab the closest big spoon on the counter to measure out sauces, condiments, and those kinds of ingredients and just reach into the bag of cereal to get a large handful for whatever we're making. But if you like to use specific measurements, those are here too.

Sugar Fixes

No pantry is complete without something sweet, so why not kick off your grocery list there?

COOKIES

Given global cookie differences, most of the store-bought cookies in our recipes are easy to swap out for a similar type. After all, whether a cookie is called a Thin Mint or a Grasshopper, it's still a minty wafer cookie dipped in chocolate. That said, there are two exceptions:

- **Oreos** There is NO substitute for Oreos! (Should you be interested in hearing more on that subject, check out page 199.)
- **Nilla Wafers** While also a wholly unique cookie in terms of texture and flavor, unlike Oreos, Nilla Wafers can be hard to find outside the U.S. In recipes where there isn't a viable substitute (like Nilla Butter, page 147), we've got a backup recipe ready for you—made with Oreos, of course, on page 148.

CHOCOLATE

There may be nothing more divisive in the baking aisle than chocolate. Australians love their British-style chocolate (Cadbury!), Americans swear the hodgepodge found on their store shelves (Hershey's, Nestle, Guittard) is far superior. In any of our Snack recipes, use whatever brand and style you like—milk, semisweet, dark, white. We even consider those butterscotch chips, whatever they are, "chocolate." Chips, chunks, bars—they all get you to the same place.

CANDY

We both have a HUGE sweet tooth, and it appears everyone else on social media does too. You'll see a lot of candy in this book, all meant to inspire new Snack ideas and to be used at your discretion. It is our duty, and now yours, to try any new candy spotted at the airport, gas station, or any other place that might contain such sugary delights. You never know where culinary inspiration awaits!

FRUIT ROLL-UPS

While technically not a candy given its all-natural ingredients, we all know Fruit Roll-Ups are an excuse to eat something sweet and gummy as part of a "healthier" Snack. One rule: You must use **real** Fruit Roll-Ups at all times. All other "fruit leathers" we've tried don't have the right texture or flavor to freeze up into mind-blowing ice cream ravioli (as in our Fruit Roll-Up Ravioli, page 167) and other delicacies.

Things in Bags and Boxes (Chips, Cheesy Puffs, and Cereals)

A mainstay of our culinary creations, chips and their cheesy corn puff cousins hit the retail stage today in a constantly changing and dazzling array of flavors meant to shock your palate. While some combos are best left in corporate test kitchens, others will leave you wondering why you didn't come up with them first. And cereals occupy the same world. They, too, are available in "everyday" as well as palette-dazzling flavors and colors, and function as both an independent Snack and a justifiable Snack ingredient.

CHIPS

Whether you find yourself with a bag of Doritos or Takis, Lay's or Red Rock Deli chips (the Honey Soy Chicken flavor is a must if you are in Australia!), our general rule is you can never have too many chips in the pantry. And we all know the more powdery the coating on any flavored chips, the better! That's especially true when they are a Snack ingredient and you really want the artificially flavored deliciousness to come through.

CORN PUFFS

Most of the Snack recipes in this book use the "crunchy" variety of cheese puffs; some brands call them "fries" or "curls." Classic Cheetos are our go-to, and since we love cheese AND spice, Flamin' Hots, too. But the corn puff world is vast, so go with what you prefer—Chester's Flamin' Hot Fries, Vitners Sizzlin' Hot Crunchy Kurls, or Brim's Fiery Hot! Crunchy Cheese Curls. And if puffier cheese balls or puffs are all that's left on the shelf, they should work in any recipe in this book, too. The one thing we absolutely cannot endorse is any cheese puff, curl, or fry posing as a "healthier Snack" alternative. The very idea defies the entire reason these artificially flavored and undeniably delicious, extra cheesy wonders of the food world exist!

CEREAL

While suitable on their own any time of day, cereals can also inspire endless Snacks, from ice cream pies (like Party Shirt Ice Cream Pie, page 183) to classic Australian (Honey Joys, page 73) and American (BBQ Rice Krispies, page 173) Snack bars. Whenever you see that two-for-one special on boxes of sweetened puff cereal (Fruit Loops, Fruity Pebbles, Cocoa Puffs) or their less sweet or unsweetened counterparts (Corn Flakes, Rice Krispies), grab them. Snacks await!

Pickles!

A category entirely its own, a jar (really two or three) of pickles should be kept in the fridge AT ALL TIMES.

CLASSIC DILLS

Our pickle go-to is always Claussen's in the fridge case. Wholes, spears, even their "sandwich slices" (an extra-long ridged slice from a whole pickle that makes regular hamburger chips look like mere imitators) are Incredible. The dill flavor and other seasonings along with the vinegar ratio in the brine is just right. They're crispy instead of floppy and far exceed the weird, overly cured taste of some shelf-stable pickles or the hardly flavored at all "fresh" or home-made-style pickles we've tried. You can even season up your salad dressings with the leftover brine, like in the Next-Level Ranch (page 43). Now you're actively participating in upcycling!

PICKLED JALAPEÑOS, PEPPERONCINI, AND OTHER VEGGIES

A variety of pickled things are handy to add a quick hit of bold flavor anywhere it's needed. The brine of spicier blends is also a secret ingredient, whether it goes in the slow cooker with a pot roast (as on page 98) or makes your everyday table salt Next Level (like in Pickle Salt, page 37).

Condiments, Dressings, Sauces, and Spreads

We looove having a variety of hot sauces handy. It can turn almost any decent Snack into something incredible.

HOT SAUCE

While we love hot sauce, neither one of us is from a place that is known for its spicy-as-hell food. Shake on however much heat you can handle. A few we like:

- Valentina, Cholula, and other Mexican-style dried chile pepper and vinegar-based hot sauces. The perfect final hit of smoky, tangy heat when you want to season up a Snack.

- Frank's RedHot! THE Southern-style cayenne pepper and vinegar-based hot sauce, great for both shaking on things and saucing up things. (You gotta try Ivy's chicken on page 111!) Crystal from New Orleans is also top notch.

- Sriracha and similar Cal-Thai or Thai-style fresh chile pepper- and garlic-based hot sauce. Usually on the hotter, thicker, and more garlicky side, these are great for spicing up noodles (like Next-Level Instant Ramen on page 103) and using in sauces.

RANCH DRESSING

A MUST have! Hidden Valley Ranch hands down beats all bottled ranch dressing imitators. (Not paid sponsorship!) Get a few of those ranch dip and dressing seasoning packets in case of bottled dressing supply chain shortages; you may want to make your own dressing (see recipe for Next-Level Ranch on page 43), and if not, it's a great seasoning mix for unexpected things, even pot roast (page 98).

Fact! Anything labeled ranch dressing, dip, and/or seasoning mix is interchangeable and can be used for any recipe. The main difference is the type and amount of ingredients you mix them with (mayo, sour cream, and/or milk, that kind of thing).

KETCHUP, BBQ SAUCE, MUSTARD (AND SOMETIMES EVEN MAYO)

All the regular burger and sandwich staples make appearances in our pantry, even if it's not our favorite. You never know what it might do for a Snack!

CHAMOY

The hugely popular spicy-sweet-sour AND salty Mexican-style chile sauce deserves its own condiment category. Find a big producer you like (Amore, El Chilerito, and there are tons of others). We really love those from small producers that we've tried and this quick version you can make at home: Five-Minute Apricot-Chipotle Chamoy (page 44).

HARD SHELL TOPPING

The instant gratification of hard shell topping when it hits ice cream or anything cold is the way it creates a crunchy, chocolatey layer between you and the creamy ice cream. The classic chocolate Magic Shell (or Ice Magic in Australia) is easiest to find but if you really want something Incredible, it's almost as easy to make your own (see our Magical Chocolate Shell recipe on page 189). And, you can make it with any chocolate (milk, semisweet, dark, white) to create a range of sweet treats.

JELLY, JAM, CHOCOLATE-HAZELNUT AND PEANUT BUTTER SPREADS

While jelly and jam have rightfully earned their place in most refrigerator doors, some might argue that Nutella and Jif (or Bega if you're in Australia!) are not proper condiments. We fully stand behind these shelf-stable versions of fresh nut butters as not only convenient, but far superior in flavor and texture to anything that requires a special tool just to mix it up.

Fact! Shoving a spoon or knife in a jar of natural nut butter NEVER works! And trust us, use a hand-held mixer and you're gonna have oil spraying all over the kitchen!

Things in Shaker Jars and Packets

Any spice or packaged mix that will add an unexpected intensity to a Snack is always a good call!

SALT AND PEPPER

Salt is salt and pepper is pepper! Maybe if we're seasoning a steak or making our own seasoned salt (like our Pickle Salt on page 37) we might (might!) pay a little more attention to what it is. But most of the time, it doesn't matter in any of our Snacks if you use finely ground iodized salt, kosher salt, or specialty sea salt, crack your own peppercorns or just use the pre-ground stuff.

CRUSHED RED PEPPER AND CAYENNE PEPPER

Never turn down those free packets of crushed red pepper flakes you can still (maybe) get at some pizza places! (While we were writing this book, some pizza chains started "testing out" charging 99 cents for the spice, igniting social media outrage everywhere.) The good news is that crushed red pepper flakes are one of the cheapest spices to load up on at the grocery store, and can definitely get you through when whole black peppercorn prices skyrocket. It's an instant all-purpose seasoning for virtually anything, which is why you'll see it listed in recipes on its own, but also as one of the "spicy seasoning mix" options with true mixes like chili powder. Since crushed red pepper flakes are usually made from a mix of several dried chile peppers, it kinda really is a seasoning mix; cayenne peppers, the same thing in cayenne powder, usually dominate. If you're out of the flakes, powdered cayenne pepper will give you a similar flavor.

SPICY SEASONING MIXES

There are way more seasoning mixes out there than most of us need. We like anything spicy and with plenty of salt. Some we love: Barbecue seasoning, Cajun seasoning (McCormick, Old Bay), chili powder (with salt), Mexican-style chile-lime seasoning (Tajín, see recipe on page 34 if you want to make your own), and really, whatever else sounds exciting when we catch a glimpse of it.

FLAVORING PACKETS

Save the packets! Beyond legends like the seasoning packets that you get in instant ramen (see page 103), social media has awakened our palettes to not only powdered ranch dressing but brown gravy mix and French onion soup or dip mix. All are useful to season dishes from the simplest butter (like our Maitre d'Party Shirt Butter on page 31) to the most Elevated pot roast (Poor Man's Italian Beef Roast, page 98).

POWDERED DRINK MIXES

Once the gateway to the best drinks you had as a kid, unsweetened powdered drink mixes (Kool-Aid) offer a distinct tart, tangy, and almost candy-like pucker to everything from frozen grapes (page 141) to the rim of a cocktail glass. Get the **unsweetened** mix, which comes in those little packets for like three for a dollar, not the giant containers of pre-mixed Kool-Aid powder. The powder tends to soak up moisture from the air and clump together, so once you've opened the package, there's really no going back. You can try to seal it back up tightly and see if you have any luck.

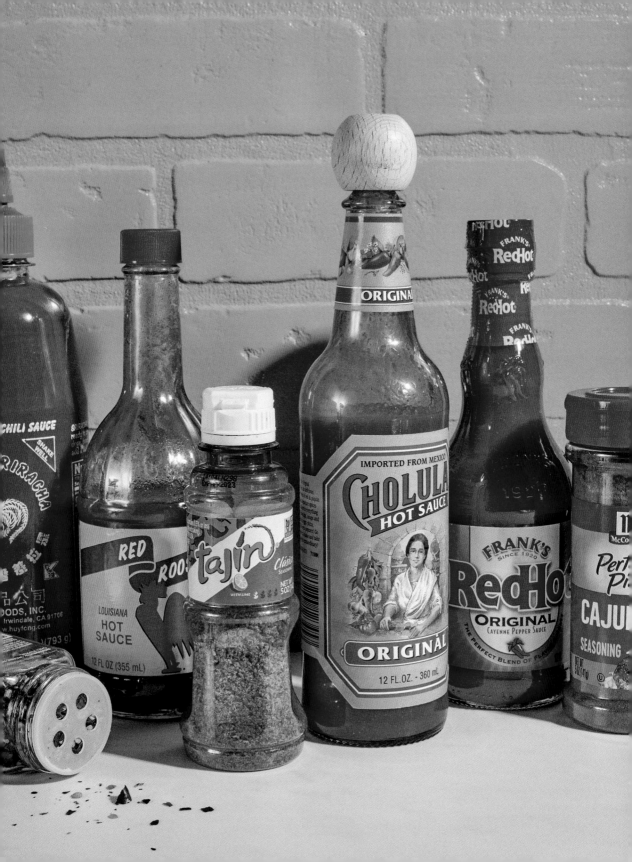

Flour and Sugars

Our motto: Stick to the basics!

FLOUR

All-purpose flour works great for pretty much all purposes (right?). And while self-rising flour, an Aussie favorite, is great if you're making cookies and that sort of thing, it's worth sticking to AP with a little baking powder if you're making the best chocolate lava mug cake ever (turn to page 207). There's so little flour, the cake needs that solid hit of baking powder.

SUGAR

The three we keep in stock are granulated, brown (light or dark, doesn't matter), and powdered (a.k.a. confectioners' or icing sugar). While the latter many people prefer to sprinkle lightly on sweets, we take a different approach: Dump a shit-ton of powdered sugar on a plate and dunk whatever you've got into the pile!

Other Useful Dry Ingredients

We always keep three never-fail packaged goods around . . .

RAMEN

Legendary! (See page 101.)

PANCAKE MIX

Essential! Not only for pancakes and waffles, but for making anything donut-like, including the Best PB&J ever (page 57). Regular butter-milk mix made from white flour, please, not whole grain or any "healthy" mixes threatening to disrupt the balance of dessert counting as breakfast. And while we know we're supposed to use a spoon to "lightly" scoop up the dry mix and put it in a measuring cup, we just dump the mix into the measuring cup—nothing a little more milk in any recipe can't resolve if the batter is too thick.

BREADCRUMBS

We like finely ground seasoned breadcrumbs like Italian-style (Progresso, Contadina) crumbs with their garlicky, oregano thing. You could also just keep plain breadcrumbs around that work with any type of Snack and make them Italian-style by seasoning them with a few spices (garlic powder and oregano are key, as is salt!).

Lemon and Lime Juice

To squeeze, or not to squeeze, that is the (real) question! Freshly squeezed lemon and lime juice taste better, but haven't we all bought those little round bottles of lime and lemon juice? First, they look cool. And they're nice to keep around for a quick hit of sour. Just remember to refrigerate them after opening and use them up within a coupla days.

Fact! If you have extra fresh or bottled juice, you can freeze it in an ice cube tray. Then pop out the frozen juice, put it in a zip-top bag and put it back in the freezer. When you need some, you can just thaw out a cube.

Dairy and Nondairy

Regardless of whether it's still called the dairy case, the fridge section is always a welcome cool hangout on a hot day.

MILK

Use the type of milk you like, animal, grain, nut, or otherwise. They may have hints of coconut, almond, or the grass-fed bovines they came from. Our rule: If you like a certain milk in your coffee or cereal, it's likely going to suit you when used as a Snack ingredient. In most of our recipes, you can use milk with any fat percentage; when a higher fat content makes a difference and whole milk is noted in the ingredients, go with an "extra creamy" nondairy milk. But do save the sweetened or flavored versions for your coffee; in general, they're too sweet for cooking.

CREAM AND THE ALT FROZEN TOPPING WORLD

Heavy cream or heavy whipping cream, as it's known in the U.S., is interchangeable with thickened cream (the Aussie name for cream with a high-fat content) or double cream (British). ANY can be used for any application. Each has a slightly different fat content, but all are rich enough to make whipped cream or homemade butter (page 33).

As for frozen whipped topping like Cool Whip, that's a whole other food mystery—and one that isn't commonly found outside of North America. While homemade whipped cream is an even tastier substitute in most cases, there really isn't a decent substitute if you want to make your own soft serve (page 191). If you're in Australia, you're just gonna have to head to Macca's to get a soft serve cone!

BUTTER AND MARGARINE

What say you? Margarine is softer than butter when cold, so straight out of the fridge it's easier to spread on something like bread (especially when you're half asleep) and usually a lot cheaper. Butter is firm when cold (not a problem for toasted bread) and undeniably wins taste tests; leave it on the counter for 30 minutes and it will soften up. Whether we grabbed salted or not depends on whether we bothered to look closely at the package. Save a few exceptions, it doesn't matter in our Snack recipes whether you use butter or margarine, salted or unsalted. Even when a recipe notes that one is best (say, there's already a lot of salt in something, so maybe go with unsalted), we're never going to let a stick of salted butter stop us from enjoying a Snack.

CHEESE

Pile it on! We are firm believers that cheese should be measured, and eaten, by the handful. And while someone will surely come up with a brilliant dairy cheese alternative akin to the flavor and texture miracles that have already occurred in the vegan milk world, we have yet to taste a passable substitute for cow/goat/other animal milk–based cheeses.

- **Hard Cheeses** Pre-shredded cheese is the fastest route to cheesy goodness, but feel free to shred your own. We also leave the strength of your cheese (mild versus sharp cheddar, for example) in your hands.

- **Goat Cheese** Loved by some (X!), goat cheese receives a lukewarm reception from others (Ivy!). Make the Grilled Goat Cheese Cannoli (page 117) and end the debate once and for all.

- **Cream Cheese** Blocks of cream cheese have a firmer texture when cold than that in the pre-whipped tubs with their bagel-ready consistency. Either works; you can always leave a block on the counter for 30 minutes and it will soften up.

- **Parmesan** There are times when the more coarsely ground "fresh" fridge Parmesan is nice for a little texture, like if you're making a Caesar salad (grab a jar of bottled dressing and some romaine and you're there). Other moments in life call for the curiously shelf-stable, finely ground, and almost powdery parm topping that always seems to be in a green canister. (We prefer it on garlic bread, page 89.) But most times, it doesn't make any difference which you choose.

- **Spray Cheese** Its own entity, spray cheese (Easy Cheese!) is something we both somehow didn't discover until after college. Go with the cheddar flavor, not the processed (American) cheese version, for a stronger cheesy hit. If you can't find it to make the Oreo cheesecakes (page 201), the homemade queso (page 202) is a solid substitute when it's chilled for crackers, mock cheesecakes, and more!

Savory Frozen Delights

This catchall category covers both the old and new inventions by Big Food that make their presence known when the freezer fog clears.

PIZZA ROLLS

If you have not had the pleasure of discovering pizza rolls (Totino's!), the food that fuels every American college student and recent graduate dutifully attempting to join the workforce with multiple remote jobs, welcome to a new category of Snack! These ravioli-looking nuggets of dough reveal fillings consisting of marinara sauce, cheese, and various pizza toppings (pepperoni, sausage, and the like). Eat them plain or dunk them in a sauce (Ranch! Hot sauce! More marinara!); you can't go wrong.

Instead of baking these late-night dining delicacies as recommended on the package, we usually throw the frozen rolls into an air fryer for 10 to 12 minutes, sometimes longer (the time varies depending on how many you're cooking). The air-fried nuggets get crispier on the outside compared to those that are baked, and you don't have to wait for the oven to heat up. We make an exception whenever we're making Elevated Pizza Rolls (page 85), as those absolutely deserve a good deep-frying. However you cook them, do NOT believe the suggested serving size. You're going to need at least ten pizza rolls for a modest Snack, more like fifteen (or more!) for a real Snack.

POCKET SANDWICHES

What is an Uncrustable, you may be asking? Basically mini frozen PB&J sandwiches that have been cut out in a circle shape with the edges of the bread crimped like a tidy pie crust. You just thaw them on the counter for 30 minutes to 1 hour, and you've got a Snack that holds firm for a solid 8-hour day. If you live somewhere where you cannot find such American novelties, or if the idea of buying probably the easiest sandwich in the world to make in frozen form sounds ridiculous (it really kinda is), we've got an easy homemade hack to make your own mini sandwiches (PB&J Pocket Sandwiches, page 60). The added benefit of homemade: If you don't like peanut butter, or even if you do, the pocket sandwich filling possibilities are almost endless (chocolate hazelnut spread, goat cheese and jam, lunch meat and cheese).

Kitchen Gadgets

★

Less is more in our small apart-ment kitchen. We've got to have room for a turntable on our kitchen cart and all the tchotchke shit we pick up wherever we go. And we love anything, however ordinary, that can double as one or more tools in the kitchen.

Fact! A stainless steel bowl can be used as a lid for a skillet and a drinking glass works as a round cookie cutter. Still, there are a few specific gadgets we do rely on.

MICROWAVE

Some people swear they don't need a micro-wave, but we swear we do. Not only is a microwave essential for reheating last night's pizza, it's handy for melting everything from cheese to chocolate or even hard candies for various experiments. AND when whatever you just over-cooked exploded and made a huge mess, it's far easier to clean up than the oven.

SLOW COOKER

An old-school Crock-Pot is the plug-in-and-walk-away secret to easy rice, stews, and what may very well be the best pot roast of all time (Poor Man's Italian Beef Roast, page 98). You can usually find one on the cheap at your favorite online marketplace in virtually any size.

AIR FRYER

While it may appear this does not fall into our "less is more" kitchen appliance mantra, we're 100 percent in on the air fryer trend. You don't need one of those behemoths, either. A small air fryer can accommodate the makings of a Snack for one person, and you can always make a second batch of whatever's on the menu while you eat the first round (frozen pizza rolls, fries, Bacon-Wrapped Fried Pickles, page 124, perhaps?). That said, you can make almost all the recipes in this book without one.

HAND-HELD MIXER OR STAND MIXER

Appreciated mainly for their ability to mix up cookie dough and whip cream to lofty heights, a space-saving hand-held mixer (what we have) or larger stand mixer can also shred cooked chicken and pork (used for Ivy's "Famous" Hot Chicken on page 111) and turn a jug of heavy cream into homemade butter (as in Gen Z Homemade Butter on page 33) in far less time than it takes to do such chores by hand.

NONSTICK SKILLET

A must for easy (or at least easier) cleanup of the wildest experiments and even the simplest everyday Snacks, a nonstick skillet makes a pancake less likely to clump up and flipping an omelet in one piece an actual possibility.

WAFFLE IRON, JAFFLE IRON, OR PANINI PRESS

A waffle iron, jaffle iron (for the Americans: a jaffle iron is an Australian toasted sandwich press that crimps the edges of the bread closed), or panini press can be used interchangeably to make pressed or grilled sandwiches (as well as any batter-less "waffle," like that incredible Hot Cheetos Belgian Waffle on page 51). These days most have nonstick surfaces, but we still coat ours lightly with cooking spray or vegetable oil to cut down on sticking and save time on cleanup. And while we don't have a classic waffle recipe in this book, we do have the obligation to share this incredible hack! When the only thing still on during a rolling blackout is your gas stove, pull out a nonstick grill pan and use it to make several pancake "waffles." Cook the batter like you would a pancake and they'll get all those delicious ridges from the grill pan. Stack them up, and you've got the easiest mock waffles ever!

KITCHEN TORCH

Our (really, Ivy's) one indulgence is a small butane or propane-fueled kitchen torch. While definitely not necessary, fire adds the element of fun, teetering on the edge of disaster, to whatever you're cooking. Beyond caramelizing sugar to make a brûlée of any kind (like our Grapefruit Brûlée on page 131), a kitchen torch is handy for broiling a steak (including our Fridge-Aged Steak on page 107) or charring a barbecue sauce–covered chicken when your living quarters leave you left to merely dream of owning a grill.

Very Important Fact! Look up the differences before you settle on your fire starter . . . those with butane canisters, for instance, have to be stored at room temperature, not on your apartment balcony in the blazing sun.

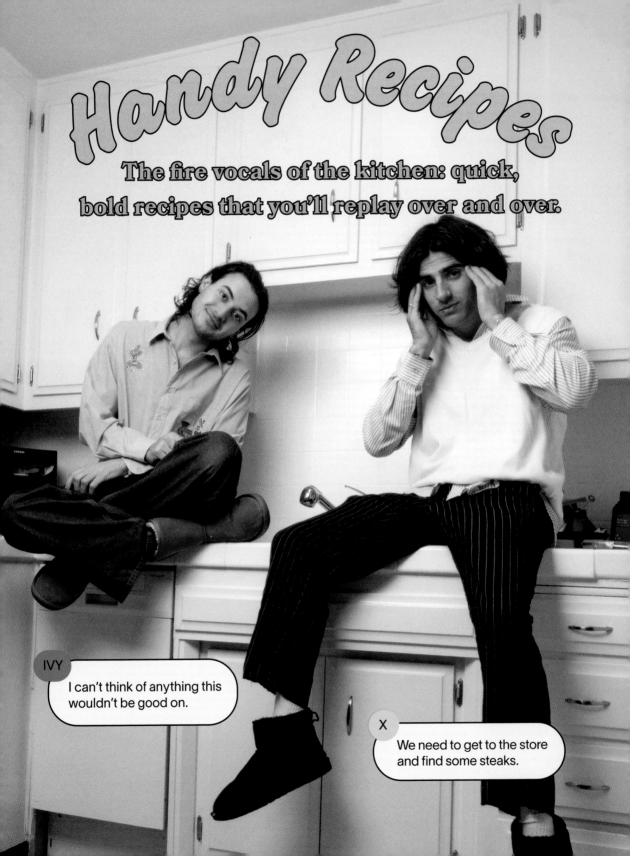

BUTTERS

We usually just buy butter (or margarine) like everybody else, but nothing says you put in tons of effort like a fancy butter. Whether you're cooking up a coupla steaks (try our recipe on page 107) or just pulling out a loaf of bread to slather it on, be sure to put on some good tunes. (Daft Punk!!) You might just "Get Lucky."

Maître d'Party Shirt Butter

Compound butter, a.k.a. maître d'hôtel butter, was a thing in French restaurants long before TikTok. Waiters would come to your table and mix herbs into whipped butter for your steak so it felt fancy. Consider this a more modern version using those little seasoning packets that come with instant mac 'n 'cheese and ramen; you can also use those powdered ranch dressing and onion soup mix packets. Whatever you pick, this butter would be incredible on a steak, chicken, shrimp, potatoes, pasta, or a giant loaf of bread. Maybe just don't serve it to a French chef.

Makes about 8 tablespoons (½ cup / 115 g)

- ½ cup (1 stick / 115 g) unsalted butter, at room temperature, or margarine
- 1 to 2 generous spoonfuls (2 to 4 tablespoons) powdered seasoning mix: instant mac and cheese or ramen seasoning; powdered ranch salad dressing, dip, or seasoning mix; French onion soup or dip mix, or similar
- Salt (if you want)

In a small bowl, use a fork to mix together the butter and 1 generous spoonful (2 tablespoons) of the seasoning mix. Really get in there and smash the two together. If the butter needs more flavor, add another 1 to 2 small spoonfuls (1 to 2 tablespoons) of seasoning mix and/or salt.

Use the butter now, or if you want to make nice slices later, put the butter in the fridge to firm up until it's easy to shape, about 20 minutes. Use your hands to shape the butter into a log, wrap it in plastic wrap, and roll the butter around on the counter to smooth it out into a cylinder. Refrigerate the butter until it firms up, for at least 1 hour or up to 1 week, before slicing off "rounds."

In 60 seconds or less

Find a mason jar and put some **heavy cream** in it. Cover the jar and shake it like crazy until the **butter** separates from the buttermilk. Strain off the buttermilk, knead the butter until it's creamy, and season it with sea salt.

CHEAT SHEET

Various seasoning mixes have different intensity levels; the cheesy powdered coating on mac 'n' cheese is pretty mild while those ramen packets are a lot stronger. Start with a smaller amount and add more if the butter needs it.

Normally we don't care, but go with unsalted butter or margarine here. There's already plenty of sodium love in those packets.

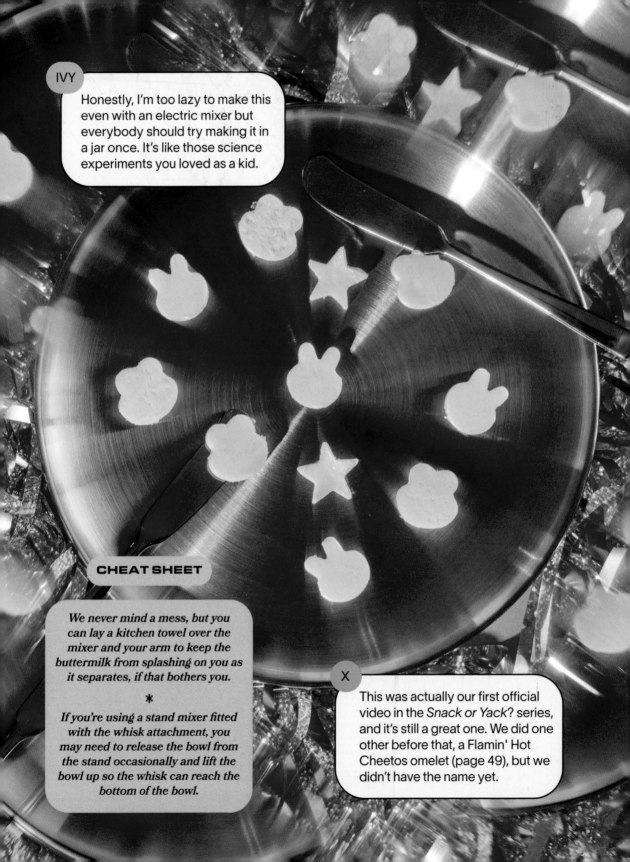

IVY

Honestly, I'm too lazy to make this even with an electric mixer but everybody should try making it in a jar once. It's like those science experiments you loved as a kid.

CHEAT SHEET

We never mind a mess, but you can lay a kitchen towel over the mixer and your arm to keep the buttermilk from splashing on you as it separates, if that bothers you.

＊

If you're using a stand mixer fitted with the whisk attachment, you may need to release the bowl from the stand occasionally and lift the bowl up so the whisk can reach the bottom of the bowl.

X

This was actually our first official video in the *Snack or Yack?* series, and it's still a great one. We did one other before that, a Flamin' Hot Cheetos omelet (page 49), but we didn't have the name yet.

Gen Z Homemade Butter

Making butter the old-fashioned way will make you appreciate modern appliances like electric mixers. All you have to do is put heavy cream in a jar and then shake the jar like crazy (with the lid on!) until the cream separates into part butter and part buttermilk. While a fun experiment, it's something you only want to do once given how long you have to shake that thing. With a mixer, it requires much less effort and it's easier to strain off the buttermilk; if you take the butter out of the jar and knead it like pizza dough a little while, it gets extra creamy. You could season up the butter any way you want (chopped chives or parsley, fresh garlic or garlic powder), but a little good sea salt goes a long way.

Makes about 5 tablespoons
(3 ounces / 85 g)

- 1 cup (240 ml) heavy whipping cream
- 2 generous pinches sea salt

In a medium bowl, whip the cream on high speed with a hand mixer (or stand mixer fitted with the whisk attachment)—scraping down the sides of the bowl every once in a while—until the butter separates from the buttermilk, 5 to 6 minutes. The cream will turn to whipped cream first, then start to thicken and turn pale yellow, and then suddenly (be patient, it takes a while!) little clumps of butter will appear and the separated liquid will slosh around the bowl.

Set a strainer over a small bowl and use your fingers to scrape the butter off the beaters or whisk attachment into the strainer. Pour any liquid in the mixing bowl through the strainer to catch any butter bits.

Use your hands to form the butter into a ball and knead it a good fifteen to twenty times over the strainer; it should feel creamier as more liquid releases. Sprinkle the sea salt over the butter and knead it a few more times to incorporate. Now put the butter in a small ramekin or dish and smooth the top so it looks nice (you just made butter, it deserves to look its best!).

Use the butter now when it's super soft, or cover and refrigerate it until it firms up, about 1 hour or up to 5 days.

Fact! Most commercially available cream and milk have been pasteurized, so the buttermilk that separates from the butter isn't true buttermilk (neither is most of the buttermilk you buy at the grocery store; it's also been pasteurized). But add a squeeze of lemon juice to the separated buttermilk, and now you've got what every grandmother knows is the best quick buttermilk solution. Make some fried chicken!

SEASONINGS

Most days, we'll be grabbing the bottled seasoning mix or really, just some red pepper flakes and salt. But sometimes you need a little extra something.

Chile-Lime Seasoning

We love Tajín, the Mexican-style powdered seasoning that's got a spicy kick from dried chile peppers, a tangy punch from limes, and plenty of saltiness. If you've got some chili powder, salt, and fresh limes, you can make basically the same thing in less time than it takes to find your car keys to go to the store. Pick a chile powder that's less spicy or one with more heat (or add some cayenne pepper), make it saltier (how we like it), or up the lime zest for a margarita—whatever you want!

Makes about 1½ tablespoons

- 1 small spoonful (1 tablespoon) chili powder, any kind
- Pinch cayenne pepper
- ½ teaspoon salt
- Zest of ½ lime

In a small dish, mix the chili powder, cayenne, salt, and lime zest. Taste and add more salt if you want.

Use the mix the same day or cover the dish with plastic wrap and store at room temperature for up to 2 days.

CHEAT SHEET

For a tangier seasoning mix, add ¼ teaspoon of citric acid. It's not some cleaning solution like it sounds but the naturally occurring acid in limes and lemons. People use it when they're canning and preserving stuff, so you can sometimes find it at the grocery store or online.

Bottled chile-lime seasonings usually use dried lime zest. Since the zest is fresh in this version, the spice mix won't last more than a couple of days— that's why we make a small batch.

In 60 seconds or less

Mix together some **chile powder** + **cayenne** + **salt** + **lime zest** and you're done!

Italianesque Breadcrumbs

One of the "problems" with constantly trying new Snacks is we don't have room in our pantry to keep all the stuff we keep buying. This stripped-down version of Italian-style breadcrumbs is easy to make whenever you want those Mega Fried Chicken–Cheese Balls (page 114) or just need some to fry up a pork chop or whatever you've got going. And now you only need to keep plain breadcrumbs in the pantry (which are good on their own for a lot of other stuff). We like a lot of garlic powder and oregano for that really loud red sauce, Italian restaurant vibe.

Makes about 1 cup (115 g)

- 1 cup (4 ounces / 115 g) plain fine breadcrumbs (Progresso)
- 1 teaspoon garlic powder
- ½ teaspoon onion powder
- 1 teaspoon dried oregano
- ½ teaspoon salt

In a small bowl, mix the breadcrumbs, garlic powder, onion powder, oregano, and salt. Use the breadcrumbs now or put them in a food storage container and store them in a dry place for up to 1 week.

CHEAT SHEET

We usually don't hold back on the salt, but with breadcrumbs it's good to start with less in case the Snack you end up making is already salty.

In 60 seconds or less

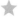

Mix together some **plain breadcrumbs** + **spices** (garlic and onion powder, dried oregano, salt, or whatever you've got) and you're done!

X: This is so easy and tastes so much better than the boxed seasoned breadcrumbs!

IVY: Instead of the spices, I'd probably just throw in like a spoonful (1 tablespoon) of Italian seasoning with the salt.

Pickle Salt

Salt makes the processed food world go round; pickles make our world a little better every single day. When we were working on this book, it was the summer that dill pickle–flavored everything took off. (Chips, almonds, dips!) There was even a seasoned salt at Trader Joe's that sold out before we could try it. We go through a lot of pickled things (dills, pepperoncini, jalapeños), so we've always got leftover brine. Why not make our own seasoned salt? Turns out you can just mix equal parts salt and brine, bake it in the oven on low heat until the liquid evaporates and the salt clumps up, then grind up the salt into smaller crystals. Brilliant!

Makes 3 tablespoons

- 3 small spoonfuls (3 tablespoons) coarsely ground salt (kosher or sea salt)
- 2 generous pinches garlic powder
- 2 generous pinches dried dill (if you have it)
- 3 small spoonfuls (3 tablespoons) pickle brine from pickled jalapeños, dills, or similar

Preheat the oven to 300°F (150°C).

Grab a baking pan (square, round, loaf, it doesn't matter) that's large enough to spread out the salt in a single layer. Mound the salt, garlic powder, and dill, if you're using it, in the middle of the pan. Pour the pickle brine on top, and use your fingers to mix together the salt and spices with the brine.

Spread out the mixture into a single layer and bake until the brine has completely dried up, 10 to 12 minutes. (Watch carefully during the last few minutes to make sure the salt on the edge of the pile doesn't brown.) Let the salt cool completely.

Use a knife to scrape up any salt that has solidified on the bottom of the pan and grind up the salt in a mortar and pestle to the size you like. Use the salt now or store it in a sealed jar at room temperature for up to 1 month.

CHEAT SHEET

A coarser salt works best (kosher or a more coarsely ground sea salt); anything with super fine crystals like iodized, popcorn, or other finely ground salt doesn't dry as evenly. Go with a pickle brine without sugar (sugar burns easily in the oven).

If you don't have a mortar and pestle, leave the salt in the baking pan and smash it up with a meat mallet. Or lay a small metal bowl on top of the salt and press down firmly to crush up the crystals.

IVY: I'd definitely throw this on some popcorn!

X: You get more of the garlic than the flavour of the actual pickle. I could see that on something that's not too strong, like a baked potato, but you get a lot more flavour and a little bit of heat when you use pickled jalapeño brine.

Instant Tangy Candy Coating

This super intense powder tastes like sour candy and is Incredible on anything that needs that tangy pop that you can only get from the best sour gummy candies. Try it sprinkled over fruit, a cocktail, a bowl of fruity ice cream or sherbet, or those Double-Stuffed Air-Fried Twinkies (page 217). You can't go wrong!

Makes 1 to 2 servings; about 1 teaspoon

- 1 (0.16 ounce / 4.5 g) packet unsweetened powdered drink mix (Kool-Aid), any flavor (about 1½ teaspoons)
- 2 to 3 teaspoons granulated sugar

In a small dish, mix the powdered drink mix and 2 teaspoons of the sugar. It should be really tangy, but taste and add another teaspoon sugar if you want.

Use the mix right away or put it in a small zip-top food storage bag, press down on the bag to remove all the air before you seal it, and store it at room temperature for up to 24 hours.

CHEAT SHEET

It's best to make small batches of this mix right before you need it. Unsweetened powdered drink mixes soak up moisture from the air so they can clump together within a few hours of opening a package.

In 60 seconds or less

Mix together a packet of unsweetened **Kool-Aid** with a little **granulated sugar** and prepare for a huge hit of sour candy tang!

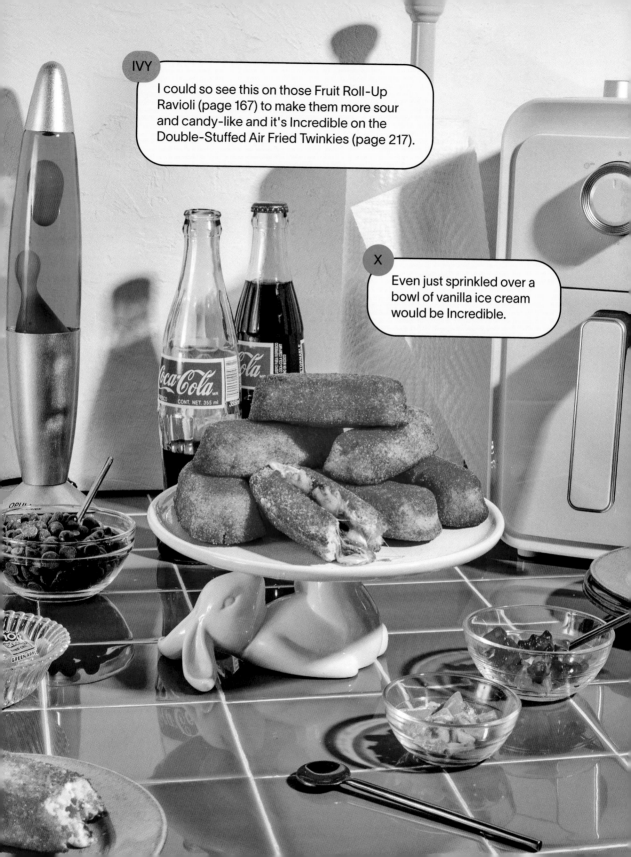

CONDIMENTS

We usually just buy all our condiments, but we're down with making a few that you can't (yet at least!) get at the store.

Buffalo Pickle Relish

We're both big classic Buffalo wings (Frank's RedHot!) and Claussen's pickles fans. Put the two together, and anything this relish touches is going to be Incredible!

Makes about ⅓ cup (75 ml)

- ½ whole dill pickle or 2 spears (Claussen's), cut into large chunks
- ½ cup (120 ml) Frank's RedHot

In a blender, blend the pickles and hot sauce until the pickle is finely chopped and the sauce has a chunky relish-like texture.

Enjoy your deli-worthy condiment right away or put the relish in a jar, cover, and refrigerate for up to 1 week.

CHEAT SHEET

If you don't have a blender, finely chop the pickle, put it in a small bowl with the hot sauce, and use a fork or potato masher to smash the ingredients together.

In 60 seconds or less

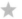

Blend together some **dill pickles** + a little **Frank's RedHot** until you have a chunky relish. Find something— a burger, chicken sandwich, hot dog, maybe?—to eat it on.

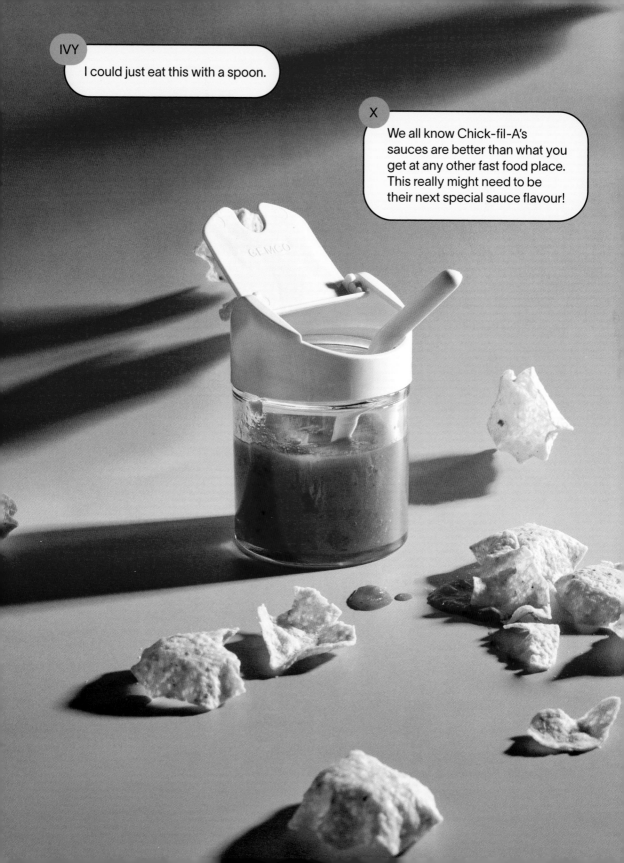

X

It's hard for Americans to understand but ranch still isn't that big in Australia, so the bottled dressing isn't at every grocery store like it is in the States. If you've never tried, the packets are so much cheaper to stuff in your suitcase (or have someone ship!) than the bottles so this recipe is a good place to start.

IVY

When you use dill pickle brine it's really subtle. I like the heat of the jalapeño brine for a change to my usual ranch, but just a little so you don't overpower the ranch seasonings.

Next Level Ranch

Someone else polished off the last bottle of Hidden Valley, and you're not up for the inevitable self-checkout scanner screwups at the grocery store. This is why there are always a few packets of ranch salad dressing mix in the pantry! We like our ranch thick and tangy, with more sour cream and less sweet mayo so you can really taste the ranch seasonings. While a lot of people add a squeeze of lemon juice, the secret ingredient here is leftover pickle brine.

Makes about 1⅓ cups (350 g)

- ¾ cup (170 g) mayonnaise
- ½ cup (120 g) sour cream
- 1 (1-ounce / 28-g) packet powdered ranch salad dressing, dip, or seasoning mix (Hidden Valley; about 4 tablespoons)
- 1 to 2 small spoonfuls (1 to 2 tablespoons) pickle brine from pickled jalapeños, dills, or similar

In a blender, puree the mayonnaise, sour cream, ranch seasoning mix, and 1 small spoonful (1 tablespoon) of the pickle brine until smooth. Give it a taste and add another small spoonful (1 tablespoon) pickle brine if you want. The dressing is ready to go for any Snack now or cover and refrigerate it for up to 5 days.

CHEAT SHEET

The type of pickle brine (from milder dills to spicy jalapeños) will affect how much the pickling spices come through in the dressing.

In 60 seconds or less

Mix together some **mayo** + **sour cream** + **one of those ranch dressing seasoning packets** + some **pickle brine** leftover in the jar. You're ready for salad, pizza, chips, or whatever is ranch-worthy that comes your way.

Five-Minute Apricot-Chipotle Chamoy

Judging by the number of TikTok videos on chamoy, there probably isn't a single food that someone, somewhere hasn't tried with the Mexican condiment that's made from dried sour fruits, chile peppers, and a mix of other ingredients that are simmered together and blended up into a salty-sour-spicy-tangy sauce. No two are alike, but one thing we've learned: The small-batch chamoy that we've tasted from mom and pop producers have had a much better flavor than the large-scale commercial ones we've tried. Most recipes start with ingredients like dried apricots, tamarind paste, and dried ancho chile peppers—things we don't have around and wouldn't know what to do with if we did. What we can manage to get our hands on is some apricot jam and a can of spicy chipotle chiles in adobo sauce. You don't even have to cook the sauce down, just blend everything up. Change up this version to make it your own, then get on to making those Elevated Chamoy Pickles (page 135)!

Makes about ¾ cup (180 ml)

- ½ cup (5 ounces / 140 g) good-quality apricot jam (Bonne Maman)
- 1 to 2 small spoonfuls (1 to 2 tablespoons) canned chipotles in adobo sauce
- 1 lime
- Salt

In a blender, puree the jam, 1 small spoonful (1 tablespoon) of the chipotles with the adobo sauce, the zest and juice of the lime, and 1 generous spoonful (2 tablespoons) water until smooth.

Season the chamoy generously with salt, taste, and add up to another small spoonful (1 tablespoon) chipotles, if you want.

Search up chamoy Snack ideas on social media (trust us, you will be overwhelmed by the options out there) and get tasting, then cover and refrigerate any leftovers for up to 2 weeks.

CHEAT SHEET

Canned chipotle peppers in adobo sauce (smoked jalapeños) give this chamoy a smokier flavor that really works with the spiciness that we really like.

In 60 seconds or less

Throw some good **apricot jam** + **canned chipotles in adobo sauce** + **the zest and juice of 1 lime** + some **salt** into the blender and puree it until you have an excellent chamoy sauce.

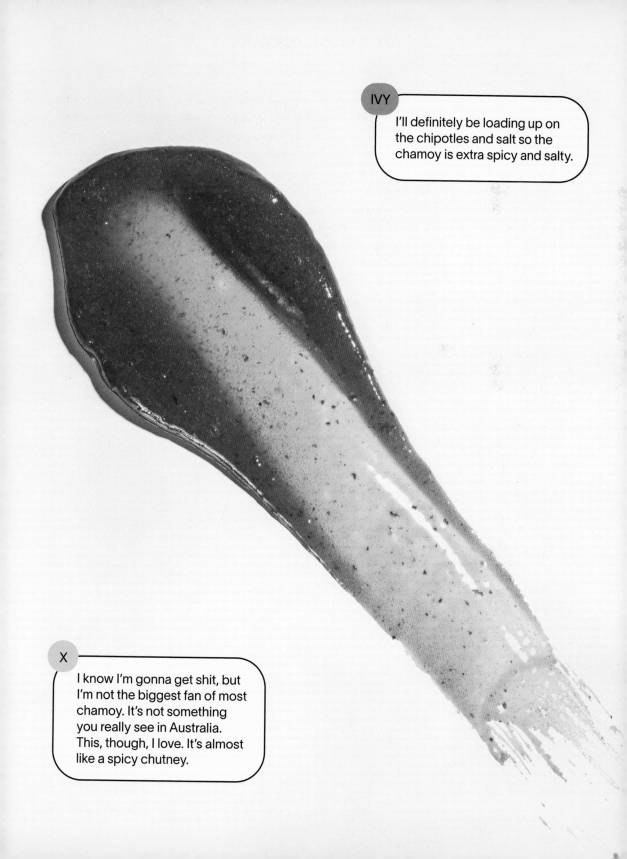

BREAKFAST OF CHAMPIONS

Intermittent fasters around the world may have abandoned breakfast, but we still believe in Big Cereal's campaign to make it the most important meal of the day. The recipes on these pages satisfy every early-morning need and midday brunch craving, but like all great Snacks, can be enjoyed any time of day.

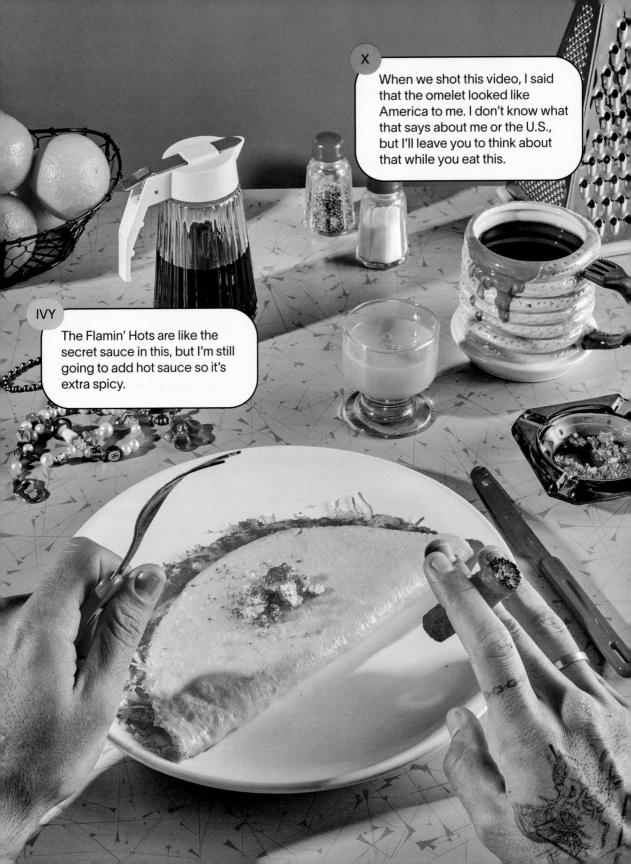

Flamin' Omelet

Given our affinity for anything spicy, cheesy, and ideally, with a healthy dose of processed food flavor, it should be no surprise that this omelet is where it all started. When we decided to spin off food-related experiments from our **Fact or Cap?** series, we hadn't even come up with the series name **Snack or Yack?** yet. The tagline for this omelet video was just, "Trying something a little new, do y'all like it?" And man, thank YOU, you did! Today that post has millions of views. We're pretty sure it had nothing to do with us and everything to do with what was in this omelet.

We'd make it for any overnight guests any time of day, especially those friends and family who are still somewhat aghast at our culinary creations. Not too crazy, but the crunchy Flamin' Hots make it just enough of an outlier to keeping things interesting. A (new!) classic that never lets you down!

Makes 1 Snack

In a large nonstick skillet, heat the butter over medium-high heat until melted and swirl the pan so the butter is evenly distributed over the bottom. Add the eggs and cook just until they begin to set on the bottom, about 1 minute.

Scatter the cheese all over the surface of the eggs, then put the cheese puffs on just one half. Use a spatula to lift up the opposite side of the omelet (the side without the cheese puffs); if the eggs are firm enough to fold the omelet in half, do that. If the omelet starts to fall apart as you lift it up, wait another 15 to 20 seconds and try again.

Cook the omelet until the cheese has melted and the eggs are almost set in the center, about 1 minute longer. Now slide that big boy onto a plate, grab the bottle of hot sauce, and enjoy!

- 1 small spoonful (1 tablespoon) salted or unsalted butter or margarine
- 4 large eggs, lightly beaten
- 2 small handfuls (⅔ cup / 75 g) grated cheese: cheddar, spicy (pepper) Monterey Jack, Provolone, or similar, or 2 slices processed (American) cheese
- 2 small handfuls (⅔ cup / 1 ounce / 28 g) spicy cheese puffs (crunchy Flamin' Hot Cheetos)
- A few good shakes of Mexican-style hot sauce (Cholula, Valentina)

In 60 seconds or less

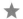

Cook up an **egg omelet** and add plenty of **cheese** + **Flamin' Hots** to the filling. Give it a few shakes of **hot sauce** and eat that while you consider making your own crazy food series on social media.

Recipe continued

CHEAT SHEET

If spicy Cheetos aren't your thing, any cheese puff or even seasoned potato chip, flavored or not, is going to be great as a crunchy omelet filling.

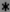

The time it takes for the omelet to set up will also vary depending on the size of your skillet, which affects how thick the layer of eggs will be. We aren't egg perfectionists, so we just cook our omelets until they seem pretty set and, most importantly, the cheese has melted.

Fact! A nonstick skillet is a must when cooking up eggs, and even then, sometimes the omelets we make don't stay together when we try to fold them. It helps to pile up any heavier ingredients (here, the Cheetos) on one side of the omelet so the part you are folding over isn't carrying a big load when you lift it with the spatula.

Hot Cheetos Belgian Waffle

This recipe defies science! It's still one of the most surprising and absolute best things we've ever made. Even Mario Lopez thought it was revolutionary when we made it for him on **Access Daily**.

We usually just dump everything into the waffle iron and call it done. It tastes Incredible, but it's really hard to get the waffle out because all of that cheesy goodness sticks to the hot plates. The best solution we've come up with so far: Layer up the waffle so you've got some Cheetos on the bottom, then your cheese and condiments, and then another layer of Cheetos. As the cheese melts, it becomes the "glue" to hold the whole thing together (since there's no batter) and you can get everything out of the waffle iron more easily. (Flipping the waffle iron upside down over a plate also helps.) Is the waffle still gonna stick some? Yup. It's still cheese puffs and cheese in a waffle iron without a batter. Doesn't bother us, but if you're a perfectionist, you can reassemble the waffle on a plate.

Makes 1 Snack

Lightly coat a waffle or jaffle iron or panini press with the cooking spray so the entire surface is covered (both the top and bottom plates!) and preheat it according to the manufacturer's instructions; if your iron or press has multiple settings, go with a mid-level one.

When the iron or press is hot, scatter enough cheese puffs over the bottom to make a single layer. Tear the cheese slices in half and lay them over the cheese puffs so the whole surface is evenly covered. Scatter the jalapeños on top of the cheese, give the whole thing a couple squeezes of mustard, then add another layer of cheese puffs.

- Nonstick cooking spray or vegetable oil, for coating the waffle or jaffle iron or panini press
- About 2 large handfuls (2 cups / 3 ounces / 85 g) spicy cheese puffs (crunchy Flamin' Hot Cheetos)
- 3 slices processed (American) cheese
- 5 to 6 slices pickled jalapeños, drained
- 2 to 3 good squeezes yellow mustard

In 60 seconds or less

Preheat a waffle iron and scatter **Flamin' Hots** on the bottom, then plenty of **processed cheese**, some **pickled jalapeños**, a few squeezes **of yellow mustard**, and another layer of **Flamin' Hots** on top. Press down hard on the lid to smash the Cheetos, let it cook until the cheese melts, and welcome to a whole new world of waffles.

Recipe continued

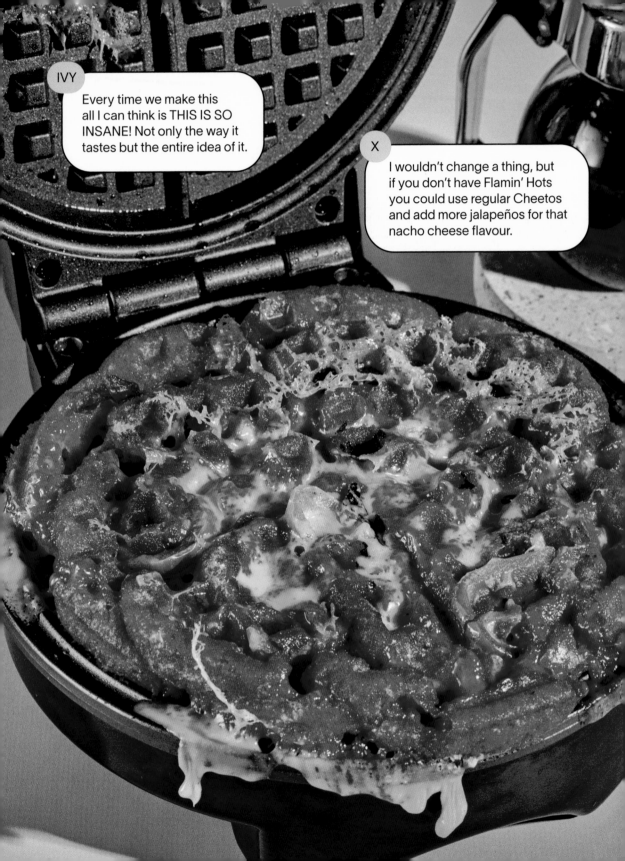

Close the lid and press it down firmly until you hear the cheese puffs crushing up. Really put some muscle into it and press down; this helps the cheese puffs stick to the cheese. (The lid won't close all the way.) Cook the waffle until the cheese is melted and, ideally, just beginning to brown, about 1 minute. (Even if the cheese hasn't gotten toasty, at this point it's better to dive into this beauty than re-close the waffle iron or you'll end up with more of a mess stuck to the lid.)

Leaving the lid open, turn off the iron or press and put a paper or heatproof serving plate over the waffle. Close the lid and flip the iron or press upside down, then open the bottom of the iron or press (now on top). Most of the waffle should (fingers crossed!) be on the plate; use a rubber spatula to release anything stuck to the cooking surface. Now ENJOY!

CHEAT SHEET

To lightly coat a waffle or jaffle iron or panini press with oil, ball up a paper towel, dip it in the oil, and use the paper towel to coat the cooking surface.

✳

The quantities of ingredients work for most classic round waffle makers or a standard-size jaffle iron or panini press. If you're using a mini- or mega-size iron or press, it's easy to adjust the quantities of each ingredient by thinking in layers: Put down a layer of cheese puffs first, then the cheese and condiments, then a final layer of cheese puffs on top.

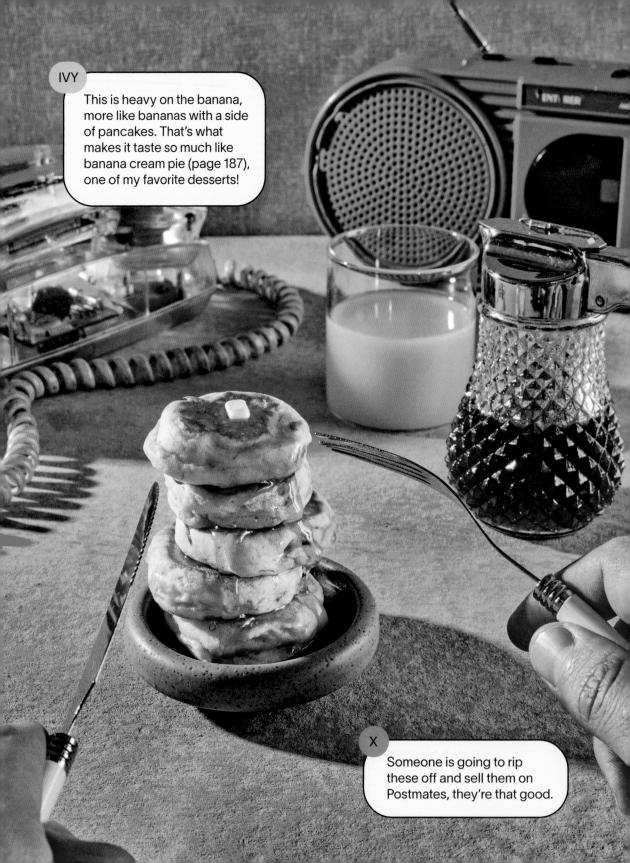

Banana Cream Pancake Bites

These mini banana pancakes may not sound revolutionary, but trust us, the flavors will transport you to a roadside mom-and-pop diner with banana cream pie in the fridge case. When you fry up individual banana slices in pancake batter (as opposed to, say, just making a giant pancake with a few banana slices in it), the banana gets super creamy, a little sweeter-tasting even. Dunked in pancake or maple syrup, they really do taste like mini banana cream pies. And while we make absolutely no health claims about any recipe in this book, thanks to all the potassium goodness in the bananas, these may actually count as a (sorta kinda?) healthy start to the day!

Makes 1 Snack

Slice the banana crosswise into pieces about ½ inch (12 mm) thick.

In a small bowl, use a fork to mix the pancake mix and milk until just combined; there should be a few lumps in the batter. Add the bananas to the bowl and gently stir the batter so each piece is well coated.

In a large nonstick skillet (with a lid if you have one), heat the butter or margarine over medium-high heat until melted and swirl the pan so the butter is evenly distributed over the bottom. Use your fingers to scoop up the bananas one at a time and drop them in the skillet; make sure each banana is well coated in batter. Cook the banana pancakes until lightly browned on the bottom and they are set enough to flip, about 2 minutes. Carefully flip each pancake with a spatula; if any bananas slide off their pancake base, just put them back on top of the pancake once you've flipped them (they will re-adhere).

- 1 very ripe banana
- ½ cup (65 g) regular buttermilk pancake mix (see page 24)
- ⅓ cup (75 ml) milk, any percentage
- 2 tablespoons unsalted or salted butter or margarine
- Pancake or maple syrup, for pouring on thick

In 60 seconds or less

Slice up a **banana**. Mix together some **pancake mix** + **milk** and stir the bananas into the mix. Heat up some **butter** in a pan and cook up the individual batter-covered banana slices like mini pancakes. Don't hold back on the **pancake syrup!**

Recipe continued

CHEAT SHEET

A super ripe banana (one that's soft but still holds its shape) tastes best, but avoid an overripe banana. It will break down into a mushy mess in the batter.

These require more cooking time than most mini pancakes because of the thickness of the banana slices. Turning off the heat and steaming the pancakes helps finish the job of cooking the batter on the sides of the bananas without burning the bottom.

Reduce the heat to low and cook the pancakes until lightly browned on the opposite side, about 1½ minutes longer. If the batter on the sides of the bananas is not fully cooked, turn off the heat, cover the skillet with a lid, baking sheet, or large heat-proof plate, and let the pancakes steam until set, about 30 seconds longer.

Pour plenty of pancake or maple syrup into the skillet, grab a fork, and enjoy!

Fact! We always eat our pancakes straight from the skillet whenever possible. It's environmentally friendly (one less plate to wash), energy efficient (the residual heat from the skillet warms up the syrup), and delicious (you get all that buttery goodness that's still in the pan).

The Ultimate PB&J

The Uncrustable is a brilliant invention that makes the easiest-to-construct sandwich almost completely effortless. (For the uninitiated, see Ingredients, page 16.) You just leave the frozen PB&J pocket sandwich on the counter to thaw out and then eat it, something its Big Snack parent company, Smucker's, makes clear is the only thing you should be doing with these. On the FAQs page of the product website, the phrase "we do not recommend you . . ." is everywhere. No toasting! No microwaving! No air (or any kind of) frying! It's all taboo. Naturally, like everyone else, that made us want to experiment and try all of these things with these and other pocket sandwiches!

This deep-fried doughnut is the undeniable winner of numerous underground experiments, and it remains one of the greatest leveling-up Snack tricks we've ever tried. We hope you'll agree that this new-and-improved release is the multiplatinum album of the pocket sandwich world!

Makes 1 Snack

Line a plate with paper towels. Pour enough oil into a medium saucepan to come roughly 2 inches (5 cm) up the sides and heat the oil over medium-high heat until very hot, about 350°F (175°C).

Meanwhile, in a small bowl, use a fork to mix the pancake mix, sugar, and cinnamon. Slowly stir in all but about 1 generous spoonful (2 tablespoons) of the milk and mix until just combined; the batter should be a little thinner than typical pancake batter. If it's still a little thick, add the remaining milk.

- Vegetable oil, for deep-frying
- ½ cup (75 g) regular pancake mix (buttermilk)
- 2 teaspoons granulated sugar
- ½ teaspoon ground cinnamon
- About ½ cup (120 ml) milk
- 2 PB&J Uncrustables, any jelly flavor, thawed, or homemade PB&J pocket sandwiches (recipe follows)
- Powdered (confectioners') sugar, for dunking

In 60 seconds or less

Heat up some **oil** for deep-frying. Mix together some **pancake mix** + a little **sugar** + **cinnamon** and add a little more **milk** than the package says. Dunk an **Uncrustable** in the batter, fry up that sandwich, make a second one, and dunk both in **powdered sugar**. The BEST PB&J ever!

Recipe continued

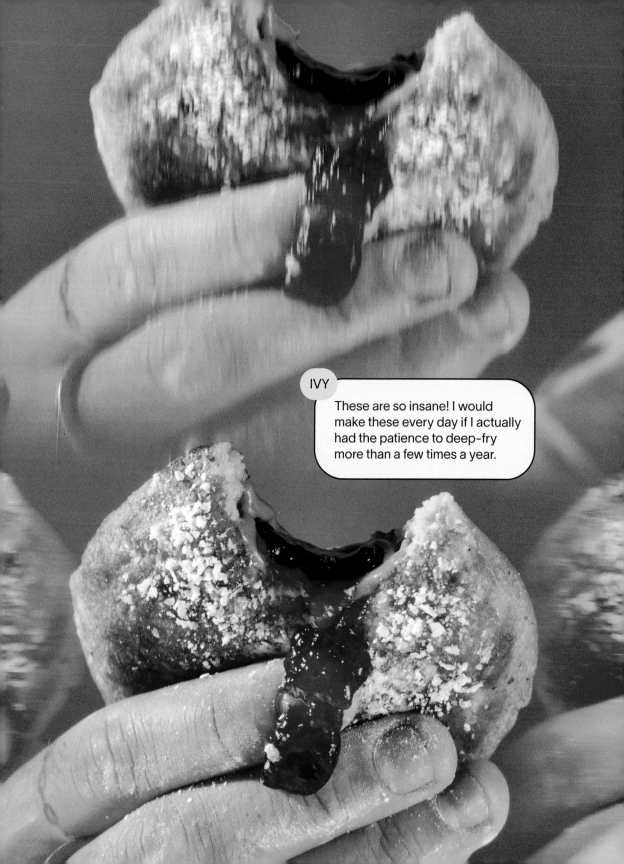

When the oil is hot, dip 1 sandwich into the pancake batter so all sides are well coated, gently drop the sandwich into the hot oil, and fry until golden brown on the bottom, about 1 minute. Use tongs to flip the sandwich (if the sandwich sticks to the bottom of the pan, run a spatula underneath it first) and fry until golden brown on the opposite side, about 1 minute longer.

Transfer the doughnut to the paper towel–lined plate to cool. (Resist the urge to taste! It will be scalding hot.) Reheat the oil to 350°F (175°C), if needed. Batter and fry the second sandwich and transfer it to the plate.

By now it should have been a solid 5 minutes since you fried the first sandwich, so it's time to put plenty of powdered sugar on a plate, dunk that first doughnut in the powdered sugar, and eat it while you wait for the second one to cool. Incredible, no?

Fact! And now for our own "we do not recommend" FAQ: Do not use an air fryer for this! You'll just end up with batter stuck all over the fryer racks and a sad remnant of a soggy Uncrustable.

CHEAT SHEET

We like this with classic grape jelly Uncrustables, but the peanut butter and strawberry jam or honey versions would also be great, even the one filled with chocolate hazelnut spread if peanut butter isn't your jam. (Get it?!)

✳

If you don't have a frying thermometer, test the temperature of the oil by adding a small spoonful of the pancake batter. It should sizzle and quickly float to the top of the oil. (Remove it from the pan before frying.)

PB&J Pocket Sandwiches

- 4 slices classic white or wheat sandwich bread
- 1 small spoonful (1 tablespoon) creamy or crunchy peanut butter spread (Jif, Bega)
- 1 small spoonful (1 tablespoon) raspberry jam

In 60 seconds or less

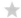

Spread **peanut butter** + **jelly** in between two slices of **sandwich bread** (more in the middle, you don't need any on the very edges). Use a drinking glass to press down on the sandwich and crimp the edges, then peel away the extra bread.

This recipe is for those who can't easily get their hands on frozen American novelties to make The Ultimate PB&J (page 57)—or just prefer to fill their freezer with pizza rolls and ice cream rather than sandwiches. We usually reach for the grape jelly when we're making our PB&Js, but strawberry or raspberry jam would also be good. You can make any pocket sandwich this way, limited only by what potential fillings you've got in the fridge (lunch meats, cheese, jam, or even mashed-up bananas, which we use in our Banana-Coconut Doughnuts on page 211).

Makes 1 Snack; 2 mini sandwiches

Lay 2 slices of sandwich bread on the counter. Spread the peanut butter in the middle of each slice, then the jam, and lay another slice of bread on top of each.

Put a roughly 3-inch (7.5-cm) wide drinking or rocks glass, rim facing down, in the middle of each sandwich, press down firmly on the glass to seal the edges of the bread, and peel away the excess bread to make a sandwich round. The filling should be completely enclosed by the bread; if not, crimp down the edges by pressing on them gently. Discard the bread scraps. Behold your pocket sandwich!

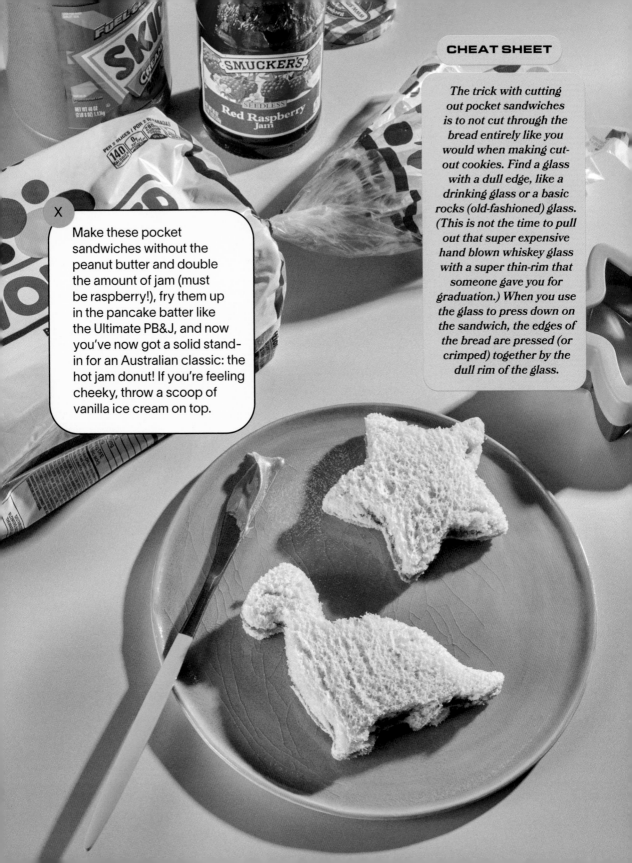

X

Make these pocket sandwiches without the peanut butter and double the amount of jam (must be raspberry!), fry them up in the pancake batter like the Ultimate PB&J, and now you've now got a solid stand-in for an Australian classic: the hot jam donut! If you're feeling cheeky, throw a scoop of vanilla ice cream on top.

The trick with cutting out pocket sandwiches is to not cut through the bread entirely like you would when making cut-out cookies. Find a glass with a dull edge, like a drinking glass or a basic rocks (old-fashioned) glass. (This is not the time to pull out that super expensive hand blown whiskey glass with a super thin-rim that someone gave you for graduation.) When you use the glass to press down on the sandwich, the edges of the bread are pressed (or crimped) together by the dull rim of the glass.

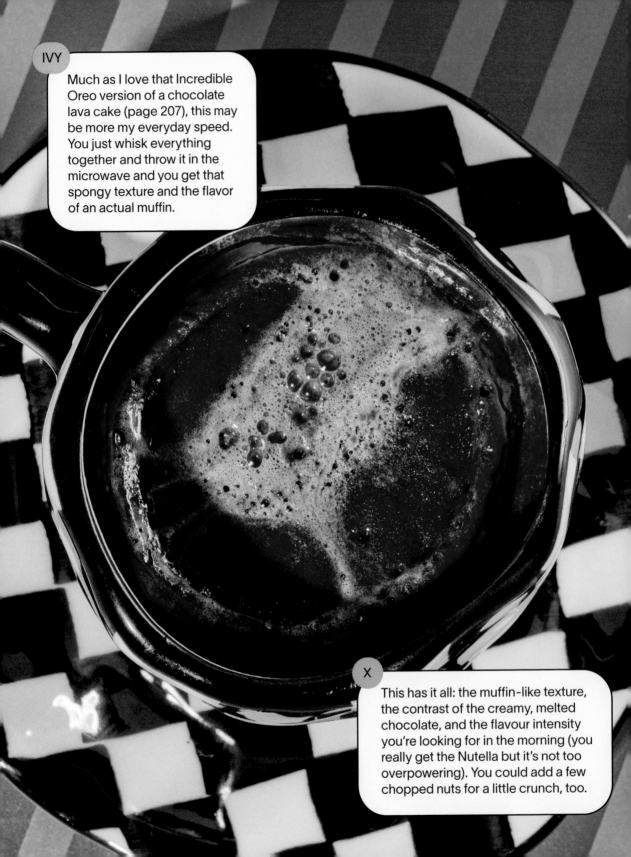

The MugMuffin

The name may be reminiscent of everyone's favorite McDonald's breakfast sandwich, but this recipe was actually inspired by the so-called peanut butter bread that Pete Campbell made on one episode of **MasterChef Australia**. He made it with just three ingredients (peanut butter + sugar + an egg) that he mixed up together and zapped in the microwave. It sounded super easy to make when you've just rolled out of bed and are still half asleep (and it is!), and while undeniably impressive, we thought it was a little dry. Here we've made one with Nutella, which is already sweetened so you don't need the sugar in the batter, while a little milk and a spoonful of chocolate chips help to make the texture a little more moist and even more chocolaty. We may not be chefs, but we think we may have nailed it!

Makes 1 Snack

Lightly coat a large microwave-safe mug with the cooking spray.

In a small bowl, whisk together the chocolate hazelnut spread, milk, and egg really well so the egg is fully incorporated. Stir in the chocolate chips, scrape the mixture into the mug, and microwave on High for 1½ minutes. Use a towel or an oven mitt to remove the mug from the microwave and make yourself a cuppa coffee or tea—this thing is way too hot to eat right away!

After a solid 5 minutes, sprinkle the powdered sugar on top, if you want. Pull out a spoon and enjoy!

- Nonstick cooking spray or vegetable oil, for coating the mug
- 3 small spoonfuls (3 tablespoons) chocolate hazelnut spread (Nutella)
- 1 small spoonful (1 tablespoon) milk, any percentage
- 1 large egg
- 1 small spoonful (1 tablespoon) chocolate chips, any kind
- A few good shakes of powdered (confectioners') sugar, if you want

CHEAT SHEET

Use a large mug (at least 1 cup / 240 ml or larger) so the muffin batter doesn't overflow while it's cooking. (It puffs up a lot as it cooks.) To lightly coat the mug with oil, ball up a paper towel, dip it in the oil, and use the paper towel to coat the inside of the mug.

*

Whisk the egg into the Nutella mixture really well or you'll have bits of eggs that will cook up into scrambled eggs in your muffin!

Chili-Cheese Cinnamon Rolls

- All beef or beef with beans chili (homemade, canned, drive thru, or frozen)
- Iced cinnamon rolls (homemade, packaged, drive thru, or frozen)
- Shredded cheddar cheese or sliced processed (American) cheese
- Chopped white onions, if you want

In 60 seconds or less

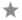

Get a **Cinnabon** + **a cup of Wendy's chili** (with cheese, onions optional), and dunk the cinnamon roll in the hot chili!

CHEAT SHEET

You could use any cinnamon roll and your favorite spicy, beefy chili. We don't remember if the one we got at the drive-thru actually came with onions (probably), but you definitely want the cheese. If you are going with onions, sweeter white or even red onions are the way to go, but honestly if yellow onions are all we've got, we're gonna use that.

Eating a Cinnabon and Wendy's chili together didn't sound all that out there to us when we saw people doing it. Who doesn't like a hot cinnamon roll AND a piping hot bowl of chili? These two are definitely better together; the doughy sweetness of the cinnamon roll balances the savory, spicy chili. Get an oversized cinnamon roll (Cinnabon!) and put a cup of chili in the drink holder for dunking, and you're set for the weekday morning commute or a weekend road trip (for more cross-country Snack ideas, check out the next page). When the chili is more the main event, the combo becomes a certifiable meal later in the day. Pile a shit-ton of chili on top of a cinnamon roll, and you've got an open-faced sandwich. On game days, we get a giant pot of chili going on the stove and pop open a coupla tubes of those smaller grocery store cinnamon rolls to serve more like a sweetened biscuit alongside.

Makes as many Snacks as you want

Heat up the chili and bake or rewarm the cinnamon rolls if needed.

Toss plenty of cheddar or processed cheese in the chili, give the chili a stir to melt the cheese, and scatter some onions on top, if you want. Have at it!

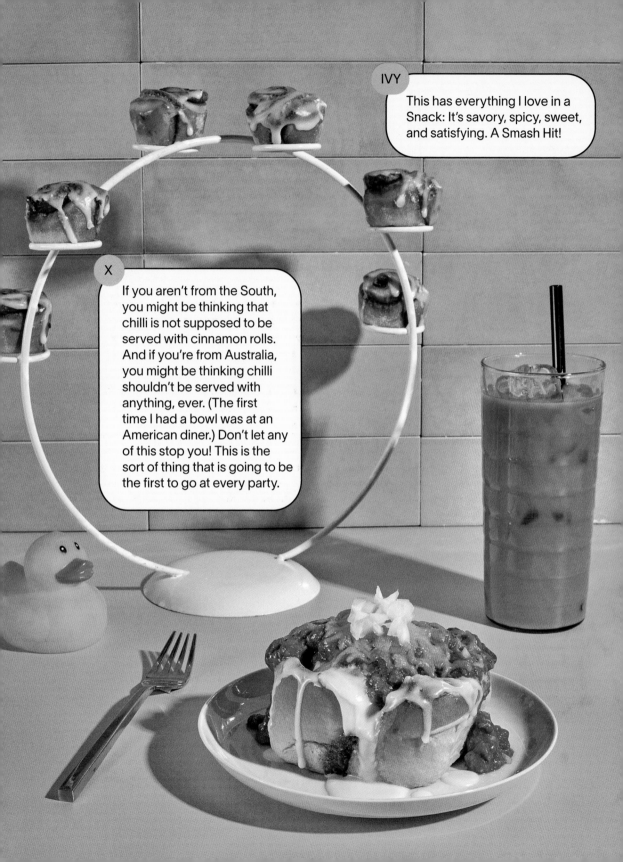

ROAD TRIP!

There's nothing that says "road trip!" more than Snacks! Some of the best trucker havens double as legit restaurants with made-to-order regional specialties or ready-made options under heat lamps; you might even score some secret sauce in the fridge case. But those times when you can't stop for a verifiable meal, the aisles of tempting packaged novelties from Big Snack (and if you're lucky, regional) brands await your approval. Even just the frozen treats in the chest freezer can open up a new world of Snack possibilities. (You MUST grab a Golden Gaytime bar, see page 195, if you're ever in Australia, or a Drumstick if you're tripping in the States!)

Whether you couldn't wait one more exit and landed at the most basic filling station after chugging that mega-size fountain drink at the last stop, or you've hit the jackpot with a mini-mart that has both a microwave AND hot dog delights on a roller grill, here are a few ideas for road trip–worthy Snacks that we've taste-tested on our **Snack or Yack?** series.

BASIC SNACKS
(No special appliances or hot ingredients required!)

PICKLES + PEANUT BUTTER

Ivy: I love pickles, I love peanut butter, and this combo was shockingly good the first time I tried it. Put a jar of peanut butter and a jar of spears in the cupholder and dunk!

NACHO CHEESE DORITOS + BBQ SAUCE

X: This tastes like a BBQ sandwich with the sweetness from the BBQ sauce and the cheesy flavour of the chips.

SLIM JIMS + PEANUT BUTTER OR PEANUT BUTTER CRACKERS

Ivy: Here you've got the spicy cured meat, the creamy, sweet peanut butter, and if you're going with PB crackers for something more substantial, the salty crackers all in one bite. (Maybe I shouldn't tell you how we got this idea, but we heard using Slim Jims slathered with peanut butter in a rat trap is a guarantee you're gonna get a rat. If you're like us, now you've really got to try this!)

FRUIT GUSHERS + CHAMOY

Ivy: This is Incredible! I'd buy tons of packs of Gushers just to make this the whole trip. You don't need to refrigerate the chamoy even after the bottle has been opened.

PILKK OR VEGAN EGG CREAM

(page 157, without the extra k, or Kahlúa) or Vegan Egg Cream (page 159)

X: You've got the classic Pepsi and milk combo for when you're maxed out on coffee but need a hit of caffeine to make it through to wherever you're crashing. Or go with the Coke and bottled chocolate syrup when you want *something* sweeter that tastes sorta like an egg cream.

SPRITE + A SPLASH OF COKE

X: This is easiest to make wherever there are fountain drinks, and it really does taste like ginger ale. Bartenders everywhere have uncovered one of life's great mysteries!

NEXT LEVEL SNACKS THAT COUNT AS ACTUAL MEALS
(For when you land a microwave and/ or hot delicacies!)

HOT CHEETOS BELGIAN WAFFLE

(page 51)

X: The road trip version of the original, no waffle iron required. Just heat a jar of queso (any kind) in the microwave, stir in some yellow mustard from the hot dog counter, and grab a bag of Flamin' Hot Cheetos for dipping.

CHILI-CHEESE CINNAMON ROLLS

(page 64)

Ivy: You don't need a hot Cinnabon and a Wendy's for this; even just a packaged cinnamon roll and some canned chili that you can throw in the microwave works. (Heat up the chili in a cup, and now you can put it in the cup holder for dunking.) If you've landed somewhere where you can score some chili cheese dogs, all you have to do is swap out the bun for a cinnamon roll. (I'd definitely eat that with the hot dog weiner, too.)

PIZZA CHIPS WITH RANCH

(page 122)

X: This requires someone in the passenger seat to help with assembly but it's SO worth it. On the road, you're gonna have to settle for microwaved pizza rolls, not deep-fried, which is perfectly acceptable in this situation. Get a bag of Cool Ranch Doritos, some cream cheese (if the gas station shop has bagels, they'll probably have those mini individual tubs; a container of sour cream also works), and pepperoni (or sliced salami: you could even cut up a beef stick). Now layer everything up like in the original recipe. Instant pizza!

THE THREE-MINUTE WHITE PIZZA

(page 95)

Ivy: People might look at you like you're a little off when you're throwing a shit-ton of shredded mozzarella cheese on a paper plate and surrounding it with string cheese, but this would be so easy to make! Leave out the seasonings on top and just throw on some salt and pepper that's always in those little packets by the napkins. If you get lucky and the place has hot nachos, you might even be able to score some pickled jalapeños or at least some hot sauce to go on top.

CHICKEN ALFREDO OPEN-FACED SANDWICHES

(page 93)

X: Except for maybe the frozen garlic bread and cooked bacon, that entire recipe was made from jarred or canned things you can find at most dollar stores (or A-list gas stations). Take a jar of Alfredo sauce, pour out half the sauce, add a can of chicken (drained) and a handful of grated cheese (any kind) to the jar, stir, and cook it up in the microwave until it's hot. All you need is a bag of tortilla chips to scoop up your homemade dip!

THE NOT ANYTHING BURGER

(page 105)

Ivy: If there's coffee, there should be hot water for tea . . . and this crazy good "burger" in minutes! You can make the patty right in the bag of Cheetos, just add your ramen noodles, crush them up, and then pour in the hot water. In the recipe we put these on buns to make a full-on burger, but originally we just ate the patty straight from the bag. (Cut it up into squares before you hit the road so the patties are easier to grab and eat.) I might still add some condiments, maybe some mustard, and you're definitely gonna need a lot of napkins!

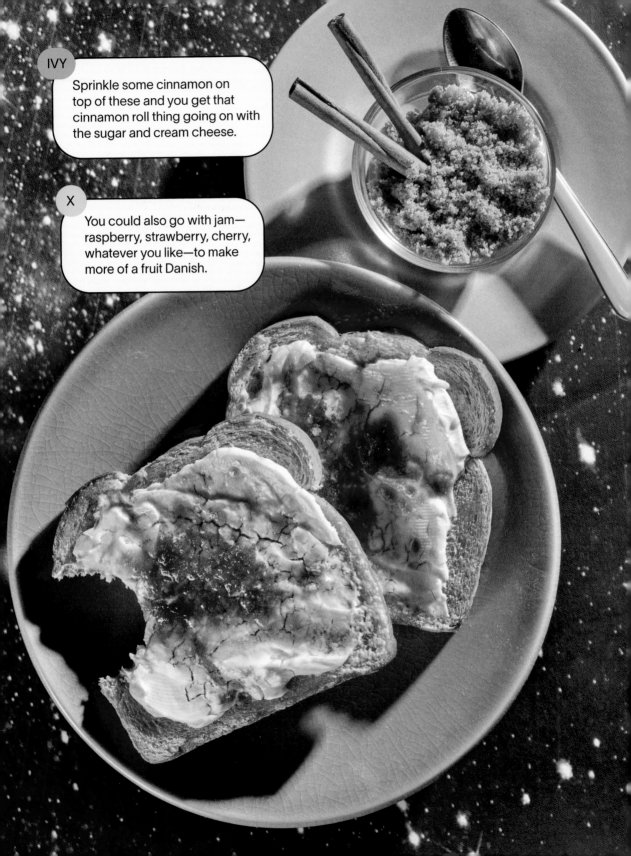

Danish Toast

This recipe is a weekday breakfast game-changer! It's the Danish cream cheese pastry you always wished you could get at the bakeshop around the corner. With a coupla everyday ingredients, you're well on your way to showing your parents that you're not a complete degenerate (just sorta kinda one) and are becoming a functioning member of society—at least when it comes to being able to make an incredible breakfast in minutes!

Makes 1 Snack

Briefly toast the bread until lightly browned but not too dark (it's headed back to the toaster or going under a broiler later). Spread ½ to 1 tablespoon of cream cheese on each slice, depending on how cheesy you're feeling, and sprinkle the brown sugar on top. Cut the butter or margarine into small pieces and scatter it evenly over both toasts.

Broil the toasts in the oven or return them to the toaster (only if you have a toaster oven!) until the butter or margarine has melted and, if you're lucky, the cream cheese begins to brown, about 1 minute. (Browning is not essential! It's better not to dry up or burn the bread.) The time will vary depending on how close the bread is to the broiler or the power of your toaster oven; watch the toast carefully as the toast can burn.

Enjoy your homemade Danishes while you consider the possibility of a future life as a professional baker.

- 2 slices classic white or wheat sandwich bread
- 1 to 2 small spoonfuls (1 to 2 tablespoons) cream cheese
- 1 small spoonful (1 tablespoon) packed light or dark brown sugar
- 1 to 2 tablespoons salted or unsalted butter or margarine

In 60 seconds or less

Lightly toast some **bread**, spread some **cream cheese** on top, and scatter plenty of **brown sugar** + **butter** over them. Broil or toast up the bread again, and you've got breakfast!

CHEAT SHEET

Don't re-toast these in a slot toaster, you'll lose all the sugar-cream cheese deliciousness (and muck up your toaster)! We've also found that air-frying the toasts, like some people like to do, can dry out the bread. These days we like to put them under a broiler, or as we finally got a toaster oven, just re-toast the bread with all the toppings.

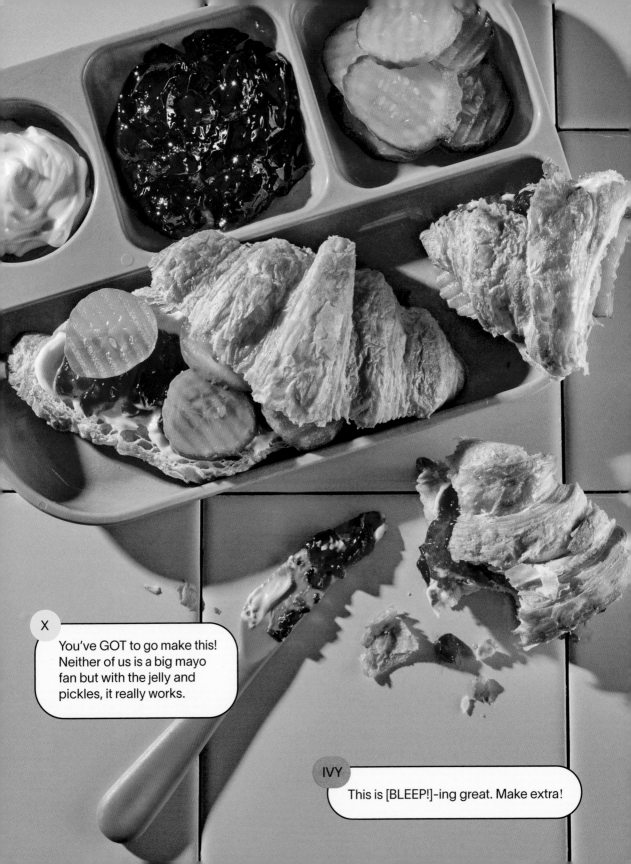

The MJP Breakfast Sandwich

This sandwich should not be as good as it is! It's made with mayo, jelly, and pickles on a croissant—that's it. Odd as it sounds, together those four ingredients somehow taste like something you'd get from McDonald's, sorta like a breakfast sandwich or even a cheeseburger only with some sweet sauce. Make this for someone and have them close their eyes while they eat it. They will be amazed!

Makes 1 Snack

Cut open the croissant and slather the mayonnaise all over the insides of both halves. Spread the jelly on one-half of the croissant, then the pickle sandwich slices or chips, close it up, and prepare to be amazed!

- 1 bakery croissant
- 1 generous spoonful (2 tablespoons) mayonnaise
- 1 small spoonful (1 tablespoon) jelly, preferably grape
- 2 large dill pickle sandwich slices or 6 to 8 dill pickle chips

CHEAT SHEET

Don't use good croissants, it's got to be those cheap ones you get in the bakery section of the grocery store.

Good pickles are a definite must. We recommend Claussen's sandwich slices, but don't let a run on premium pickles at the grocery store stop you from trying this with another brand.

In 60 seconds or less

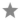

Get some **grocery store croissants** and layer up some **mayo** + **grape jelly** + **dill pickle chips** to make a sandwich. Done!

IVY

I LOVE corn flakes, so if you just poured honey over a bowl of corn flakes and handed it to me, it would be good. But these are insane! They taste like so much more than just cereal, butter, and honey. I could definitely see a Snack with half corn flakes, half popcorn, too, for that sweet-salty thing.

CHEAT SHEET

The cereal bars won't look much different after 10 minutes in the oven, but don't skip that step. Baking helps set the honey syrup so the corn flakes bind together.

*

You shouldn't have any leftovers, but if you do or are making a bigger batch, you can toss the cereal bars in a zip-top food storage bag and freeze them for several weeks. Don't leave them at room temperature too long as the corn flakes start to soften up within a day or two.

X

Make these and you'll understand why Honey Joys are so popular in Australia. You've got the crunchy cereal, the sweetness of the honey, and that buttery richness all in one bite. Incredible!

Honey Joys!

Honey Joys are THE Snack every kid grew up eating in Australia. They're sorta like Rice Krispies treats (page 173), only they're made with corn flakes and honey instead of puffed rice cereal and marshmallows. It's not something you'd normally have for breakfast, but with the cereal, they're arguably more of an authentic breakfast bar than so many Big Snack bars. Here we used a little more honey than in the classic recipe to get that bolder flavor we both like.

Makes 6 cereal bars; 2 Snacks

Preheat the oven to 325°F (165°C) and put 6 paper cupcake liners in a 6- or 12-cup muffin pan.

In a large saucepan, heat the butter over medium-high heat until melted, add the honey and sugar, and cook, swirling the pan or stirring the mixture a few times, until the honey begins to bubble, about 2 minutes. Add the corn flakes to the saucepan and use a rubber spatula to gently stir (don't smash!) the cereal into the honey syrup.

Use a measuring cup or soup ladle to scoop up the corn flakes mixture (careful, it will be hot!) and divide it among the 6 lined muffin tins. Press down gently on the tops of the bars to help them adhere.

Bake the bars for 10 minutes and let them cool in the muffin pan for a solid 15 minutes. Welcome to Oz!

- 4 tablespoons (55 g) unsalted or salted butter or margarine
- 1 generous spoonful (2 tablespoons) honey
- 1 generous spoonful (2 tablespoons) granulated sugar
- 2½ large handfuls (2½ cups / 70 g) corn flakes

In 60 seconds or less

Put those fancy paper cupcake liners in a muffin pan. Cook up some **butter** + **honey** + **sugar** until you have a bubbling syrup and stir in several handfuls of **corn flakes**. Scoop up the candies and put them in the cupcake liners, bake the bars for 10 minutes, and enjoy!

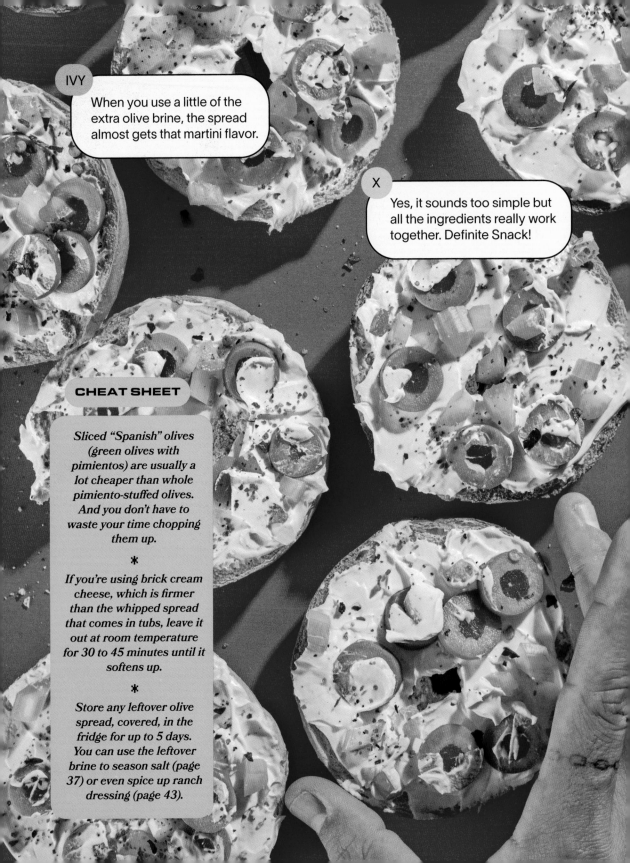

IVY

When you use a little of the extra olive brine, the spread almost gets that martini flavor.

X

Yes, it sounds too simple but all the ingredients really work together. Definite Snack!

CHEAT SHEET

Sliced "Spanish" olives (green olives with pimientos) are usually a lot cheaper than whole pimiento-stuffed olives. And you don't have to waste your time chopping them up.

✳

If you're using brick cream cheese, which is firmer than the whipped spread that comes in tubs, leave it out at room temperature for 30 to 45 minutes until it softens up.

✳

Store any leftover olive spread, covered, in the fridge for up to 5 days. You can use the leftover brine to season salt (page 37) or even spice up ranch dressing (page 43).

"Pinto Cheese" Bagels

We've done a coupla videos with the legendary comedian @AndyMilonakis; in one he made his family's favorite holiday appetizer spread. It's basically chopped up Spanish olives, a.k.a. pimiento-stuffed green olives, mixed with cream cheese that you eat on celery. Doesn't sound like much, but all together it really works. (For those who aren't in on the "pinto cheese" joke: In the video, X introduced Andy as the great "pinto cheese maker" when he meant pimiento.) Whatever you call it, you know it's definitely going to be great on a bagel. We like to add a little olive brine for more of that salty, cured flavor, and we're never going to say no to spicy seasonings. The crunch of the celery is also a must, so we just chopped up a stalk so it's part of the actual spread. Not bad for a pinto cheese bagel!

Makes about 2 cups (340 g); 6 Snacks

Drain the olives and pimientos, reserving 2 small spoonfuls (2 tablespoons) brine. In a medium bowl, use the back of a fork to mix together the olives and pimientos with the cream cheese, 1 small spoonful (1 tablespoon) of the brine, and the celery. Taste, and if the spread still needs a punch, add another spoonful brine.

Toast up your bagels, slather plenty of the olive spread on each half, and top them off with a few pinches of your spicy seasoning. Enjoy!

- About half of a 10-ounce (280-g jar) sliced green olives with pimientos (about 1 large handful / 1 cup)
- 1 (8-ounce / 225 g) tub or brick cream cheese
- 1 medium stalk celery, chopped
- 6 bagels, any kind
- Spicy seasoning: barbecue or Cajun seasoning, chili powder, Tajín, cayenne pepper, crushed red pepper, or similar

In 60 seconds or less

Mix together some **sliced green olives with pimientos** + a little of the **olive brine** + **cream cheese** + **chopped celery** really well. Spread that on **toasted bagels** and top it off with a pinch of your favorite spicy seasoning mix. Cheers to a great holiday breakfast!

X

I LOVE passion fruit in any form! One of my favourite things about visiting Hawaii is that they're everywhere and so cheap. I'd be making this every day if I had more around.

IVY

I think I gave that Monstera deliciosa smoothie an 8.5 out of 10. I'm going with a 9 on this one. It's got the creaminess of the banana but the tart passion fruit balances out the sweetness.

The Five-Dollar Smoothie

Smoothies are almost always a solid Snack. The question today is, are they worth the price? We don't need to start our day with something that costs more than a top-shelf shot of tequila, like that $17 smoothie from Erewhon (a high-end "natural foods" grocery chain in Southern California) that went viral. It wasn't even that good; the blue stuff in it, spirulina or whatever, was just weird. Far better was that "$127 smoothie," as we called it in one video, that we completely made up after a fruit vendor sent us a box of **Monstera deliciosa**, a hard-to-find tropical fruit that sorta looks like a giant green corn on the cob with an incredible almost pineapple-y banana flavor: $127 was the price for a box of the fruit!! Who's going to really make that, though?

As far as tropical fruits go, passion fruit with its tart-sweet flavor is still number one in our book. AND it makes an incredible smoothie. Grab a few passion fruits, make this, and we promise you will be looking up how to grow the vines on your apartment balcony, or short of that, indoors under the shade of your popcorn ceilings!

Makes 1 Snack

Scrape the pulp and seeds of 2 of the passion fruit into a blender or use 3 small spoonfuls (3 tablespoons) pulp. Add the banana, milk, and ice and blast everything until the ice is finely crushed.

Pour the smoothie into a glass, add the pulp and seeds of the remaining passion fruit or, if you're using frozen, 1 small spoonful (1 tablespoon) pulp, and stir a few times to get that swirly psychedelic effect. Enjoy!

- 3 passion fruit, cut in half, or 4 small spoonfuls (4 tablespoons) frozen passion fruit pulp
- 1 small very ripe banana
- 1 cup (240 ml) milk, any percentage
- 1 cup (225 g) ice

In 60 seconds or less

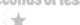

Blast some **fresh passion fruit pulp** (with seeds!) + a **banana** + some **milk** + **ice** in a blender, stir in the pulp and seeds of another **passion fruit**, and enjoy!

Fact! Look, we know some of you are going to say there is no way this is a five-dollar smoothie. And yes, passion fruit can still be pretty expensive some places. But the vines grow like crazy in hot, drier climates. (California! Australia!) In L.A. at least, you can get them pretty cheaply in the summer, especially at grocery stores that specialize in tropical fruits. People even have passion vines growing along their fences in some neighborhoods here!

Egg-in-a-Pocket

This brilliant Snack is the yin to the yang of an egg-in-a-hole. Instead of cutting out a hole in a piece of bread to serve as the cavity to fry an egg, you put the egg yolk in the center of two slices of bread, cut out a pocket sandwich, and toast it up. You are rewarded with a deliciously runny poached egg yolk enclosed by toast that you can butter up and just pop in your mouth. Something this simple could only be improved with a little hot sauce!

Makes 1 Snack

Lay the sandwich bread on the counter. Slide the yolk onto the center of the bread, sprinkle it with salt, and gently lay the other slice of bread on top. Put a roughly 3-inch (7.5 cm) wide drinking or rocks glass, rim facing down, in the middle of the sandwich, press down firmly on the glass to seal the edges of the bread, and peel away the excess bread to make a sandwich round. The egg should be completely enclosed by the bread; if not crimp down the edges by pressing on them gently. Discard the bread scraps.

Toast the sandwich in a toaster oven or slot toaster until the bread is golden brown; you want some good color but the bread shouldn't be burnt (the amount of time varies by the toaster).

Spread a little butter or margarine on both sides of the sandwich, hit it with a few shakes of hot sauce, and revel in the incredible wonders of a perfectly poached egg. (And even if it's not perfect, it's still gonna be good!)

- 2 slices white or wheat sandwich bread
- 1 large egg yolk
- 1 generous pinch salt
- Unsalted or salted butter or margarine
- A few good shakes of hot sauce, any kind

In 60 seconds or less

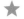

Make a pocket sandwich with **2 slices of sandwich bread** + an **egg yolk** + a pinch of **salt** and cut it out with a drinking glass so you have a circle of bread enclosing the egg. Put the sandwich in the toaster and when it's done, spread some **butter** all over it and douse it in **hot sauce**. Grab some napkins before you take a bite, it's messy!

Recipe continued

CHEAT SHEET

Yolk only! With the whites the egg won't cook quickly enough before the toast burns.

If you've never made pocket sandwiches, check out the PB&J versions (page 60) for tips on cutting out the bread so the edges are sealed.

Fact! It is our moral obligation to note that like so many things in life, we got lucky on this one the first time we made this. We just threw the sandwich in our slot toaster until the bread was nicely browned and the egg was perfectly poached. (As you saw if you watched our video, the even more amazing thing was the yolk actually stayed inside the 2 slices of bread even in a slot toaster!) But we are dealing with eggs, which never seem to cook up the same way twice for anyone. (Probably why there are so many TikTok videos on the perfect boiled, fried, poached, peeled, and every other form of eggs.) Even just the type of toaster makes a difference: a toaster oven versus a two-slot toaster (where the heat is much closer to the toast), an expensive model that promises temperature perfection versus the fantastically cheap toasters in dorm rooms worldwide that seem to toast everything to a burnt crisp in hardly a minute and are the bane of every local firefighting department.

THE MORAL OF THIS EGG STORY: You're gonna have to experiment to find the right level of toasty-ness for the bread so the egg also cooks inside. Better to have an overcooked egg than a raw one, so we recommend erring on the side of extra toasty, and a firmer egg is nothing more hot sauce can't remedy.

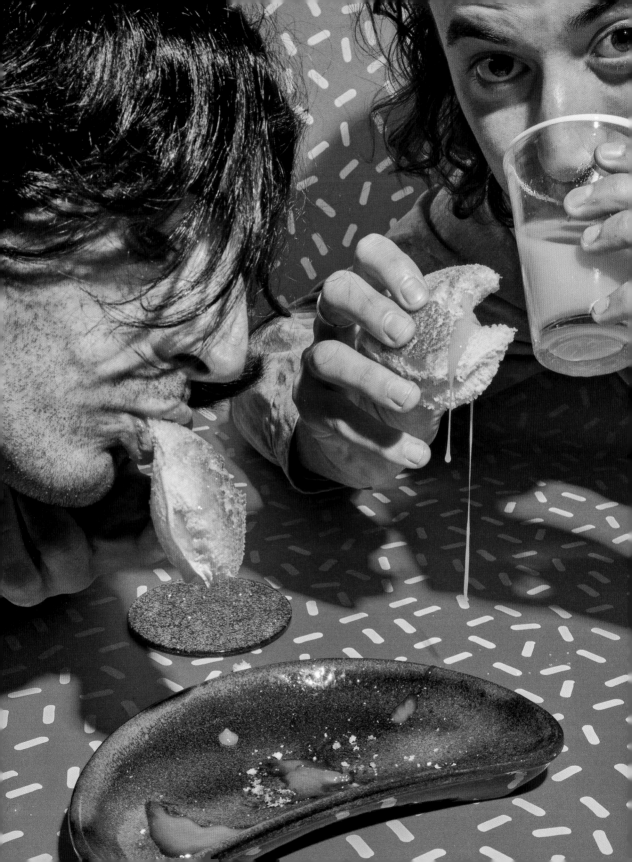

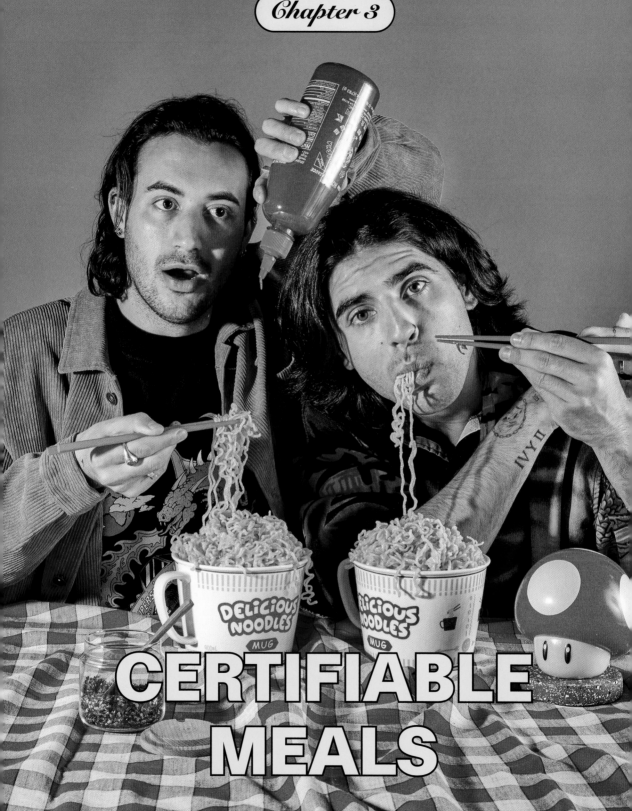

CERTIFIABLE MEALS

Whether you need to recharge with a power lunch after that triple-latte midmorning crash or have a hankering for a satisfying meal to wrap up the day so you can watch slashers on the couch all night, the recipes in this chapter are sure to satisfy.

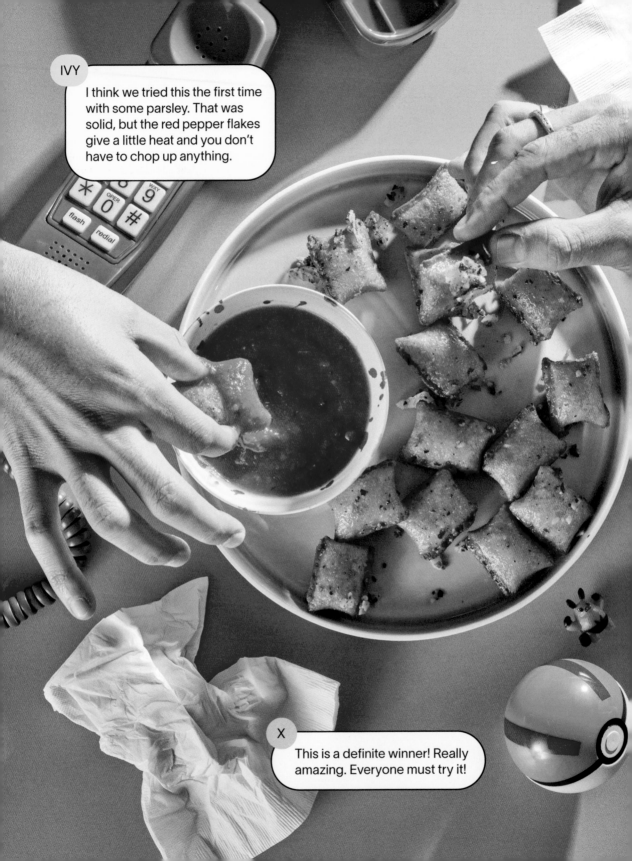

Elevated Pizza Rolls

Our Italian ancestors are probably turning in their graves over this recipe, but it's a different Snack world today . . . and one with a frozen-food aisle at our disposal! These garlic-butter pizza rolls with marinara have every Top Hit quality: They're hot, cheesy, saucy, creamy, crunchy, and satisfying. And they can be made to order if you've got virtual dinner plans or made ahead and rewarmed for actual real-time visitors. We promise they will have you—and everyone else—shouting "Mama mia"!

Makes 1 Snack

In a small skillet, heat the butter over medium-high heat until melted, add the garlic, and stir until the garlic smells incredible, about 30 seconds. Throw in as much crushed red pepper as you can handle and scrape the garlic butter into a medium bowl. Don't throw the skillet in the sink; you're gonna use it again.

Line a large plate with paper towels. Pour enough oil into a large frying pan or Dutch oven to come roughly 1 inch (2.5 cm) up the sides and heat the oil over medium-high heat until very hot, about 350°F (175°C).

When the oil is hot, add the pizza rolls and fry until golden brown on the bottom, about 1½ minutes. Use tongs to flip the pizza rolls, cook until the other side is golden brown, about 1 minute longer, then transfer the pizza rolls to the paper towel–lined plate. If a pizza roll pops open while frying, remove it from the oil and toss it. (Or eat it when it cools!)

- 1½ tablespoons unsalted or salted butter or margarine
- 1 clove garlic, minced or pressed
- Crushed red pepper
- Vegetable oil, for deep-frying
- 10 to 12 frozen pizza rolls (Totino's), any flavor
- 1 small handful (⅓ cup / 1 ounce / 28 g) finely grated parmesan cheese or parmesan topping
- ½ cup (120 ml) marinara sauce, any kind

In 60 seconds or less

Fry up some **garlic** in a little **butter**, add some **crushed red pepper**, then deep fry plenty of **pizza rolls**. Toss the pizza rolls in the **garlic butter**, add some **parmesan**, and serve those Incredible bites with **marinara** for dunking.

Recipe continued

CHEAT SHEET

If you don't have a frying thermometer, test the temperature of the oil by adding a small piece of bread (any kind) or if you're willing to potentially sacrifice a pizza roll if the oil isn't hot enough yet, one pizza roll. It should sizzle when it hits the oil. Using tongs, remove the bread before frying the pizza rolls.

*

You can fry the pizza rolls and make the garlic butter 30 to 45 minutes before you serve them. Leave the pizza rolls to drain on the paper towels at room temperature and keep the garlic butter in the skillet on the stovetop. Rewarm the pizza rolls in the oven at 300°F (150°C) until hot, about 10 minutes, and gently warm the garlic butter over low heat just until the butter is melted, if you need to. (The residual heat of the oven will likely be enough to melt the butter on its own.) Toss together the hot pizza rolls, garlic butter, and parmesan, and all you've got to do is warm up the marinara.

Add the pizza rolls to the bowl of garlic butter and toss the two together via a couple good shakes of the bowl like a great Italian chef (or yeah, just use a spoon to stir them together). Sprinkle the parmesan cheese on top. (Don't taste yet, the pizza rolls will be very hot!)

Now grab the skillet that you used to make the garlic butter, add the marinara, and rewarm it over medium heat until it's warm to the touch. Pour the marinara into a small bowl, grab the bowl of pizza rolls and plenty of paper napkins like you're at the best red sauce Italian restaurant, and dunk the pizza rolls in the marinara. Buon appetito!

Fact! While you could air fry the pizza rolls (and we're not gonna say we might not do that sometimes with this recipe), deep-frying really is worth it here. The crust gets super crunchy and golden brown, taking the dish to an entirely new dish-mension! (Hahaha! Too much Olive Garden–variety humor for ya?)

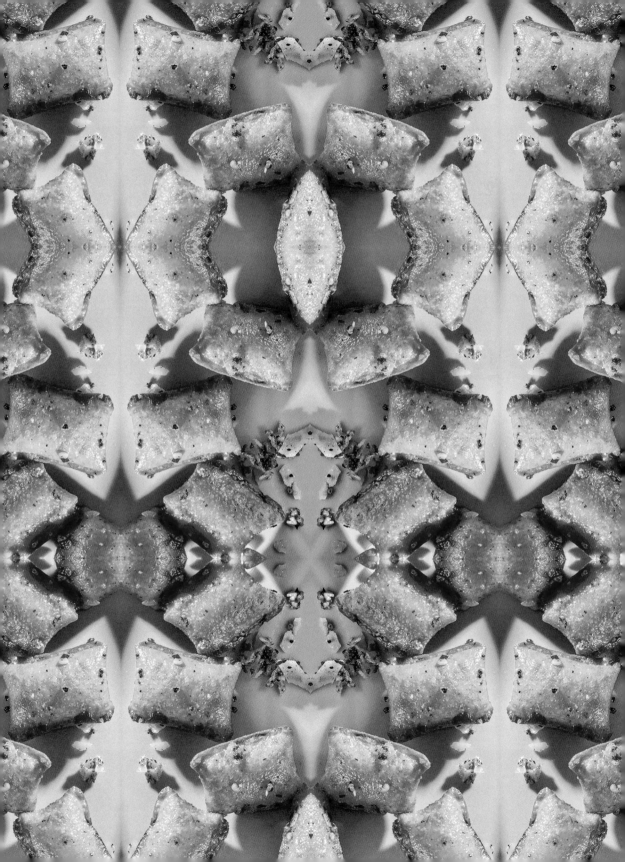

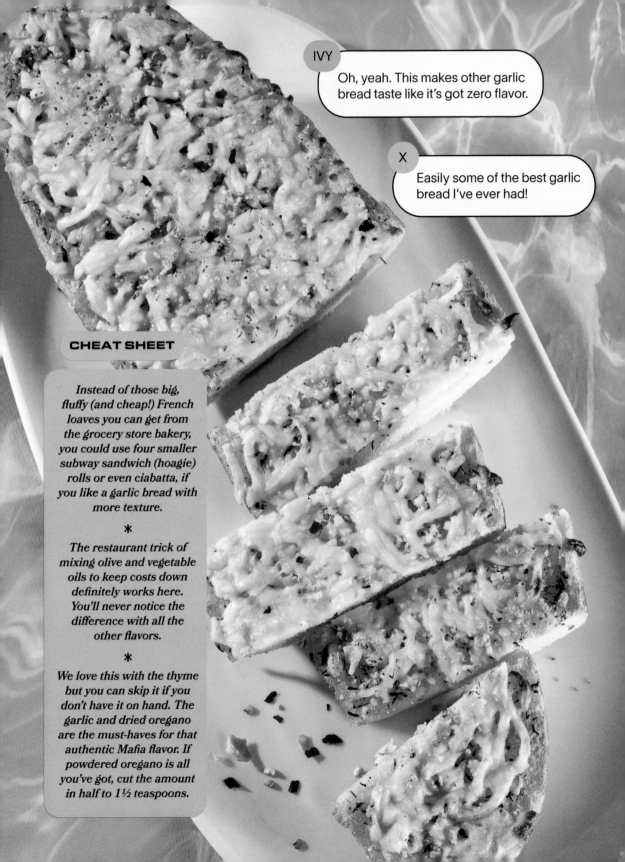

IVY

Oh, yeah. This makes other garlic bread taste like it's got zero flavor.

X

Easily some of the best garlic bread I've ever had!

CHEAT SHEET

Instead of those big, fluffy (and cheap!) French loaves you can get from the grocery store bakery, you could use four smaller subway sandwich (hoagie) rolls or even ciabatta, if you like a garlic bread with more texture.

✳

The restaurant trick of mixing olive and vegetable oils to keep costs down definitely works here. You'll never notice the difference with all the other flavors.

✳

We love this with the thyme but you can skip it if you don't have it on hand. The garlic and dried oregano are the must-haves for that authentic Mafia flavor. If powdered oregano is all you've got, cut the amount in half to 1½ teaspoons.

Loaded Garlic Bread

A version of this garlic bread with the works was the subject of one of our earliest **Snack or Yack?** taste tests and it's a proven winner we go back to whenever we're seriously hungry and want something hot that's quick to make. Since we like really BIG flavors, we've loaded the bread up with even more cheese than was in the original version and also no surprise if you know us, red pepper flakes. A lot of people like to broil garlic bread, but baking it means you don't risk burning the garlic as easily OR setting off the fire alarm if you forget the bread's still under the flames—a guaranteed way to delay the deliciousness when your neighbors come knocking. (Something we **might** have learned from experience.)

Makes 2 Snacks

Preheat the oven to 425°F (220°C).

Slice the bread in half lengthwise and lay the halves on a baking sheet, cut side facing up.

In a small bowl, mix the olive oil, garlic, oregano, thyme, and crushed red pepper. Spoon the oil mixture all over the bread so the whole surface is doused, season the bread with a few generous pinches of salt, and sprinkle the mozzarella and parmesan on top.

Bake the bread until the cheese is melted and it begins to brown on the edges, 8 to 10 minutes. Enjoy!

- 1 large (16-ounce / 455-g) loaf soft French bread
- ½ cup (120 ml) olive oil, or a mix of half olive oil, half vegetable oil
- 1 generous spoonful (2 tablespoons) minced garlic (4 large cloves)
- 1 small spoonful (1 tablespoon) dried oregano
- 1 small spoonful (1 tablespoon) dried thyme
- 1 small spoonful (1 tablespoon) crushed red pepper, if you can handle that much heat
- Salt
- 2 large handfuls (2 cups / 8 ounces / 225 g) shredded mozzarella cheese
- 2 generous spoonfuls (4 tablespoons) finely grated parmesan cheese or parmesan topping

In 60 seconds or less

Slather some **french bread** with **olive oil** that's loaded up with a shit-ton of **garlic** + **oregano** + **thyme** + **crushed red pepper.** Throw some **salt** + **shredded mozzarella cheese** + **grated parmesan** on top and bake the bread until the edges are golden brown. Prepare to be transported to Little Italy!

X's Vegemite Toastie

- 1 generous tablespoon unsalted or salted butter or margarine
- 2 slices classic white or wheat sandwich bread
- ½ to 1 small spoonful (1½ teaspoons to 1 tablespoon) yeast extract spread (Vegemite or Marmite)
- 1 large handful (1 cup / 4 ounces / 115 g) shredded cheddar cheese

In 60 seconds or less

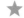

Butter some **sandwich bread** and lay the slices out on a plate, buttered side down. Spread a little **Vegemite** on one or both slices, top one slice with plenty of **cheddar cheese**, and close up the sandwich. Now grill it in a sandwich press or waffle iron until the cheese is all melty and the bread is toasty. Incredible … or Inedible?

Vegemite is Australia's version of Marmite. For the unenlightened, Marmite is an intensely flavored spread made with leftover brewer's yeast extract (originally from making beer) that has British roots. Like peanut butter, it's probably already a Snack—or yack—in your book. If you're on the fence, or even if you think you hate the stuff, you really need to try this grilled cheese sandwich!

Makes 1 Snack

Preheat a panini press or waffle or jaffle iron according to the manufacturer's instructions.

Spread the butter or margarine all over one side of each slice of bread and lay out the slices on a plate, buttered side facing down. Spread a thin layer (about 1½ teaspoons) of the yeast extract spread on one slice of bread. If you're not sure whether you like the stuff, stop there; if you're a devoted fan, spread the same amount (or as much as you want, you know what you're doing) on the other slice of bread.

Scatter the cheese over one slice of bread and close the sandwich; the butter side of the slice on top should be facing up. When the press or iron is hot, add the sandwich and close the lid. Press down gently on the lid but don't clamp the top down too hard or the cheese will ooze out as it melts. Cook the sandwich just until the cheese has melted and the bread begins to brown, 1 to 1½ minutes, depending on your machine's settings. Enjoy!

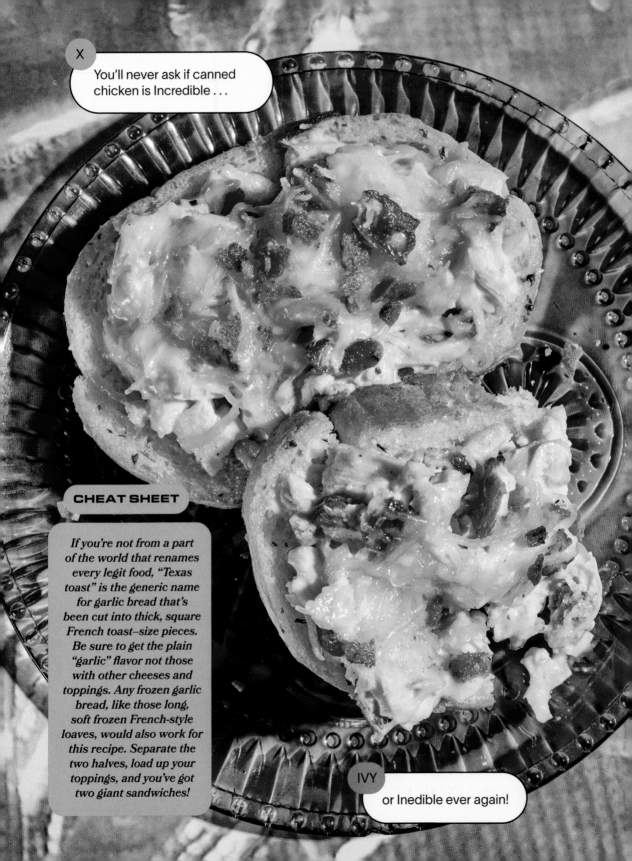

X

You'll never ask if canned chicken is Incredible . . .

CHEAT SHEET

If you're not from a part of the world that renames every legit food, "Texas toast" is the generic name for garlic bread that's been cut into thick, square French toast–size pieces. Be sure to get the plain "garlic" flavor not those with other cheeses and toppings. Any frozen garlic bread, like those long, soft frozen French-style loaves, would also work for this recipe. Separate the two halves, load up your toppings, and you've got two giant sandwiches!

IVY

or Inedible ever again!

Chicken Alfredo Open-Faced Sandwiches

This sandwich was a canned chicken "first" for both of us, and to be honest, it didn't smell like we were going in the right direction when we opened the can. But wait! This is why we are here, to disprove myths and discover unexpected new delicacies. It turns out that canned chicken is shockingly good—or at least in this recipe. The whole point of making this is to open a few cans and bags of stuff you should already have around (or should from now on) and throw it all together. For us, that means don't worry so much about measuring things out. Go with however much bacon is left in the fridge and whatever else you've got on hand. And sure, you could use any leftover shredded chicken (including Ivy's "Famous" Hot Chicken! on page 111), but you've really got to try this with canned chicken first! It will forever change your **tuna**-vision. (Hahaha.)

Makes 2 Snacks

Preheat the oven to 425°F (220°C). Lay out the garlic toasts on a baking sheet.

In a medium bowl, mix the chicken (don't forget to drain the can first!), about half the jar of Alfredo sauce, and half the bacon. Spoon the chicken mixture over the garlic bread and cover it with more Alfredo sauce if you're feeling extra "saucy." Top the whole thing off with your cheese of choice and the rest of the bacon.

Bake the toasts until the cheese is bubbly and the bread begins to brown on the edges, 12 to 15 minutes.

Let the garlic bread cool on the baking sheet for 2 to 3 minutes, then revel in your five-star meal-worthy Snack!

- 1 (11-ounce / 310-g) package frozen garlic-flavored Texas toast (6 slices)
- 1 (10-ounce / 280-g) can chicken, drained, or 1 cup (170 g) shredded cooked chicken
- ½ to 1 (15-ounce / 430-g) jar or can Alfredo sauce
- 4 to 5 slices bacon, any thickness, fried until crispy and crumbled
- 2 large handfuls (2 cups / 8 ounces / 230 g) shredded cheese: cheddar, spicy (pepper) Monterey Jack, provolone, or similar, or 6 slices processed (American) cheese

In 60 seconds or less

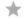

Throw some **Texas Toast** on a baking sheet. Mix together some drained **canned chicken** + **jarred Alfredo sauce** + fried and crumbled **bacon** and spread that all over the garlic bread. Top the toasts off with **shredded cheese** (whatever you like) + more **bacon** (why not?) and bake those up until they're piping hot. Enjoy!

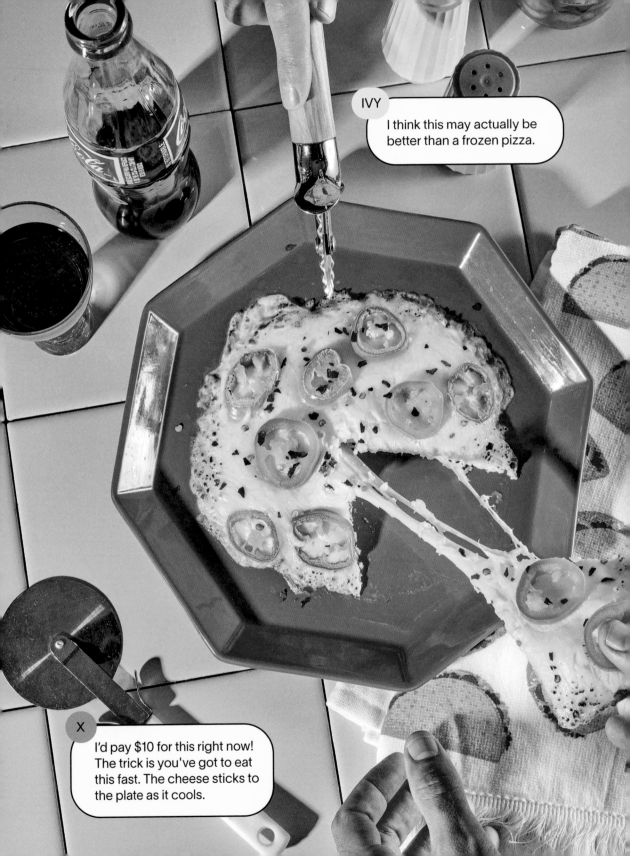

The Three-Minute White Pizza

Tell us not to do something, and we're definitely going to try it. Consider the cheese hack from @purplepossum0, a.k.a. the Cheese Goblin, which was basically just a mix of shredded mozzarella and string cheese that you nuke in the microwave. In this video, he said to definitely NOT sprinkle any popcorn salt over the top, so of course we did exactly that after the cheese cooked up. The salt is what made it Next Level! Now we think the Cheese Goblin may have meant not to sprinkle the salt on before microwaving the cheese for some reason. (Still no clue why. Maybe it affects the texture? We leave that to you to figure out.)

One thing does make a big difference in whether this recipe works or not: what kind of cheese you use and how you arrange it. The string cheese on the outside of the plate cooks up to create an almost spongy pizza-like crust at the edges, and the (regular) mozzarella in the center becomes an oozy delicious cheesy center. Why not turn this into an actual pizza, then?!

We like ours with pickled jalapeños; works really well with the simple flavors of a truly pure-cheese pizza. You could go anywhere down that pickled road: pepperoncini, banana peppers, green olives. Red pepper flakes are another must for us, and definitely don't forget the salt!

Makes 1 Snack

- 4 mozzarella string cheese sticks
- 1 large handful (1 cup / 4 ounces / 115g) shredded mozzarella cheese or 6 squares pre-sliced deli-style mozzarella
- 5 to 6 sliced pickled jalapeños, drained
- Salt
- Crushed red pepper

In 60 seconds or less

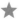

Grab a paper plate and make a square out of **4 sticks of string cheese** in the center. Fill in the square with a lot of **shredded or sliced mozzarella** and put some **sliced pickled jalapeños** on top. Nuke the cheese in the microwave for a solid 3 minutes, sprinkle some **salt** (any kind!) and **red pepper flakes** over the top, and get ready to be amazed!

Recipe continued

CHEAT SHEET

Pre-shredded or packaged pre-sliced mozzarella makes the pizza assembly super quick, but you could thinly slice half of an 8-ounce (225 g) block of mozzarella instead. (Don't use fresh mozzarella, it's way too moist.) And don't skimp on the quantity of mozzarella! You need a lot to keep the cheese from burning during the lengthy cooking time. If the pizza cools off and starts to stick to the plate before you've polished it off, zap it in the microwave for another 20 seconds or so.

*

The size of the plate also matters. If it's too large, the cheese will spread out too thin and can burn; too small and you end up with a saucier "pizza" that's more like queso.

*

Popcorn salt is very finely ground plain or flavored salt. But any texture of salt works here; just remember to sprinkle it on after the pizza cooks.

Grab a regular-size paper plate or a microwave-safe plate that's about 9 to 10 inches (23 to 25 cm) in diameter. On the plate, make a large square shape out of the string cheese, then throw the shredded mozzarella in the middle (or arrange the cheese slices in the center). Scatter the jalapeños all over the top.

Microwave the cheese on High for 3 minutes; it should be bubbly and golden brown on the edges. The cheese will look done after 2 minutes, but keep pressing through and microwaving until you get a pizza-like crust on the edge.

Sprinkle a little salt and plenty of crushed red pepper on top of the cheese, let the pizza cool off for a few seconds (not too long or the cheese will stick to the plate), and have at it!

Fact! Yes, string cheese is technically mozzarella, but it's drier than most block or shredded mozzarella (that's why it is "stringier") so you get that spongier crust-like string cheese edge when the pizza cooks.

Poor Man's Italian Beef Roast

- 1 (3½- to 4-pound / 1.6 to 1.8 kg) beef chuck roast or similar boneless, fatty cut
- 1 (16-ounce / 455-g) jar sliced pepperoncini, with the brine
- 1 (1-ounce / 28-g) packet powdered ranch salad dressing, dip, or seasoning mix (Hidden Valley; about 4 tablespoons)
- 1 (0.9-ounce / 25-g) packet powdered brown gravy mix (McCormick's; about 4 tablespoons)
- 4 tablespoons (55 g) unsalted or salted butter or margarine

In 60 seconds or less

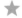

Put a **pot roast** in a slow cooker, throw in a **ranch dressing seasoning packet** + **a brown gravy mix packet** + **a jar of peperoncini** (with the brine!) + **some butter**. Cook that thing low and slow, get some **hoagies rolls** and **provolone**, put on a game, and toss back a coupla of Italian beef sandwiches!

Recipe continued

This pot roast is by far one of the best things we've ever made AND it's ridiculously easy to make! You just throw everything in a slow cooker and walk away. We messed around with the quantities of the ingredients to get to this version, which has a lot less butter than when we first made it (you've already got plenty of fat from the beef) and only one packet each of the ranch and brown gravy mixes. Rare for us, but we thought the one we made in our original video with two packets of each was a little too salty. Pile the beef and jus on a French or hoagie roll with provolone, and you've got an incredible Italian beef sandwich on the cheap!

Makes 6 Snacks

Put the beef roast in a large slow cooker, fat side facing up, and pour the pepperoncini, including the brine, all over and around the meat. Sprinkle the ranch seasoning and brown gravy mix over and around the beef and toss the butter into the slow cooker.

Cover the slow cooker and cook the beef on High for 2 hours, then reduce the heat to Low and cook until the meat is fall-apart tender, 4 to 5 more hours.

Scoop up that spicy, beefy goodness along with plenty of jus and pepperoncini and enjoy it now, or reduce the temperature on the slow cooker to Warm and let those smells fill your kitchen for another 2 or 3 hours before everyone shows up to polish it off. (Remind them to bring the French rolls and provolone for Italian beef sandwiches!)

If you have any leftovers (you shouldn't), cover and refrigerate the beef in the jus for up to 5 days.

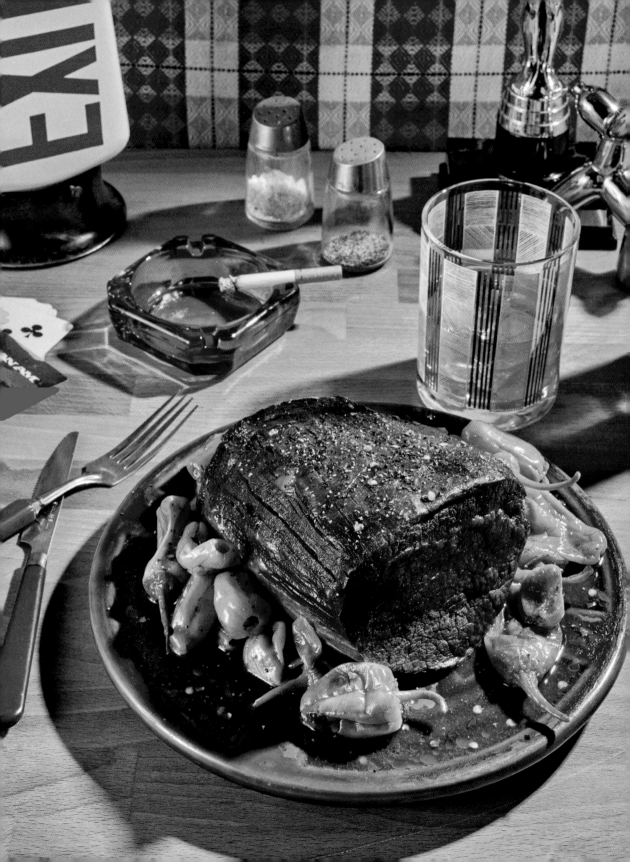

RAMEN!

There are two things we can always count on: There's a package of instant ramen hidden somewhere in the pantry (sometimes you just gotta dig deep), and we're gonna get Drake requests ALL night when we're DJ-ing—the only difference is that ramen is always a YES.

It's undeniable that ramen has been an Influencer within our instant-meal culture since the King infused the fashion industry with his signature gold lamé bling, and it's still just as worthy of experimentation today. When it comes to ramen recipes, we're probably more like Elvis impersonators than the real deal; there are entire social media accounts dedicated to recipe hacks using a package of the instant noodles. But we have mixed up a few combos that we think are worthy of sharing. Whether you're looking for a quick stovetop meal like the Next-Level Instant Ramen (page 103), want to go on a psychedelic ride with a crazy mash-up of ingredients (you MUST try the Not Anything Burger on page 105, our Elevated version of "prison ramen"!), or if you are craving something sweet like our Chocolate Ramen Crunchies on page 175), we've got something for every noodle appetite.

But first, here are a few ramen do's and don'ts that we've put to the test:

* With ramen, there's no need to overthink brands and flavors. We grab whatever brand (usually Nissin or Maruchan) and flavor (chicken, beef, shrimp, and similar) that's in stock at our grocery store. There are so many equally delicious brands out there that come in flavors like duck, tom yum pork, curry-spiced noodles, and so much more so feel free to go wild! And of course, there are the endless extra hot packages waiting to test your heat tolerance, like Samyang's infamous 3X Spicy Buldak (based on the Korean dish called "fire chicken"). Pick one, pick them all, that's half the fun.

* If you make something that doesn't need the seasoning packet, always save it to make something else delicious! Beyond the obvious noodles, pastas, and other grains that can be given a new life by the contents of these packets, you can use these seasonings to make dips or butter (page 23), season meat or fish, or virtually anything—as long as it isn't already really salty. (There's a lot of salt already in most packets.)

* We leave you with a ramen **Fact** that's sure to impress a first date: The average 3- to 3.5-ounce (85 to 100 g) package of instant ramen has roughly 2 to 2½ teaspoons of seasoning mix.

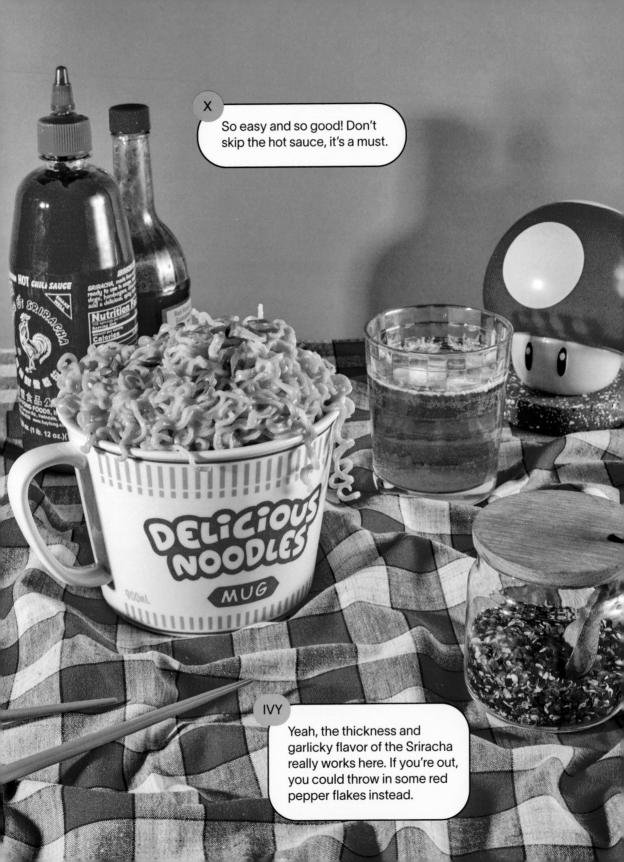

Next-Level Instant Ramen

While there are some things, in theory, that you are supposed to leave behind when you graduate from college—public holidays, tank tops, loud music, instant ramen—we still do our best to embrace them all whenever possible. However, in today's ever-changing, social media–driven world, we also try to reinvent our approach whenever possible. This dish is a case in point and we hope you will agree that it elevates ramen to a new sensory level. And even better, it's just as easy to make on a portable stove in your dorm room as it is to whip it up in an actual kitchen. Whether you're looking to impress a new date or celebrating because you just got a C+ on your organic chemistry final, this dish will wow instant ramen lovers and skeptics alike!

Makes 1 Snack

Cook the ramen noodles according to the package directions and drain. (Save the seasoning packets for something else delicious; see our box on ramen do's and don'ts on page 101.)

In a large skillet, heat the butter over medium heat until melted. Add the cream, processed cheese, and a squeeze of Sriracha and stir until the cheese has melted, about 1 minute. (Don't let the mixture boil or the cream may curdle.) Dump the noodles into the skillet and toss them in the sauce until they are well coated. Squeeze as much Sriracha on top of the noodles as you want and throw on the green onions.

Grab a fork, some chopsticks, or whatever you've got and slurp up your chef-worthy noodles straight from the skillet. (One less dish to clean!)

- 1 (3- to 3½-ounce / 85- to 100-g) package instant ramen, any flavor
- 1 tablespoon unsalted or salted butter or margarine
- ¼ cup (60 ml) heavy cream or heavy whipping cream
- 2 slices processed (American) cheese
- A few good squeezes Sriracha
- 1 green onion (scallion), sliced, if you want to add a green veggie

In 60 seconds or less

Cook up some **ramen noodles** (save the seasoning packet for something else). Melt some **butter** in a pan, add a little **heavy cream** + a couple slices of **processed cheese** + a good squeeze of **Sriracha**, and cook that until the cheese melts. Now dump the noodles in the pan, stir everything up, squeeze some more **hot sauce** on top and throw on some **green onions**, if you're feeling like a little something healthy.

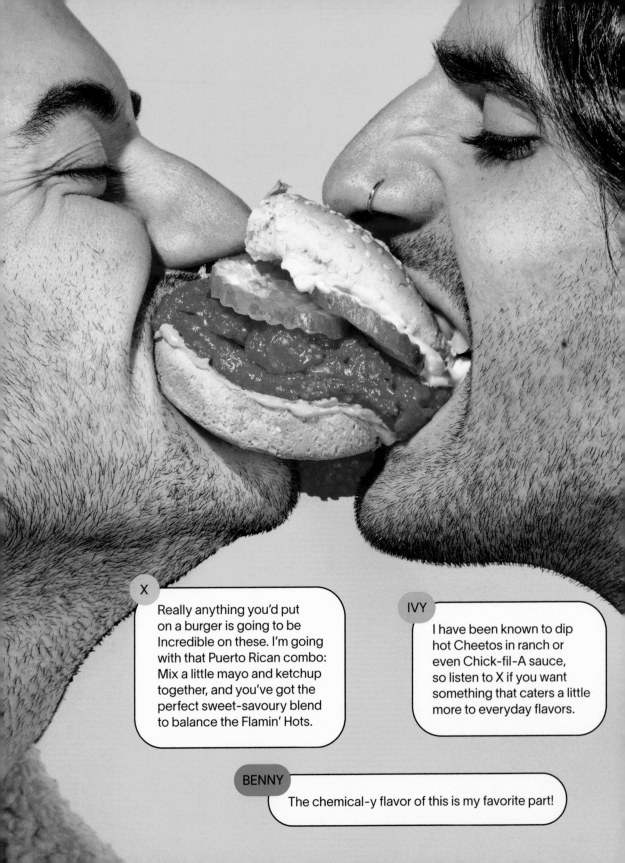

The Not-Anything Burger

(Not grass-fed, not meat, not vegan, and definitely not organic!)

And now, we introduce you to what may very well be the world's first burger that defies all description! A while back there was this "prison ramen" hack that went viral where you smash up ramen noodles and Flamin' Hots and mix them together in the Cheetos bag with some hot water. The result was not at all what we were expecting—or like anything we've ever experienced. Even our friend and music producer @ itsBennyBlanco (also of Fruit Roll-Up Ravioli fame, page 167), was floored. What you end up with is a giant, fluorescent red patty with the unmistakably delicious artificial flavor of the Flamin' Hots and an indescribable texture. Most surprisingly, it was really juicy; the fat in the Cheetos disperses like the beef fat does in a good burger patty. Most people just eat the patty right out of the bag (a good option on a road trip; see page 66), but add some burger buns and your favorite condiments, and now you've got a full spread that will wow everyone you invite to your indoor cookout!

Makes 4 Snacks

- 1 (8½-ounce / 240-g) bag spicy cheese puffs (crunchy Flamin' Hot Cheetos; about 5½ cups)
- 1 (3- to 3½-ounce / 85- to 100-g) package instant ramen noodles, any flavor
- 1 cup (240 ml) boiling water
- 4 hamburger buns
- Your favorite condiments: mustard, mayo, ketchup, ranch, even pickles

In 60 seconds or less

Crush up a bag of **Flamin' Hot Cheetos** + a bag of **ramen** (noodles only) in a food storage bag, add **boiling water**, and massage the bag until you can shape the mixture into a giant square patty. Cut open the bag, shape your creation into 4 burger patties, and serve them on **buns** with whatever **condiments** you like.

Recipe continued

CHEAT SHEET

You can crush up the Flamin' Hots and ramen noodles directly in the Cheetos bag, but it's easier to do in a large food storage bag where you have a little more room and less spillage potential. And part of the fun is watching the transformation of this thing from dry noodles and chips to a giant patty, which you can witness in a clear bag.

This is the ultimate DIY party meal. All you have to do is get a shit-ton of bags of Cheetos and ramen and let everyone have at it!

Put the cheese puffs and ramen noodles in a large zip-top food storage bag and partially seal the bag; leave a little room open on one end of the bag for the air to escape. Gently crush the cheese puffs and ramen noodles with a meat mallet, hammer, rolling pin, or stomp on them so most are broken into pea-size pieces. Save the seasoning packets for another Snack.

Put the food storage bag in a bowl (in case there are any holes in the bag), carefully pour the boiling water into the bag, and partially seal the bag again so there is room for some steam to escape. Massage the cheese puffs and noodles together with your hands until the hot water has been mostly soaked up by the noodles, about 30 seconds. (If the bag's too hot for you to handle, wrap it in a kitchen towel.) Lay the bag on the counter and shape the mixture into a large square about 1 inch (2.5 cm) thick and roughly the size of a small electronic tablet (say, about 6 by 8 inches / 15 by 20 cm). Set aside the bag for 2 to 3 minutes so the patty can firm up and cool a little. The bag may seal up completely from the steam, which is fine. Meanwhile, get your buns and condiments ready.

Open the bag and use scissors to cut open the side of the bag that is facing up. Cut the ramen patty into 4 squares and shape each square into a round, burger-like patty. Now slide those beauties onto the buns with your condiments of choice and prepare to experience an incredible Snack!

Fridge-Aged Steak with Maitre d'Party Shirt Butter

And now, after that commercial break on the previous page featuring an undeniably delicious meat substitute, back to Real Meat! We're game to try anything that gives us an excuse to grab a coupla steaks. Still, one of the strangest food experiments we've ever done was when @NickUhas, the ultimate science geek, invited us over to try his hack for grilling steak over Doritos "coals." If you missed it, Nick burned down a ton of Doritos until they became basically charcoal (it really did look legit!) and used it to fuel his grill. We love Nick, we love Doritos, and we love steak, but we just didn't get the nacho cheese flavor (or any flavor really) from the steaks.

What ended up being Incredible is this hack for "dry aging" a steak; we've heard chefs use this shortcut when they don't have the time to dry age a steak for weeks or the space for a curing room. (Who has either?) All you do is season any good cut of beef with salt and pepper and let it cure for at least 24 hours in the fridge uncovered (the key). Afterward, the steak has that unmistakable dry-aged texture, color, and even somehow tastes beefier. You could stop there, and we usually do, but if you want to put some seasoned butter on top, you've got a definite Smash Hit!

Makes as many Snacks as you want

- Thick-cut steaks, any kind: ribeye, T-bone, filet mignon, New York strip, porterhouse, or similar
- Salt and freshly ground pepper
- Maitre d'Party Shirt Butter, any flavor (page 31), or salted butter: 1 small spoonful (1 tablespoon) per steak

In 60 seconds or less

Season a coupla **steaks** with **salt** + **pepper**. Let them cure in the fridge, uncovered, on a baking rack or whatever you have to elevate the meat, for a solid 24 to 36 hours. (Put a plate or something else underneath the rack to catch any juices that drip off the meat.) Cook those big boys however you like and finish them off with some **flavored butter**, if you want. Tell us that isn't on par with some of the best steaks you've ever had at any steakhouse!

Recipe continued

CHEAT SHEET

We both love filet mignon (we know, we know). People like to knock it but there's something about that buttery texture and this technique really ups the flavor. It's also Incredible with firmer cuts that are known for their "beefier" flavors like a ribeye, T-bone, or porterhouse.

When curing the meat, the goal is to make sure there's a little air circulation beneath the steaks; this allows all sides of the meat to dry out slightly and cure evenly.

If you don't have a baking rack that fits in the fridge, you can use a metal burner rack from the stove to prop up the meat. Or, interlock the tines of 2 forks together to make a V-shape, then lay the forks (still interlocked!) on their sides on the tray, plate, or whatever is going on beneath the meat in the fridge. The forks should now be stable enough to prop up a steak without falling over.

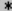

If you don't have a grill, you can get close to the blackened goodness of a good sear with a kitchen torch. After you cook the steaks, blast the top of the meat with the flames for a few seconds to char the surface.

If you're curing a lot of steaks, clear off the top shelf of your refrigerator and line the shelf with a large, rimmed sheet pan or baking dish to catch any juices from the meat. If you've got only one or two steaks (you really should have at least two!), a large plate, square brownie pan, or something similar works.

Rub the steaks all over with the salt and pepper. Put the steaks on a baking rack, put the rack over whatever you have lining the fridge shelf, and refrigerate the steaks, uncovered, for 24 to 36 hours.

When you're ready for an Incredible meal, pat the steaks dry with paper towels (don't rinse them off!) and cook them up however you like—on the grill, in a hot iron skillet, or broil them in the oven. You know best how you like your steaks, depending on the cut, what you're using to cook them on, and what side of the rare-medium-well done world you fall on.

Transfer the steaks to a plate and let them rest at room temperature for a solid 10 minutes so the juices can settle.

Slather the seasoned or salted butter on top and taste for yourself why the fridge steak cure method is a definite Fact!

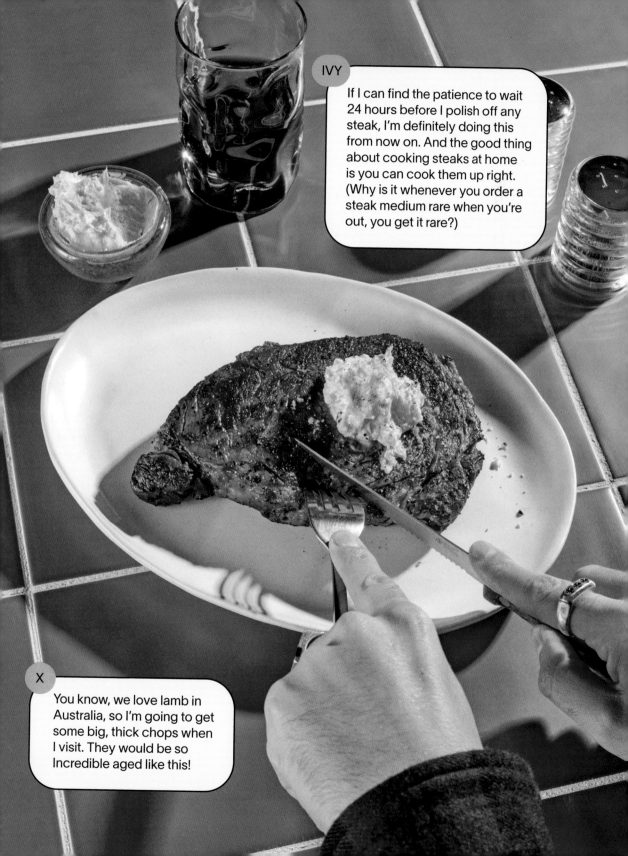

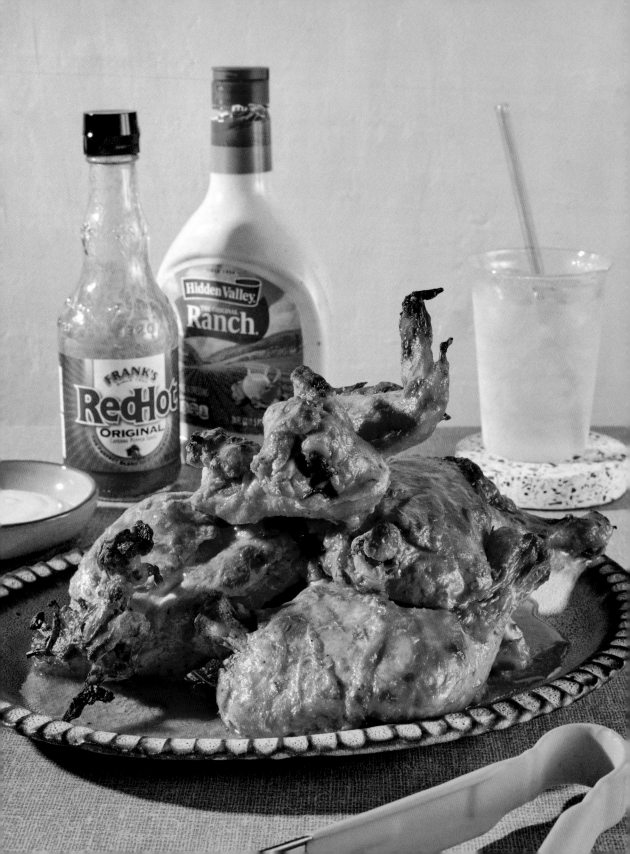

Ivy's "Famous" Hot Chicken

In the video where we were making the Mega Fried Chicken–Cheese Party Balls (Incredible!) on page 114 for the first time, we said that we used "Ivy's famous hot chicken." It wasn't so much an actual recipe but more what we always do when we cook chicken (and anything else!): Put a shit-ton of hot sauce on it. Buffalo wings and ranch are two other things that we never turn down, so here we debut Ivy's "new" famous hot chicken, buffalo-style, with a double hit of ranch and plenty of Frank's RedHot. (It must be Frank's!) We hope you'll agree that it rivals any good chain restaurant's "famous" chicken.

Makes 4 Snacks

- 4 to 5 pounds (1.8 to 2.3 kg) of chicken: Bone-in chicken: whole (quartered), breasts, thighs, or a combination
- Half of a 1-ounce (28 g) packet powdered ranch salad dressing, dip, or seasoning mix (Hidden Valley; about 2 tablespoons)
- Salt
- ⅓ cup (75 ml) Frank's RedHot
- 4 tablespoons (55 g) unsalted or salted butter or margarine
- Next-Level Ranch (page 43) or bottled ranch dressing, for dunking

Rinse the chicken, trim off any excess fat, and pat it dry with paper towels.

Sprinkle the powdered ranch mix and as much salt as you like evenly over all sides of the chicken. We always like to generously salt our birds, but keep in mind the ranch mix already has a sodium punch (if you're using salted butter, too, maybe dial it back a bit). Put the chicken in one or more large zip-top food storage bags, divide the hot sauce among the bags, and seal the bags. Lay the bags on their sides (not a bad idea to put a baking pan beneath the bags in case you didn't seal them well!) and refrigerate the chicken for at least 6 hours or better still, overnight. Flip the bags roughly halfway through the marinating time so all sides of the chicken get a chance to soak in the marinade.

Recipe continued

In 60 seconds or less

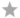

Season some **bone-in chicken pieces** with half a **ranch dressing seasoning packet** + **salt**, put the chicken in a zip-top bag, pour plenty of **Frank's RedHot** in the bag, and let it marinate in the fridge for a good while. Heat up the oven, put some **butter** on a large, rimmed sheet pan, then the chicken, and roast the chicken until it's golden brown and Incredible. Don't forget the **bottle of ranch!**

CHEAT SHEET

Use any cut of chicken you like but stick to bone-in, not boneless; you're going to want to do some serious gnawing on these.

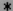

The total roasting time will vary depending on how much chicken you have on each sheet pan, the size of the pieces, and which part of the bird you're cooking.

When you're hungry, preheat the oven to 425°F (220°C).

Cut the butter into 5 or 6 pieces and scatter the pieces on the bottom of a large, rimmed sheet pan. Take the chicken out of the marinade—don't pat it dry—and arrange the pieces, skin side down, on the bottom of the pan in a single layer. Discard the excess marinade.

Roast the chicken for 20 minutes, then use a spatula to flip each piece, sliding the spatula firmly under each piece to keep the skin intact as much as possible. Don't sweat it if you lose some skin. It's still going to taste great.

Reduce the heat to 375°F (190°C). Put the chicken back in the oven and roast until the juices run clear when you stab the meat with a fork or an instant-read thermometer reads 165°F (75°C) in the thighs or breast.

Let the chicken rest in the pan for 15 minutes, pull out the ranch, and have at it!

Cover and refrigerate any leftovers (you'll definitely want them for the recipe on the next page!) for up to 5 days.

Mega Fried Chicken–Cheese Balls

- 1 large handful (1 cup / 4 ounces / 115 g) leftover shredded chicken
- 1 large handful (1 cup / 4 ounces / 115 g) shredded cheese: cheddar, spicy (pepper) Monterey Jack, provolone, or similar
- 1 generous spoonful (2 tablespoons) Mexican-style hot sauce (Cholula, Valentina), plus more for serving
- Vegetable oil, for deep-frying
- ½ cup (65 g) all-purpose flour
- 2 large eggs
- 1 large handful (1 cup / 4 ounces / 115 g) Italianesque Breadcrumbs (page 36) or Italian-style seasoned breadcrumbs (Progresso, Contadina)
- Next-Level Ranch (page 43) or bottled ranch dressing, for dunking

THIS is what to make whenever you have leftover baked, rotisserie, boiled, or any other kind of chicken. Ivy's spicy chicken on the previous page would also be so dank here! Mix together the chicken, some shredded cheese (whatever kind you like), and of course we're doing hot sauce, then all you have to do is shape that up into balls, dunk them in a breadcrumb coating, and fry those beauties up. And ranch is a definite yes. The first time we made these, we did a single dip in the crumb coating, but these are even better double dipped (what isn't?) so you get a thicker crust. We can't think of a time when these cheesy fried chicken wonders wouldn't be appreciated: the holidays, the Super Bowl, or as a satisfying any-time-of-day Snack.

Makes 2 Snacks; 6 chicken-cheese balls

In a large bowl, mix the chicken, cheese, and hot sauce. Scoop up a generous ¼ cup (about 5 tablespoons / 40 g) of the chicken mixture, shape it into a ball, and firmly press it together with your hands so it holds its shape. You should have 6 balls that you can fry up now, or put the balls back in the bowl and pop them in the fridge for up to 4 hours. (If you are going to fry them later, cover the bowl with plastic wrap so they don't dry out.)

When you're ready for a Snack, set up your assembly line for frying. Line a large plate with paper towels. Pour enough oil into a medium frying pan or Dutch oven to come roughly 2 inches (5 cm) up the sides and heat the oil over medium-high heat until very hot, about 350°F (175°C).

Recipe continued

114

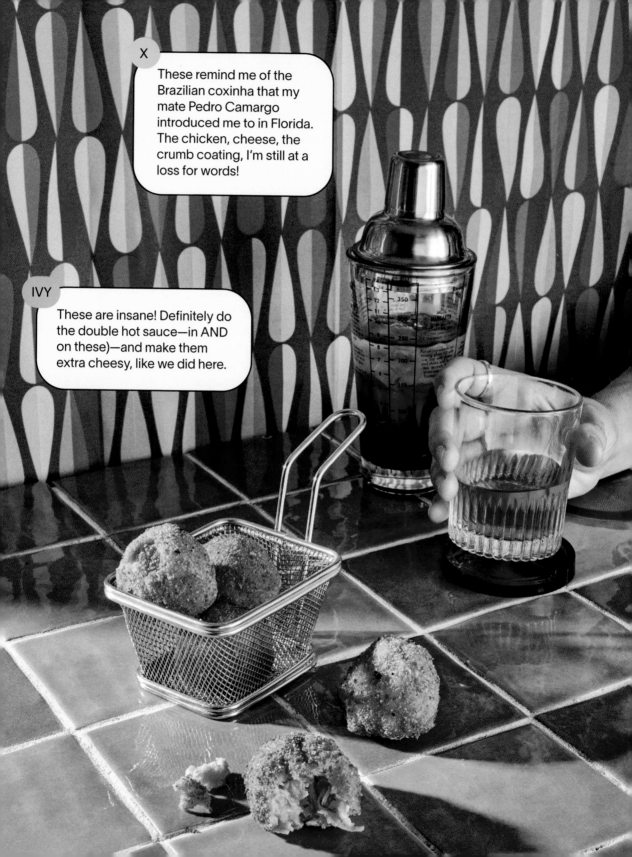

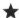
In 60 seconds or less

Mix together some **leftover shredded chicken** + **shredded cheese** + **hot sauce**, shape it into balls, and roll the balls in **flour**, then **eggs**, then **Italian-style breadcrumbs**. Fry those up in hot **oil** until golden brown, shake some **hot sauce** + **ranch dressing** on top, and prepare to be blown away!

Put the flour in a medium bowl (even a soup bowl works for this). In another bowl, lightly beat the eggs with a fork and put the breadcrumbs in a third bowl.

Roll 1 chicken-cheese ball in the flour, then the eggs (shake off the excess), then roll the ball in the breadcrumbs. Re-dip the ball in the eggs, roll it in the breadcrumbs again, and press the ball together firmly with your hands. Repeat the breading process with the remaining balls.

When the oil is hot, gently drop 3 balls into the oil and fry until golden brown on the bottom, about 1 minute. Use tongs to flip the balls and cook until the other side is golden brown, about 1 minute longer, then transfer the balls to the paper towel–lined plate. Don't taste them yet, they're super hot!

Reheat the oil to 350°F (175°C), if needed. Fry the remaining balls the same way and transfer them to the plate.

Give everything a few good hits of hot sauce, grab the ranch, and get to work on that first batch of chicken-cheese balls while the second batch cools.

Fact! Chicken is far easier to shred than most of us make it. If you haven't tried Ivy's hand mixer trick for shredding chicken, which he debuted worldwide in the video when we first made these, now is the time! Just dump your (boneless!) cooked chicken pieces into a bowl and have at it! Be sure to keep the mixer on low speed or you'll end up with chicken all over the place, and if you're using a stand mixer, use the paddle attachment.

Dinner (and Dessert!) Goat Cheese Cannoli

Don't let the simplicity of this recipe deter you! It takes every-day ingredients—sandwich bread, goat cheese, and butter—and reinvents them in a surprising new way (or surprising to us at least). The key is the goat cheese-to-bread ratio. Generally we're fans of extra cheesy everything, but if you overstuff the bread here, the sandwich won't roll up as easily. Using plenty of butter or margarine is also essential, more so than in a regular grilled cheese. We've got no clue why, we're just going for it. If you want a spicy-sweet dessert, spread a little jam on the last sandwich!

Makes 1 Snack

Trim off the crusts of the bread, if you want. Shape the cheese into 4 logs about the length of the bread and put each log on one side of each piece of bread. If you're making one dessert sandwich, spread the jam alongside the goat cheese on one slice of bread and hit it with a few grinds of pepper. Swipe your finger through the butter and run your finger along the opposite edge of each slice of bread; this will be the "glue" that helps hold the bread together. Roll up the bread like a cigar and gently press down at the seam to fully cover the cheese and seal the bread. Repeat until you have 4 rolled-up sandwiches.

- 4 slices classic wheat or white sandwich bread
- 2 generous spoonfuls (4 tablespoons) goat cheese
- 1 small dollop (1 teaspoon) jam or jelly, any flavor
- Freshly ground black pepper
- 4 tablespoons (55 g) salted or unsalted butter or margarine

In 60 seconds or less

Roll up some **goat cheese** in a couple of slices of **sandwich bread.** Put some **jam** on one and sprinkle some **freshly ground pepper** over each. Roll up the sandwiches like a cigar and seal the edges of the bread with **butter**, then pan-fry them in more butter until they're nice and toasty. Bone apple tea!

Recipe continued

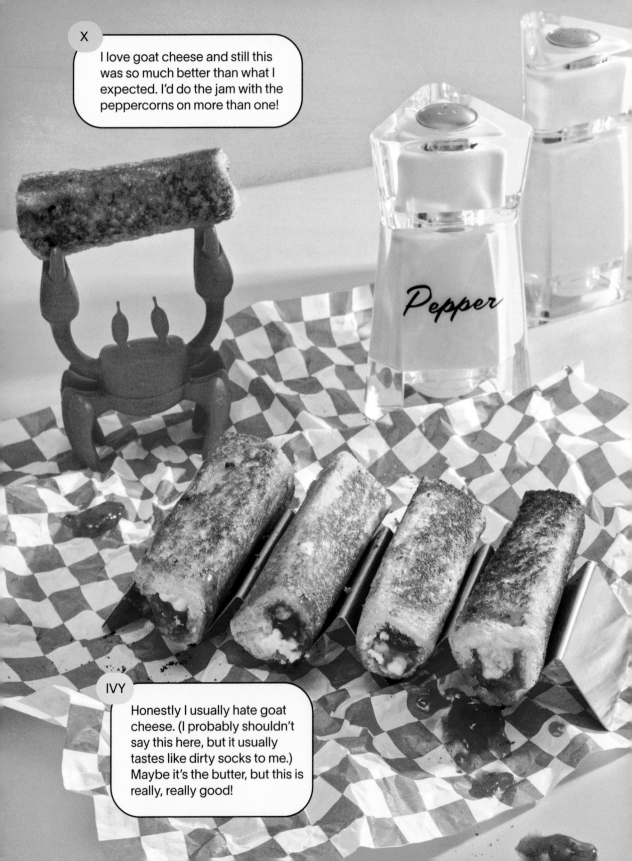

In a large skillet, heat the rest of the butter over medium-high heat until melted and swirl the pan so the butter is evenly distributed over the bottom of the skillet. Add the sandwiches to the skillet and use your fingers to roll each around in the butter or margarine so all sides are coated. If the sandwiches start to unroll, use your fingers or tongs to press them back together; they stay together better once the cheese starts to soften up. (And if they start to unroll, don't worry, they still taste great!) Fry the sandwiches on all sides until golden brown, 4 to 5 minutes, and use tongs to transfer them to a plate.

Kinda sorta like cannoli sandwiches, yes?

CHEAT SHEET

While not mandatory, trimming the crusts of the bread makes these little sandwiches appear fancy.

✳

Don't skip the freshly ground pepper on the one with jam. It adds punch to the sweetness.

NEXT LEVEL SNACKS AND DRINKS!

On those days when less committal Snacks pump the turntable, there are unexpected combinations waiting to delight your senses in every corner of the pantry, fridge, and when you're ready for a liquid refreshment, wherever you stash the soda and liquor. Whether sweet, savory, salty, spicy, or a combination, the unifier between all the recipes in this chapter is that all are satisfying and better still, require minimal time and effort to make!

Pizza Chi with Ranch

- 8 frozen pizza rolls (Totino's), any flavor
- About 3 small spoonfuls (3 tablespoons) cream cheese
- 8 Cool Ranch Doritos
- Crushed red pepper
- 8 pepperoni slices (about 1 ounce / 30 g)
- Optional additional toppings: sliced olives, pickled jalapeños or pepperoncini, or whatever else you like

In 60 seconds or less

Air fry **some pizza rolls**. Grab a handful of **Cool Ranch Doritos**, spread a little **cream cheese** on each chip, and top each off with a pinch of **crushed red pepper** + a **pepperoni slice** + **any other pizza toppings** you want. Grab a pizza roll, put it on top of a chip, and shove the whole thing in your mouth at once. Repeat.

Don't knock this mock pizza until you try it! Somehow the Doritos (it's got to be Cool Ranch, even though we all know the Nacho Cheese flavor is far better on its own) and cream cheese mimic both a crispy pizza crust and ranch dip in one bite, while the hot marinara-filled pizza roll and slice of pepperoni on top finish the job as the toppings. You will wish you knew about this in college!

Makes 8 mini pizzas; 1 Snack

Set an air fryer to 400°F (205°C), throw in your pizza rolls, and cook until they're piping hot, about 8 minutes. Use tongs to remove the pizza rolls from the air fryer, transfer them to a plate, and let them cool for a solid 3 to 4 minutes.

Meanwhile, use your finger to gently spread about 1 small dollop (1 teaspoon) of the cream cheese on each Dorito. Some of the chips may break, which is fine. Top the cream cheese with a pinch of crushed red pepper, and a slice of pepperoni. Don't add any additional toppings just yet, if you're planning to try different combos.

When you're ready to experience a new flavor sensation, lay a hot pizza roll on top of one of your chip creations. Use one finger to hold the pizza roll on the chip so it doesn't fall off, close your eyes, open wide, and eat the whole thing at once. Incredible, no?!

Now that you've experienced the original, experiment with different flavor combos by adding any other pizza toppings on the rest that you want.

Recipe continued

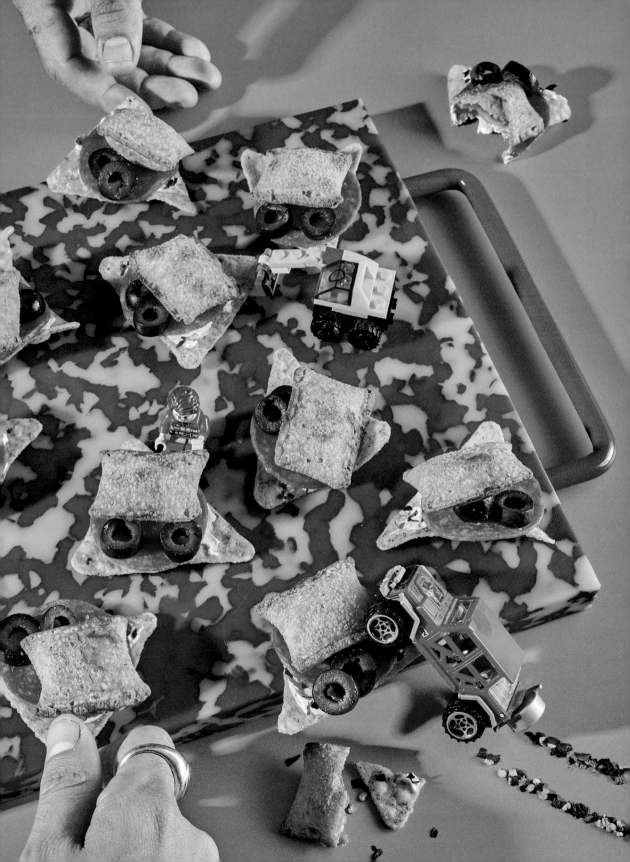

IVY

This really does taste like a real slice of pizza with ranch dressing. Even the cold cream cheese is spot-on; it balances out the hot pizza roll. You're gonna want a cold beer.

CHEAT SHEET

If you want to go truly Next Level on this and you've got the time, deep-fry the pizza rolls (see page 85 for instructions). And sure, you could bake the pizza rolls according to the package instructions, we just love our pizza rolls fried!

*

Some of the Doritos may break when you spread the cream cheese on top. We see that as a good thing; a broken chip is a lot easier to shove in your mouth all at once than a whole one stacked with all this stuff.

*

These pizza chips are perfect to make for a party AND you can let everyone else do the assembly work. (They'll want to anyway.) Put out all the ingredients, demo how to make one, and get the #houseparty started.

X

This doesn't have quite the full texture of pizza but the taste is absolutely there. You will make these ALL the time!

Bacon-Wrapped Fried Pickles

If you've star-hopped on the Hollywood Walk of Fame, been to the Santa Monica Pier, or checked any other L.A. tour bus essentials off your must-see list, these pickles will take you down memory lane. Every time we fry one up, we're reminded of our fine city's infamous bacon-wrapped hot dogs, a.k.a. "danger dogs" (like so much in Hollywood, infamous for a variety of reasons—look them up if you care to know why). They're usually topped with grilled onions, poblano peppers, and a mix of condiments, but it's undeniably the bacon that unifies the street dogs. And now with this recipe, they're available in a simplified, but no less delicious, pickle form! Delay the inevitable deliciousness no longer. Grab that jar of pickles off the top shelf of the fridge and the pack of bacon that's been sitting in your meat drawer and treat yourself to the most Incredible, and incredibly simple, Snack.

Makes 1 Snack

Starting at one end, wrap the bacon firmly around each pickle in a spiral pattern. If you're using whole dills, you should be able to cover about half the pickle with 1 slice; continue wrapping the pickle with a second slice of bacon. If you're using spears, 1 slice of bacon should cover an entire spear. Tuck under any end pieces of bacon so they are snugly enclosed; this helps keep the bacon from unraveling in the air fryer.

- 2 large whole dill pickles or 4 spears
- About 4 slices regular bacon, not thick cut
- A few good shakes of Mexican-style hot sauce (Cholula, Valentina)
- Next-Level Ranch (page 43) or bottled ranch dressing, for dunking

In 60 seconds or less

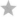

Wrap a **dill pickle** in **bacon** and air fry it, flipping it once as you cook it. Get some **hot sauce** + **ranch**, and revel in your five minutes of Hollywood pickle fame!

Recipe continued

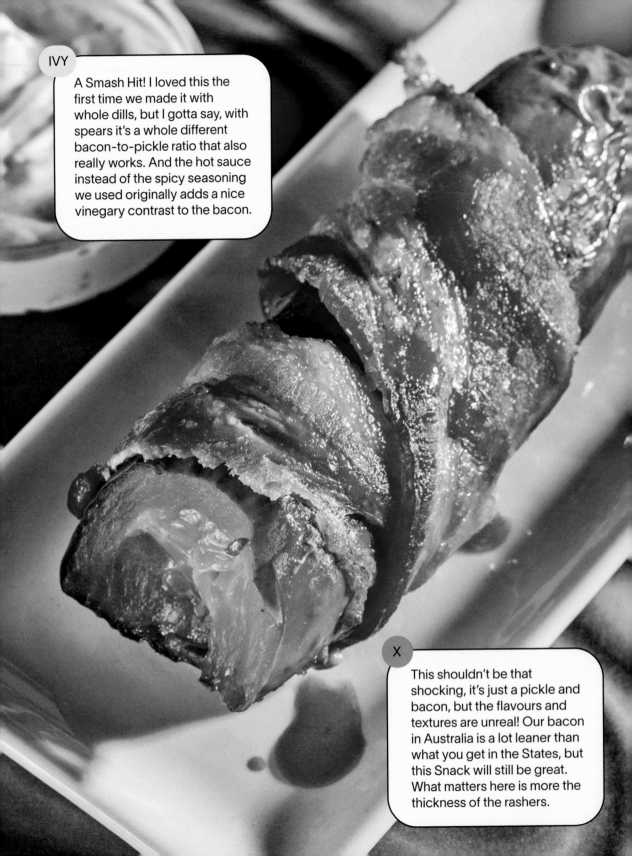

Set an air fryer to 400°F (205°C), put the pickles on the rack so most of the seams (where you tucked in the ends of the bacon slices) are facing down, and cook for 10 minutes. The bacon on the top and sides of the pickle should be golden brown. Use tongs to flip the pickles so the bottom side faces up and cook for 3 minutes longer or until just beginning to brown; the bacon that was on the bottom won't be golden brown like the rest of the bacon, but that's fine.

Use tongs to remove the pickles from the air fryer and—important!—let them cool for a solid 2 to 3 minutes; the pickles will be very hot.

Give the pickle a few hits of hot sauce, grab the ranch from the fridge, and get ready to be blown away!

CHEAT SHEET

The super thick-cut bacon you get from the butcher that's Incredible any other time won't fry up quickly enough before the pickle starts to dry out. Go with regular packaged bacon and pick the meatiest pieces (the thin fragments inevitably found in every package shrivel up in the air fryer).

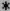

If you don't have an air fryer, this is not the time to deep-fry! There's no batter here like in an old-school fried pickle that you get at the carnival. (A wet pickle = hot oil = not a good combo!) You can pan-fry the pickle over medium-high heat as an alternative to air frying. To do so, insert a few toothpicks all the way through the pickle so the bacon won't unwrap as you flip the pickle in the skillet to brown all sides. Cook the pickle until the bacon is golden brown and you're good!

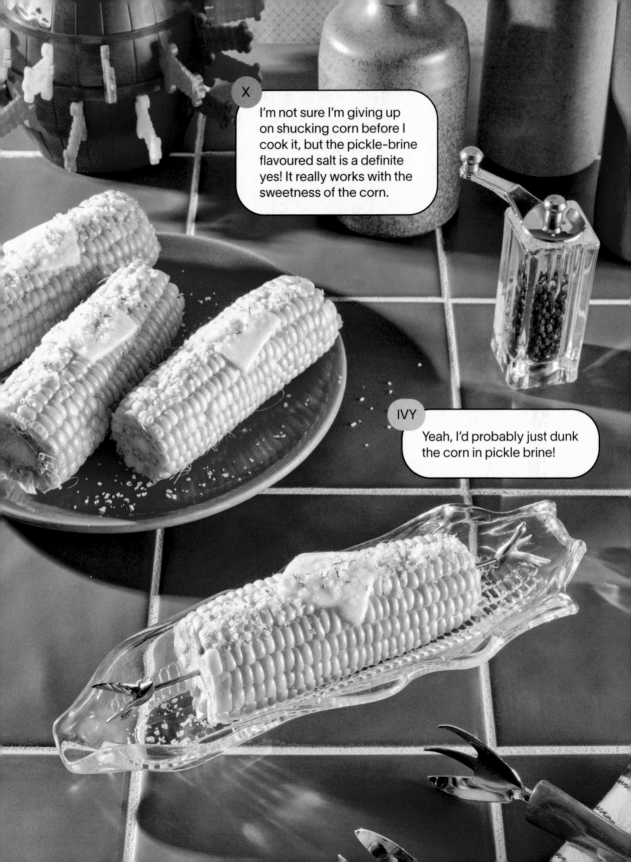

Corn IN the Cob with Pickle Salt

We love "does it work?" challenges that sound too good to be true. There was this viral trend that involved microwaving an ear of corn in the husk with the silk. Afterwards you cut off the stalk end and just squeeze the opposite end and the corn supposedly pops out clean without any silk still attached. Look, we're not gonna lie; the corn is a lot harder to get out of the husk than people made it look. We had to yank it out with our hands, but we got pretty close to having no silk left on the ear.

Makes 1 Snack

Microwave the corn on High for 3 minutes, or if you like really soft kernels, 4 minutes. Let the corn cool for like 5 minutes; it will be CRAZY hot when it comes out of the microwave!

Cut off the tough stalk end of the corn. Use your hands to firmly squeeze the bottom of the opposite tassel end of the husk until the cob pops out. You need to squeeze really hard like you're trying to get the very last bits of toothpaste out of the tube. If that doesn't work, just yank out the corn cob with your hands and pull off any remaining silk.

Slather the corn with the butter or margarine, sprinkle plenty of the salt on the corn, and decide for yourself whether this corn-shucking trend is a Fact . . . or Cap.

- 1 large ear corn on the cob in its husk, rinsed
- 1 tablespoon unsalted butter or margarine
- Pickle Salt (page 37) or sea salt, for sprinkling

CHEAT SHEET

There's plenty of salty goodness in the pickle or regular salt so unsalted butter or margarine is best.

In 60 seconds or less

Cook up some **fresh corn**, husk and all, in the microwave (watch the video where we try it). After you shuck it, slather plenty of **unsalted butter** over the corn and sprinkle **Pickle Salt** on top, then report back on whether that corn husking hack actually worked.

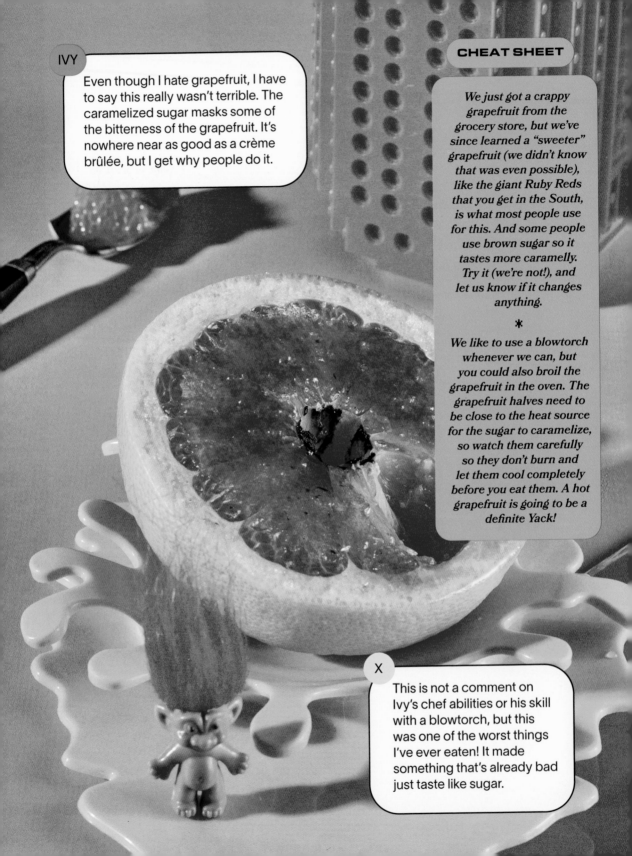

IVY

Even though I hate grapefruit, I have to say this really wasn't terrible. The caramelized sugar masks some of the bitterness of the grapefruit. It's nowhere near as good as a crème brûlée, but I get why people do it.

CHEAT SHEET

We just got a crappy grapefruit from the grocery store, but we've since learned a "sweeter" grapefruit (we didn't know that was even possible), like the giant Ruby Reds that you get in the South, is what most people use for this. And some people use brown sugar so it tastes more caramelly. Try it (we're not!), and let us know if it changes anything.

*

We like to use a blowtorch whenever we can, but you could also broil the grapefruit in the oven. The grapefruit halves need to be close to the heat source for the sugar to caramelize, so watch them carefully so they don't burn and let them cool completely before you eat them. A hot grapefruit is going to be a definite Yack!

X

This is not a comment on Ivy's chef abilities or his skill with a blowtorch, but this was one of the worst things I've ever eaten! It made something that's already bad just taste like sugar.

Grapefruit Brûlée

Ever since TikTok became a breaking news source for new trends, the "everything old is new again" adage has been put to the test over and over again. Apparently, people have been sprinkling a little sugar on top of halved grapefruits and broiling them until the tops are caramelized since **Leave It to Beaver** was the big-ticket show that everyone was dying to see. For us, this was a novel idea that was more about finding out if a deliciously crunchy caramelized topping would make something we both hate—grapefruit—shift from the status of Inedible to Incredible. Given that we all know the best part of a crème brûlée is that crunchy burnt sugar topping, it sounded possible. We don't always agree, but usually there's something about whatever we're tasting that we kinda (sorta) both like or both don't like. Here though, we had polar opposite opinions. **Snack or Yack?** You decide.

Makes 1 Snack . . . or is it a Yack?

Slice a small bit of rind off the top and bottom of the grapefruit so the fruit stands upright on the north or south ends without rolling away. Cut the grapefruit in half through the middle (the equator, basically) and sprinkle whichever sugar you're using evenly all over the flesh of each half. Blast the sugar with a kitchen torch until the sugar caramelizes to a dark golden brown color, about 1 minute.

Grab your phone and a spoon, click to start a video, take a big bite, and share with the world what you think!

- 1 red or pink grapefruit, preferably Ruby Red
- 1 generous spoonful (2 tablespoons) granulated or packed light or dark brown sugar

In 60 seconds or less

Cut the ends off a **grapefruit**, slice it in half through the middle, and throw some **brown sugar** on top. Blast the sugar with a kitchen torch until it's caramelized, and see what you think.

Triple-Candied Strawberries

While on the more enjoyable side of fruit, it's still hard to argue that strawberries beat candy.

In this brilliant creation, Jolly Ranchers—undeniably the best hard candy with a near perfect tart-sweet balance—are combined with the refreshingly sweet flavor and juicy-soft texture of a strawberry. Melt the candies in the microwave and you can dip the fruit in the hot candy syrup the same way you would if you were making chocolate-covered strawberries. Roll them in Pop Rocks, another candy legend, and maybe even sprinkle a little Kool-Aid mix on each for added punch (why not?), and you have a guaranteed Smash Hit for any age group! And yes, these may be a little more time consuming to make than most of the Snack recipes in this chapter, but these are worth the effort . . . and your teeth will thank you that you don't have time to make them on a daily basis.

Makes 6 to 8 candies; 2 Snacks

Rip off a sheet of aluminum foil or parchment paper that's about the size of a tablet computer, put it on the counter, and coat it lightly with the cooking spray.

Trim the tops off the strawberries if you want or leave them whole for that chocolate-dipped strawberry vibe. Poke a bamboo or metal skewer (or short of those, a fork) through the stem end of each strawberry.

Unwrap the Jolly Ranchers and arrange the candies in a single layer on a large paper plate. Put the powdered drink mix in a small ramekin, if you're using it, and the Pop Rocks on a small plate; any type will work.

- Nonstick cooking spray or vegetable oil, for coating the foil or parchment paper
- 6 to 8 medium strawberries, rinsed and dried on paper towels
- 2 small handfuls (⅔ cup / about 12) Jolly Ranchers, any flavor
- 1 (0.16-ounce/4.5-g) packet unsweetened powdered drink mix (Kool-Aid; about 1½ teaspoons), any flavor, optional
- (2 .37-ounces/10.5-g) packages popping candy (Pop Rocks), any flavor

In 60 seconds or less
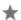

Spear some **strawberries** with a skewer or fork, melt some **Jolly Ranchers** in the microwave, and roll the strawberries in the hot candy syrup, then sprinkle a little unsweetened **Kool-Aid mix** on top, if you want, and roll them in **Pop Rocks**. Enjoy the enticing popping sounds of your fruit candy creations as they cool for several minutes, and enjoy!

Recipe continued

CHEAT SHEET

The number of strawberries you're gonna need depends on how large they are. We like to have plenty at the ready so we can use up all the candy syrup.

✳

We love the strawberries with Blue Raspberry Jolly Ranchers and a mix of the Blue Razz and Strawberry Pop Rocks, but it's your experiment. A mash-up of different flavors melted together would even be great.

✳

If you have paper plates, now is the time to use them! If not, you can line a microwave-safe plate with parchment paper so the melted candy doesn't stick to the plate. When you're done you can just toss the paper plate or parchment, no hard candy cleanup required.

CAUTION!

Candy melts at very high heat, so the Jolly Ranchers get scalding hot. This recipe is not recommended for children or anyone who can't stop touching and tasting shit when they are cooking!

Microwave the candy on High until melted, 30 to 40 seconds; it should be bubbly in spots. Quickly (and carefully!) roll a strawberry in the hot melted candy so it's lightly coated in the syrup; it's fine if the strawberry isn't fully covered. Sprinkle a generous pinch or two of the powdered drink mix over the strawberry, if you're using it, then roll each strawberry lightly in the popping candy (don't go overboard or you'll run out of Pop Rocks!) and put it on the oiled foil or parchment paper. Do the same with the rest of the strawberries.

If the melted candies harden before you finish dipping the strawberries, microwave them again on High until melted, about 15 seconds. Don't overcook the candy at this point as it can easily burn.

Let the coated strawberries cool completely, at least 5 minutes, before you dive in. (These get super hot!) After you've polished off the strawberries, be sure to crack off any candy stuck to the paper plate or parchment paper that has melted down into a deliciously thin sheet of candy. Recycling at its finest!

Elevated Chamoy Pickles

One of the unintended outcomes of our TikTok series to find the best Snacks is that we've become (certifiably unqualified!) experts on food trends. Eating pickles with chamoy together in some form is one example. This Snack is basically a quick version of the whole dills you can buy that have been marinated in a brine made with the salty-spicy-sour-sweet sauce. And, since it uses pickle chips, you can eat it with a spoon right out of the jar—no dishes to clean! Definitely experiment with different proportions of each ingredient, and don't skimp on the salt, it's the secret ingredient here. It's the kind of thing we would put out for a party for everyone to try a bite or two or use as a dip or spread. But if you watched our original video when we made this, you know that some people really do eat half a jar of this stuff! You're only limited by the size of your pickle jar.

Makes as many Snacks as you want

Drain about half the brine from the pickle jar.

Add a solid ½-inch (12 mm) of chamoy, several generous shakes of hot sauce (more if you've got a big jar of pickle chips), and as much spicy seasoning mix as you want. Grate enough lime peel to cover the surface of the pickles in a single layer of zest and do the same with the salt; really put a nice layer of salt on there. Screw the lid securely on the jar and shake the jar until everything is well mixed together.

Grab a spoon and give your creation a taste, add more of anything else you want, and tell us that isn't one of the strangest and best things you've had in a very long time!

- 1 jar (any size) dill pickle chips
- Bottled chamoy or Five-Minute Apricot-Chipotle Chamoy (page 44)
- Mexican-style hot sauce (Cholula, Valentina)
- Spicy seasoning: barbecue or Cajun seasoning, chili powder, Tajín, cayenne pepper, crushed red pepper flakes, or similar
- Fresh limes (for their zest only)
- Salt

In 60 seconds or less

Open a jar of **dill pickle chips** and drain off half the brine. Now load up the jar with **chamoy + hot sauce + some kind of spicy seasoning mix + lime zest + salt**, close the lid, and shake the jar like crazy. Grab a spoon and dig in!

Recipe continued

CHEAT SHEET

We like our chamoy pickles with more of a citrusy kick, so we throw in some fresh lime zest (most people just use Tajín, which contains lime flavoring). And since you're adding the zest, you can use any spicy seasoning mix you've got—chili powder, barbecue seasoning, Old Bay, that kind of thing (most don't have citrusy flavors like the Mexican seasoning mix). Tajín for a double hit of citrus is also gonna be great.

✳

Normally fresher-tasting refrigerated Claussen's are our go-to for any pickle project, but here any basic dill burger chip that's on the condiment aisle works better. They tend to be brinier with bigger spice flavors so they can stand up to the chamoy.

✳

Save the extra pickle brine for the Hot "Pickle" Cereal recipe right after this!

ONE-HIT SNACKS!

These are a few of the most memorable Hits we've tried on our **Snack or Yack?** series that you can put together super-fast—or in the case of those epic Yacks, skip entirely. (But if you're like us, now you *really* want to try them.)

GRANNY SMITH APPLE + FRESH LIME JUICE + HONEY

Ivy: This is Incredible, and I think it actually may count as a certifiable healthy Snack!

PICKLE + CHAMOY (THE SAUCE, NOT POWDER; RECIPE ON PAGE 44) WRAPPED IN A FRUIT ROLL-UP

X: I'm not going to yell it from the rooftops, but this could be a Snack. There are a lot of flavours going on, so I'd say definitely give it a try.

BABY CARROTS + LEMON JUICE (LOTS!) + SALT + PEPPER

X: Are carrots ever as good as potato chips? No. But these are pretty damn good.

PLAIN GOLDFISH CRACKERS IN APPLE JUICE

Ivy: The Goldfish get soggy fast, but I'm going with a Snack on this one. Eat it quickly!

WATERMELON + FETA CHEESE

X: This you must try! You've got the savoury side with the feta and the right sweetness with the watermelon. I'd definitely top this off with some balsamic vinegar if you have some.

WATERMELON + YELLOW MUSTARD

Ivy: There is no need for this! Stick with the feta. We should have stopped there, but we fell for the banana mayo challenge from the same TikToker.

SUPER RIPE BANANA + MAYO

X: Do NOT [BLEEP]-ing do this to yourself!

STRAWBERRIES + SOUR CREAM + BROWN SUGAR

Ivy: A Smash Hit! You need to get over the smell, it doesn't match the taste here. The sour cream tastes almost like whipped cream when you add the brown sugar.

STRAWBERRIES + OLIVE OIL + SALT

X: Why are people putting olive oil on everything these days? Stick with the sour cream and brown sugar combo.

BAILEY'S IRISH CREAM LIQUEUR + CRANBERRY JUICE + PINEAPPLE JUICE

Ivy: Not bad, but it's not the strawberry short-cake flavor that was promised. And I don't usually say this, but the alcohol is distracting.

SIMPLY LEMONADE + BLUE RASPBERRY LEMONADE KOOL-AID (UNSWEETENED)

Ivy: Hit! The Kool-Aid really intensifies the tanginess of the lemonade. You could do this with any kinda mild (not too tangy) grocery store lemonade, but you need the citrusy lemonade-flavor drink mix, too; anything else just makes the lemonade taste like Kool-Aid.

MILK + KOOL-AID (ANY FLAVOR)*

X: Absolutely disgusting! This tasted like sour milk. We even checked the milk to make sure it was fresh.

* This might still be worth a try. We later found out we used the unsweetened Kool-Aid you get in those little packets that we use for most Snacks. (Three for $1!) But here we were supposed to use the pre-sweetened Kool-Aid, or even just add sugar to the unsweetened mix.

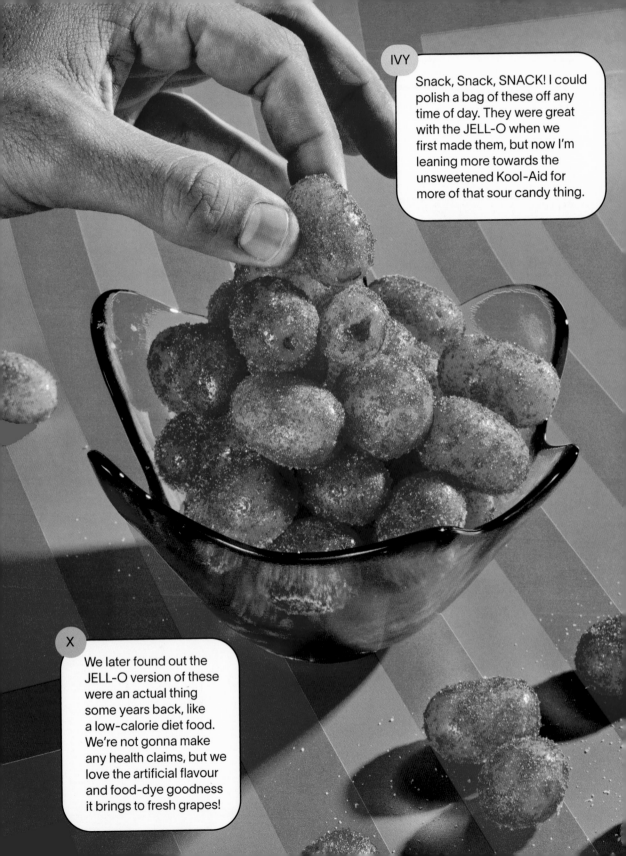

The Summer Refresher

Even though fresh fruit is filled with natural sugars, it can be missing that punch—especially if, like us, you shop at a grocery store with more aisles devoted to Big Cereal and Big Snack than produce. This recipe manages to refresh grapes whose flavor doesn't measure up to their good looks. A summer game-changer!

Makes 1 Snack

Rinse the grapes and spread them out on a kitchen towel to remove some of the excess water; don't dry them completely. Put the grapes in a medium zip-top food storage bag, pour the gelatin or powdered drink mix on top, seal the bag, and give the bag several good shakes until the grapes are well coated.

Freeze the grapes until the coating firms up a little, at least 20 minutes, or if you want fully frozen grapes (and have the patience), a solid 2 hours or overnight. Either way, they're delicious!

Fact! *Powdered flavored gelatin or powdered drink mix + water = Jell-O or Kool-Aid!* The grapes need to be moist enough so the powdery gelatin or drink mix coating sticks; if they're too wet the coating will clump up and turn whatever color gelatin or drink mix you bought.

- 1 large handful (1 cup / 5 ounces / 140 g) grapes
- 2 teaspoons sugar-free gelatin mix (JELL-O) or 1 (0.16-ounce/4.5-g) packet unsweetened powdered drink mix (Kool-Aid; about 1½ teaspoons), any flavor

In 60 seconds or less

Wash a handful of **grapes** and lay them out on a kitchen towel to partially dry, then throw them in a food storage bag with a little **unsweetened JELL-O or Kool-Aid mix**. Shake that bag like a Polaroid picture, freeze the grapes until they're as firm as you want, and get to Snacking!

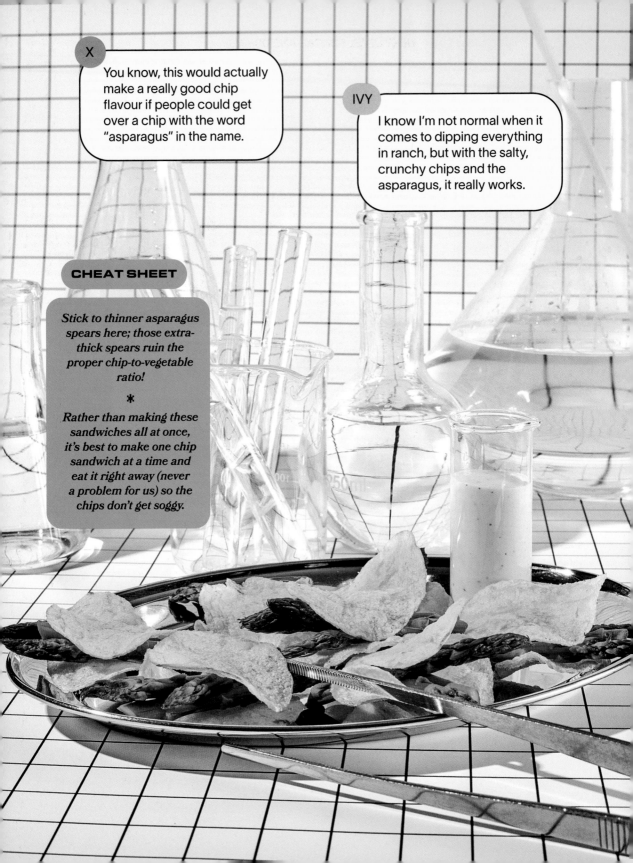

Asparagus Chipwiches

We understand that some of you may have reservations about any type of vegetable being a Snack, or simply the idea of combining a potato chip with something healthy. This is why we're here, to make sure you never ruin a perfectly good bag of potato chips ever again! Get a bag of Lay's and some asparagus, and definitely give this combo a chance. When you add not one but two sauces—hot sauce and ranch, naturally—they're almost like something you might get at a high-end restaurant.

Makes 1 Snack

Rinse the asparagus spears, pat them dry, and trim off the ends. Cut each spear into three or four pieces so each is about the size of a potato chip.

In a large skillet, heat the butter or margarine over medium-high heat until melted and swirl the pan so the butter is evenly distributed over the bottom. Add the asparagus and cook, shaking the pan occasionally so the spears cook evenly, until tender, 2 to 3 minutes. Put the asparagus on a plate and give it several good hits of hot sauce.

Grab the chips and make a mini sandwich by putting two or three asparagus spears in between two chips, dunk one end of the sandwich in a little ranch, eat, and repeat!

- ½ bunch (8 ounces / 225 g) thin or medium-thick asparagus spears
- 2 tablespoons salted or unsalted butter or margarine
- A few good shakes of Southern or Mexican-style hot sauce (Frank's RedHot, Cholula, Valentina) hot sauce
- About 1½ large handfuls (1½ cups / 30 g) classic potato chips (Lay's)
- Next-Level Ranch (page 43) or bottled ranch dressing, for dunking

In 60 seconds or less

Cut up some **asparagus spears**, pan fry them in some **butter**, and season them with **hot sauce**. Open a bag of **Lay's** and make mini sandwiches: **a chip + a few asparagus spears + a chip**. Dunk the sandwiches in **ranch**, and you'll never complain about eating your vegetables ever again!

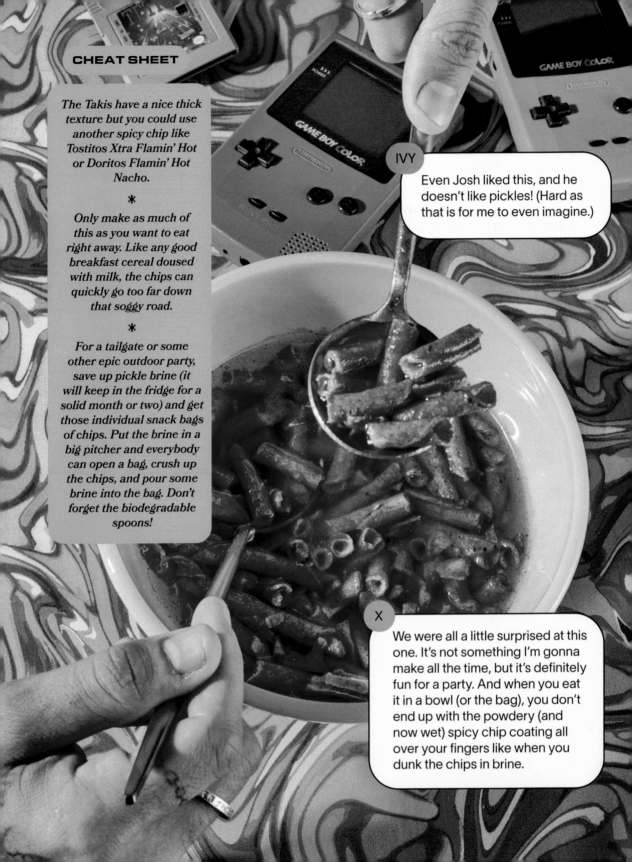

CHEAT SHEET

The Takis have a nice thick texture but you could use another spicy chip like Tostitos Xtra Flamin' Hot or Doritos Flamin' Hot Nacho.

✳

Only make as much of this as you want to eat right away. Like any good breakfast cereal doused with milk, the chips can quickly go too far down that soggy road.

✳

For a tailgate or some other epic outdoor party, save up pickle brine (it will keep in the fridge for a solid month or two) and get those individual snack bags of chips. Put the brine in a big pitcher and everybody can open a bag, crush up the chips, and pour some brine into the bag. Don't forget the biodegradable spoons!

IVY

Even Josh liked this, and he doesn't like pickles! (Hard as that is for me to even imagine.)

X

We were all a little surprised at this one. It's not something I'm gonna make all the time, but it's definitely fun for a party. And when you eat it in a bowl (or the bag), you don't end up with the powdery (and now wet) spicy chip coating all over your fingers like when you dunk the chips in brine.

Hot Pickle Cereal

And now for a little something unexpected: soggy chips! Wait, hear us out. We did a tasting when X's sister, Olivia, was visiting from Australia and we had Ivy's closest childhood friend, a.k.a. "Josh from Florida," crashing at our place—we took a handful of Blue Heat Takis and dipped them in pickle brine. No one was expecting much, but it was strangely addictive in that "we gotta have another bite" way. The Takis that tasted best were the ones super soaked in brine, so now we go all in and throw them in a bowl, crush them up a little, and pour some brine on top. It ends up like a bowl of cereal; the chips are crunchy at first and then they soften up. We loved this with the spicier blue Takis, but you can work your way up the heat ladder and start with the milder original red ones if you want. If you're still not sure you're all in with this combo, wait until you're down to the dregs in the bag and the last pickle in the jar. Nothing lost if you think it's a Yack, and you may have found an Incredible new Snack!

Makes as many Snacks as you want

Put as many Takis as you want in a cereal bowl and lightly crush the chips with your hands so they are broken into bite-size pieces. Pour just enough brine on top to barely cover the Takis, like you're pouring milk on cereal. Grab a spoon and hurry up and eat your spicy hot (but icy cold!) cereal while it's got the perfect texture!

- Blue Heat or Original Takis
- Dill pickle brine (preferably Claussen's), chilled

In 60 seconds or less

Crush up some **Takis** and throw them into a bowl, then pour leftover **dill pickle brine** on top. Grab a spoon and eat it super fast!

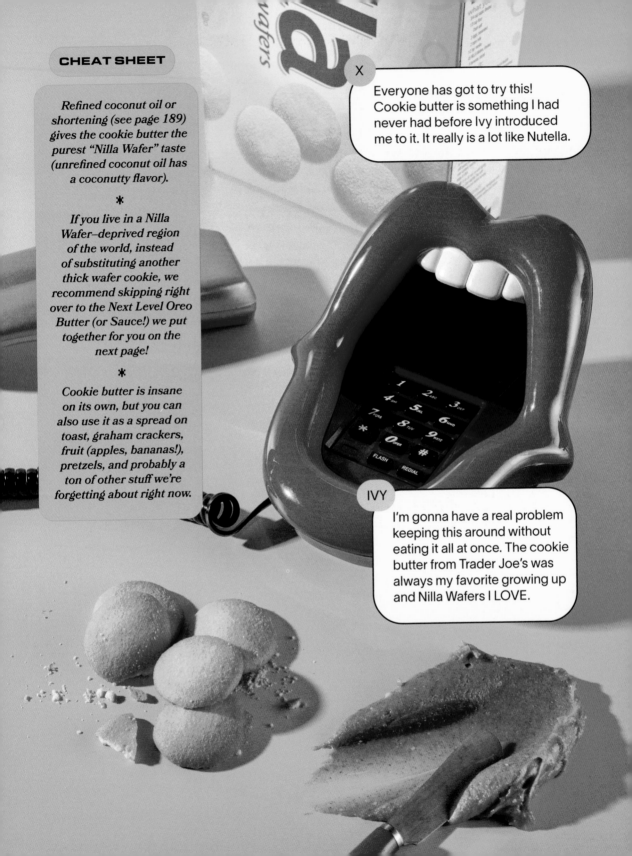

CHEAT SHEET

Refined coconut oil or shortening (see page 189) gives the cookie butter the purest "Nilla Wafer" taste (unrefined coconut oil has a coconutty flavor).

✳

If you live in a Nilla Wafer–deprived region of the world, instead of substituting another thick wafer cookie, we recommend skipping right over to the Next Level Oreo Butter (or Sauce!) we put together for you on the next page!

✳

Cookie butter is insane on its own, but you can also use it as a spread on toast, graham crackers, fruit (apples, bananas!), pretzels, and probably a ton of other stuff we're forgetting about right now.

X

Everyone has got to try this! Cookie butter is something I had never had before Ivy introduced me to it. It really is a lot like Nutella.

IVY

I'm gonna have a real problem keeping this around without eating it all at once. The cookie butter from Trader Joe's was always my favorite growing up and Nilla Wafers I LOVE.

Nilla Butter!

If you aren't familiar with the deliciousness known as cookie butter, you need this recipe in your life! Cookie butter is in the same food group as Nutella (meaning, it can be eaten any time of day), only the spread is made with ground up cookies instead of hazelnuts and chocolate. Like its Italian counterpart, it's Incredible on toast, waffles, crackers, fruit (apples, bananas), and so much more. Most people make cookie butter from speculoos, those gingerbread-y wafer cookies that come in the little red package that you get on some airlines. Given our mutual love for Nilla Wafers, this recipe shouldn't be all that surprising. Somehow the butter magically transforms into what we can only imagine the Nilla Wafer cookie dough tastes like . . . and you know that's gonna be Incredible!

Makes about ⅔ cup (85 g); 4 Snacks

Crumble the cookies over a blender, add the milk, coconut oil, brown sugar, cinnamon, and 1 generous spoonful (2 tablespoons) water, and puree until the mixture is chunky. Scrape down the sides of the blender and blast the cookie butter again until it's smooth.

It should be pretty thick, but if you want a creamier texture, add a splash more water and blend one more time.

Enjoy the cookie butter now straight up or with anything you please. Or wrap the spread in plastic wrap and throw it in the refrigerator for up to 5 days for a chilled cooked dough-like Snack.

- 30 Nilla Wafers
- ⅓ cup (75 ml) whole milk
- 1 generous spoonful (2 tablespoons) refined coconut oil or vegetable shortening
- 1 generous spoonful (2 tablespoons) packed light or dark brown sugar
- Generous pinch cinnamon

In 60 seconds or less

Toss some **Nilla Wafers** in a blender with **milk** + a little **refined coconut oil** + **brown sugar** + **cinnamon** + **water** and blast them until you have a creamy spread. Incredible!

Next-Level Oreo Butter (or Chocolate Sauce!)

- 12 original Oreos
- ⅓ cup (75 ml) whole milk
- 2 tablespoons refined coconut oil (see page 189) or vegetable shortening

In 60 seconds or less

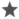

Grab a big handful of **Oreos**, take the filling out of half (eat it!), and put them in a blender with some **milk** + a little **refined coconut oil**. Blend it up until you've got a cookie butter, or if you want more of a sauce, add a little more milk.

CHEAT SHEET

To make Oreo chocolate sauce, add about 1 generous spoonful (2 tablespoons) more milk to the blender. If the consistency of the sauce is still too thick, add another splash of milk. To serve the sauce warm, heat it over very low heat in a saucepan, stirring constantly, until it's just warm to the touch. (Don't overheat the sauce or it can burn.)

So yeah, this recipe might just be an excuse to sneak another Oreo recipe into the book (see page 199 for even more things to do with our favorite cookie). Regardless, it's impossible for us to make something with Nilla Wafers and not wonder how it would taste with Oreos. And, as there are plenty of people abroad who can't get their hands on Nilla Wafers, providing a more accessible Oreo version is really a public service. We tried this without taking out the Oreo filling but the butter was way too sweet; with just the cookies and no filling, it wasn't sweet enough (and you didn't really get that it was made with Oreos). But we finally nailed it! Take the filling out of half the cookies, and you're there.

Makes about ¾ cup (100 g); 4 to 5 Snacks

Scrape out the filling from 6 of the Oreos (eat the filling, of course). Crumble the chocolate cookies and the remaining 6 whole Oreos over a blender, add the milk and coconut oil, and puree the mixture until it's nice and chunky. Scrape down the sides of the blender and blast the cookie butter again until it's smooth.

Whatever cookie butter you don't toss back now (be sure to get every last bit off the blender!), wrap in plastic wrap and toss in the refrigerator for up to 5 days.

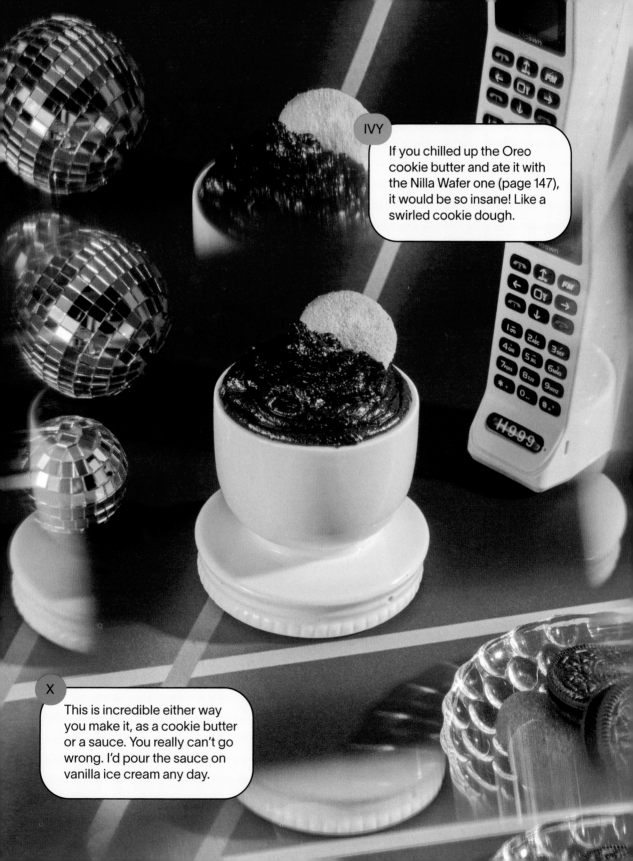

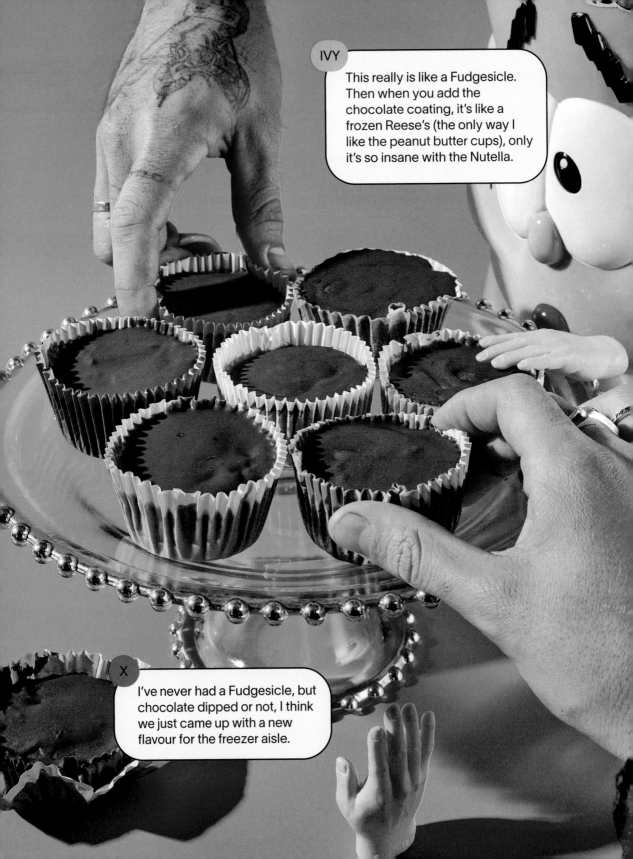

Two-Ingredient Fudge Pops

Nutella occupies that Web3 world of food. Is it a breakfast staple, a midday sandwich spread, a dessert, or all of the above? One thing we can all agree on is that it's an everyday Snack that invites experimentation. Among our **Snack or Yack?** video taste tests was a Nutella "ice cream" that you make with just two ingredients (Nutella + heavy cream just shaken up together in the jar and frozen) that made the viral rounds. It was good, but almost too rich and Nutella-y. Plus the spread is so thick, it's impossible to fully mix it with anything without pulling out a spoon. This version uses a lot more cream and the power of a blender to do the mixing work so you get more of a fudge pop texture. And really, isn't a fudge pop better than ice cream anyway when you want a quick Snack? Make a big batch of these, and you're good for the week.

Makes 12 mini fudge pops; 4 to 5 Snacks

Put 12 paper cupcake liners in a 12-cup standard-size muffin pan.

In a blender, puree the chocolate hazelnut spread and about ½ of the cream until smooth. Add the rest of the cream and give it another blast so the spread is fully incorporated.

Pour the fudge pop base into the lined muffin cups; they should be pretty full but don't sweat it if some of the fudge pop base spills out of the cupcake liners.

- 1 (13-ounce/370-g) jar chocolate hazelnut spread (Nutella; about 1 cup)
- About 2 cups (480ml) heavy cream or heavy whipping cream

In 60 seconds or less
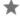

Mix together some **Nutella** + **heavy cream** in a blender, pour them into cupcake liners in a muffin pan, and freeze them up until they're solid. Peel back the paper and eat it like a Reese's. (Oh WAIT! That gives us an idea … check out the next page!)

Recipe continued

CHEAT SHEET

You can make more (or fewer) fudge pops by sticking to the same 1 part chocolate hazelnut spread to 2 parts heavy cream ratio.

Freezing the fudge pops in paper cupcake liners makes them easy to pop out and eat. If you don't have any handy, you can freeze these in small paper cups. If you want, pop a wooden popsicle stick (or something similar, like a straw) in each cup when the fudge pops are almost frozen but not fully set. That's too much work for us; we're just gonna peel back the paper and have at it.

Freeze the pops until pretty firm, a solid 3 hours (they won't get rock hard), or cover the muffin pan with plastic wrap and keep them in the freezer for up to 1 week.

When you want a Snack, run a knife around the edges of the cupcake liners to loosen any that are stuck to the pan (if any of the fudge pop base spilled out of the liners) if needed. Peel away part of the paper liner and go for it before they melt!

Fact! If you've ever made ice cream, you know that a custard base tastes a lot sweeter at room temperature than when it's frozen. It has to do with how sweetness is registered by the brain and affects everything from refrigerated sodas to all the sugary treats in the freezer aisle. Something to consider if you're ever creating your own ice cream (or ice pop) flavors!

Frozen NB (Nutella Butter) Cups!

Dip the fudge pops in chocolate and it's like eating a frozen Reese's cup, only it's WAY better with the Nutella.

Makes 2 mini fudge pops; 1 Snack

Squeeze the chocolate shell topping into a small bowl.

Fold back any of the paper cupcake liner that extends above the top of each fudge pop and dip the top of the fudge pops in the chocolate shell topping so the entire top is covered.

Pop the fudge cups back in the freezer for 10 minutes or so to firm up a little, and you're done!

- About 1 generous spoonful (2 tablespoons) Magical Chocolate Shell (page 189), warm, or store-bought chocolate shell topping (Magic Shell or Ice Magic), at room temperature
- 2 Two-Ingredient Fudge Pops (page 151), frozen solid

CHEAT SHEET

If you're using homemade chocolate shell topping, you'll need to rewarm it if it's been in the fridge (for how to do this, see page 189).

In 60 seconds or less

Make some **Two-Ingredient Fudge Pops** (page 151). Dip the tops of the treats in **chocolate shell topping**, and now you've got frozen chocolate-covered fudge cups!

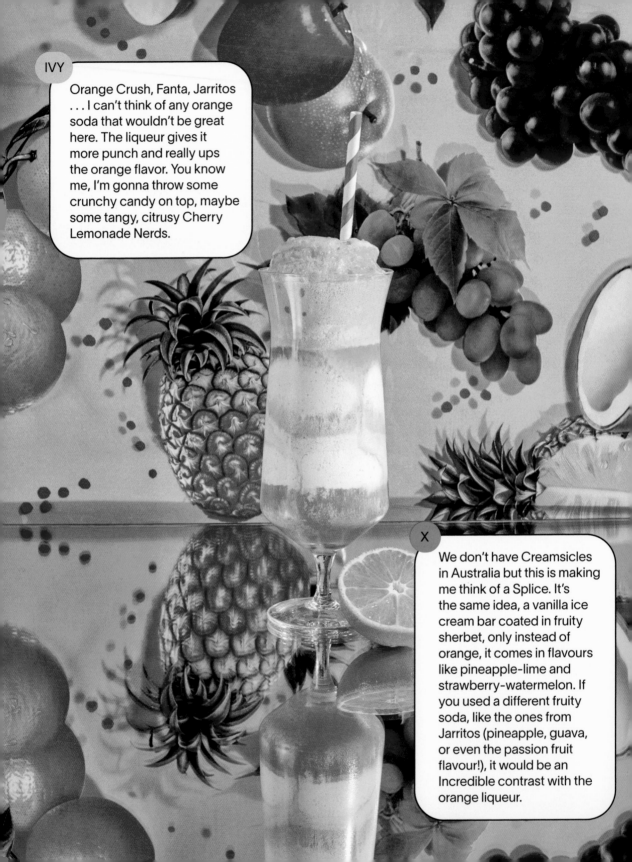

IVY

Orange Crush, Fanta, Jarritos . . . I can't think of any orange soda that wouldn't be great here. The liqueur gives it more punch and really ups the orange flavor. You know me, I'm gonna throw some crunchy candy on top, maybe some tangy, citrusy Cherry Lemonade Nerds.

X

We don't have Creamsicles in Australia but this is making me think of a Splice. It's the same idea, a vanilla ice cream bar coated in fruity sherbet, only instead of orange, it comes in flavours like pineapple-lime and strawberry-watermelon. If you used a different fruity soda, like the ones from Jarritos (pineapple, guava, or even the passion fruit flavour!), it would be an Incredible contrast with the orange liqueur.

Orange Soda Done Right

Even for us, sometimes it's the simplest combinations that are still the best. We've put a lot of orange soda trends to the test, like putting coffee creamer in a fountain drink if you're at a fast food place. None have been bad (it's sugary orange soda!), but none have been remarkable, either. The one combo that is worth making is the tried-and-true classic: orange soda with vanilla ice cream. Yes, it's just an ice cream float, but it tastes like a Creamsicle! Top it off with a shot of orange liqueur, and it's Next Level.

Makes 1 Drink

Put the ice cream in a giant glass and add as much soda as you want. We like to start with about ½ the can, then top off the drink with more as the ice cream melts.

Now pour the orange liqueur on top (don't stir), and we don't need to tell you what to do next!

- 2 to 3 scoops (1 to 1½ cups / 150 to 225 g) vanilla ice cream
- About 1 (12-ounce / 360-ml) can orange soda (Fanta), chilled
- 1 shot (1½ ounces / 45 ml) orange liqueur (Cointreau, Grand Marnier, Triple Sec)

In 60 seconds or less

Do we really need to explain how to make an **ice cream float** with **orange soda** and a shot of **orange liqueur**?

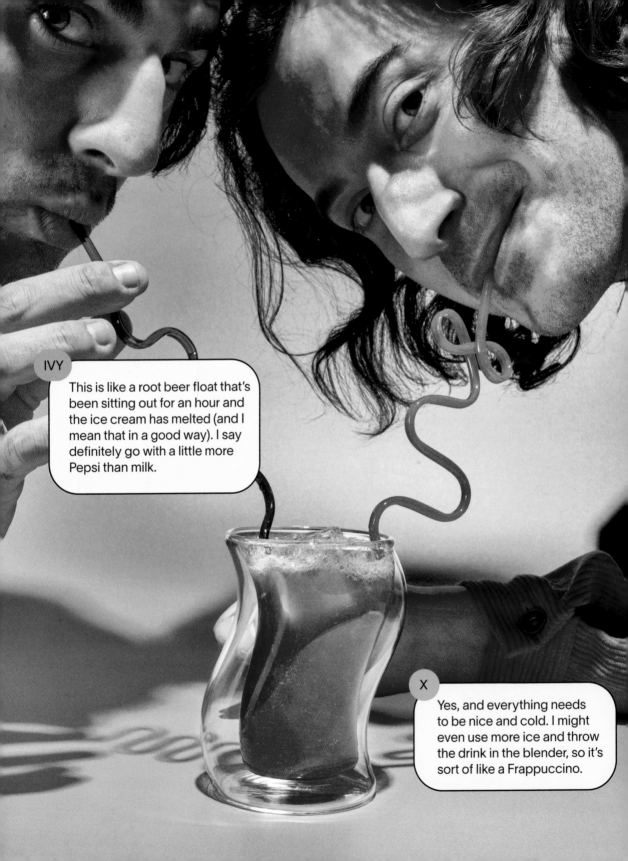

Pilkk

There's a reason so many Pilk (Pepsi + milk) videos were streaming everywhere at one point. As with several of our other TikTok-inspired culinary experiments, we have since learned that combining a fizzy cola with an ice-cold glass of milk isn't new. (This is why we love comments on our posts!) If you're a fan of classic television, you may remember the drink was Penny Marshall's go-to on **Laverne and Shirley**. It's a double shot, extra caffeinated world today, so we've added another K to the mix (Kahlúa, or coffee liqueur), but you could definitely stick to the old-school classic here. The amount of milk and soda you will need depends on your glass, so choose one wisely . . . a highball glass, a bigger Solo cup, or go out like Laverne and pull out a bucket!

Makes 1 Drink (any size you want!)

Add 2 or more ice cubes to any size glass (or bucket!). Fill about a third of the glass with Pepsi and then add the same amount of milk. Give everything a stir, taste, and add a little more Pepsi, if you want.

Top off your fizzy refresher with the coffee liqueur, throw on some old sitcom reruns, and enjoy!

- Pepsi, chilled
- Whole milk
- 1 shot (1½ ounces / 45 ml) coffee liqueur (Kahlúa), more if you're feeling cheeky

CHEAT SHEET

Full-fat milk gives the drink a nice richness; you could also use part heavy cream or heavy whipping cream for more of an eggnog vibe.

✳

If you actually are using a bucket to make this (#houseparty punchbowl!), start with one 2-liter (68 ounce) bottle of Pepsi for every half gallon (1.89 to 2 liters, depending where you live) of milk and a 750-milliliter bottle of Kahlúa. And be sure to grab another bottle of Pepsi so you can add more if you want!

In 60 seconds or less

Mix together some **milk** + **Pepsi** in a glass with a little ice, and top it off with a shot of **Kahlúa**. Or, make a bucket-load for a party!

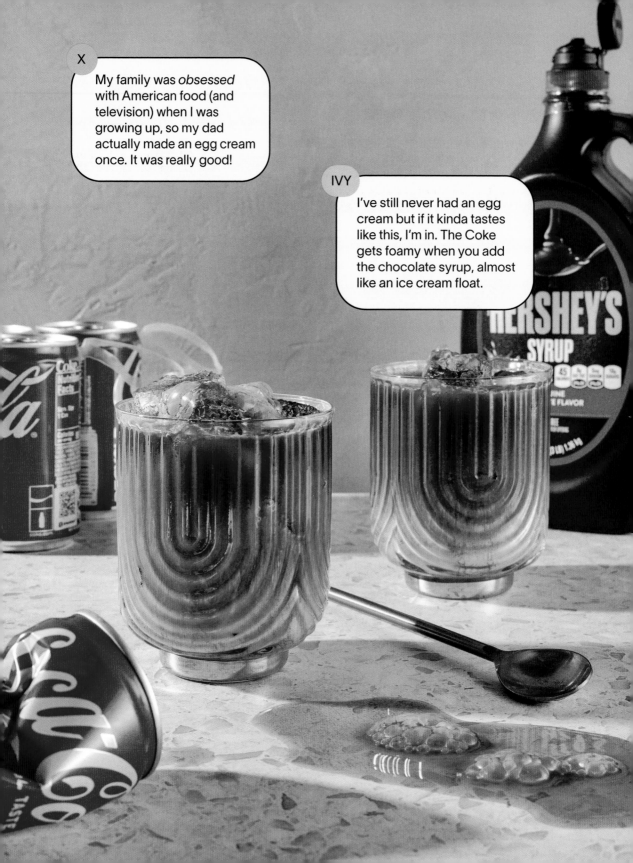

Vegan Egg Cream

While definitely not the version Elaine mixed up on **Seinfeld**, this Coke and chocolate syrup "egg cream" really does have a similar flavor to the New York diner classic made with milk, chocolate syrup, and seltzer water. Top it off with a generous splash of extra thick Alt Milk, and this could be the next Smash Hit at any veg-friendly NYC diner today!

Makes 1 Drink

Pour the Coke into a large glass, stir in the chocolate syrup so it's well combined, then add 3 or 4 ice cubes to the glass.

Top off the drink with the nondairy milk and stir only once this time (so there are streaks of Coke and milk visible). Find a coupla **Seinfeld** reruns on YouTube, sit back, and enjoy the show.

- About one-half of a 12-ounce (360 ml) can of Coke, chilled
- 1 generous spoonful (2 tablespoons) bottled chocolate syrup (Hershey's)
- 1 to 2 generous spoonfuls (2 to 4 tablespoons) unsweetened extra creamy nondairy milk, any kind

CHEAT SHEET

If you're making this drink for someone who really is vegan, many store-bought chocolate syrups like Hershey's are vegan. Some nondairy milks are made in factories that process non-vegan ingredients, so double check the labels.

In 60 seconds or less

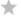

Pour some **Coke** + **chocolate syrup** into a glass, stir well, then add a few **ice cubes**. Top it off with a generous pour of **extra creamy vegan milk**, stir once, and you're good.

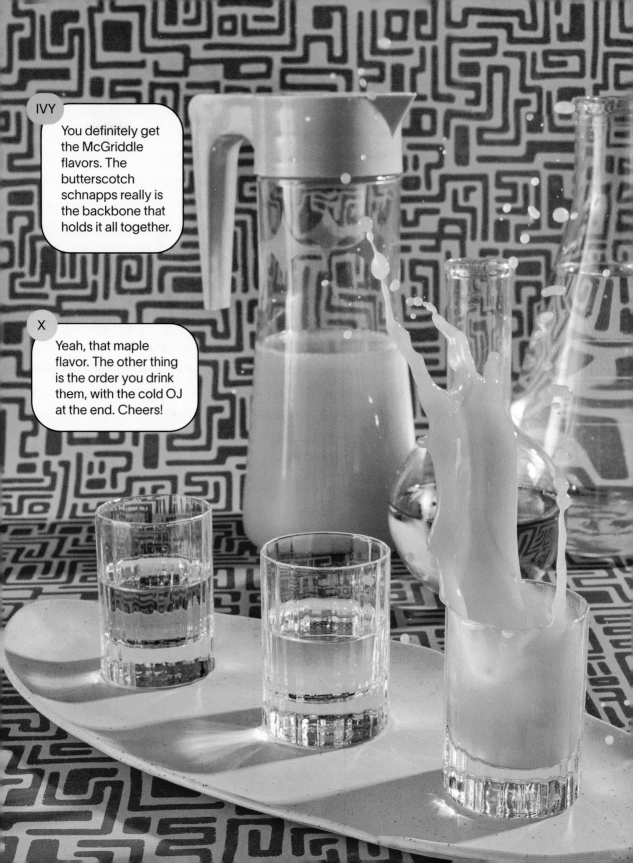

Instant "McGriddle"

No matter where you are in life, there seems to never be enough time to do it all. This cocktail simplifies at least one lazy weekend decision: Do you grab your keys and get a coupla McGriddles, or do you stay home and throw back a few shots? Now you can do both at the same time! The ingredients sound like they couldn't possibly mimic the flavors in the maple syrup-flavored pancake breakfast "sandwich" with scrambled eggs, bacon, and American cheese. But when you drink the whiskey, schnapps, and OJ one right after another, your palette is somehow tricked into thinking you just hit the drive-thru. With the whiskey you get that smoky, almost bacon-like flavor, the butterscotch schnapps hints at the maple-y pancakes, and the orange juice somehow finishes off the sandwich experience in ways we still can't figure out. Maybe the answer is less about the sandwich, and more about what you get with it. Coffee might also be in order, but no one orders a McGriddle without a glass of OJ.

Makes 1 Drink

Line up your shot glasses: the whiskey, the schnapps, and then the orange juice.

Take each shot in succession, allowing time to savor each ingredient for a second or two before you move on to the next. Now sit back and enjoy the warm feeling in your stomach and the delicious lingering flavors on your tongue!

- 1 shot (1½ ounces / 45 ml) Jameson Irish whiskey
- 1 shot (1½ ounces / 45 ml) butterscotch schnapps
- 1 shot (1½ ounces / 45 ml) pasteurized orange juice (Minute Maid Original), chilled

CHEAT SHEET

For an authentic McGriddle flavor, we recommend sticking to pasteurized orange juice, not freshly squeezed, and better still, what McDonald's serves if you've got it: Minute Maid Original!

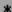

This isn't a round of Text or Shot (a.k.a. Cell Phone Roulette)! While you want to toss back each shot one after the other, you also need to take a moment to taste each ingredient separately.

In 60 seconds or less

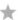

Line up shots of **Jameson** + **butterscotch schnapps** + **Minute Maid OJ** and taste them one after another. Crazy, right?

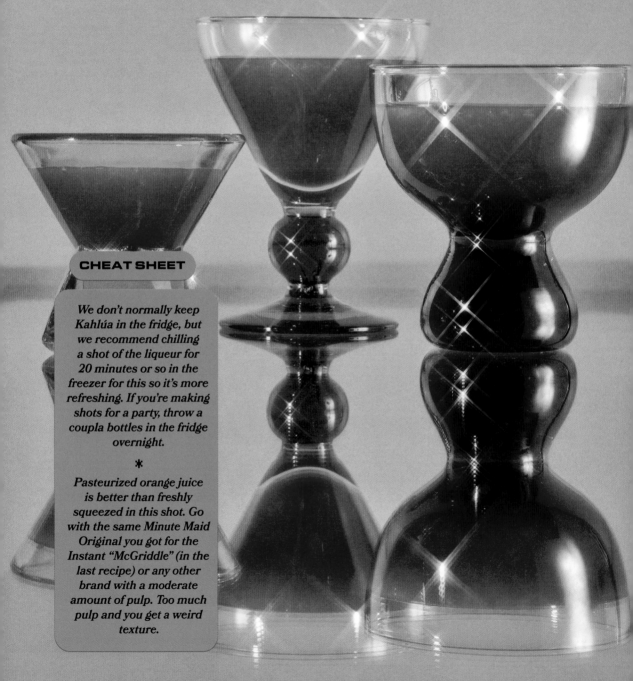

X
This will make you realize how little chocolate is actually in a Tootsie Roll.

IVY
The sugary coffee and rum in the Kahlúa somehow really does work with orange juice.

CHEAT SHEET

We don't normally keep Kahlúa in the fridge, but we recommend chilling a shot of the liqueur for 20 minutes or so in the freezer for this so it's more refreshing. If you're making shots for a party, throw a coupla bottles in the fridge overnight.

✱

Pasteurized orange juice is better than freshly squeezed in this shot. Go with the same Minute Maid Original you got for the Instant "McGriddle" (in the last recipe) or any other brand with a moderate amount of pulp. Too much pulp and you get a weird texture.

Drinkable "Tootsie Roll"

From Baby Boomers to Millennials and more recent Gen Z drinkers, everyone will experience a hint of nostalgia from this simple, two-shot wonder. It's got all the taffy deliciousness of a Tootsie Roll without the hassle of unwrapping a half-dozen candies.

Makes 1 Drink

Just put the Kahlúa and orange juice into a glass and throw back that shot already!

ORANGE T-ROLL

To make an extra orangey drink, use:

- ½ shot (¾ ounce / 22 ml) coffee liqueur, chilled
- 1 shot (1½ ounces / 45 ml) orange juice, chilled

DOUBLE CHOCOLATE T-ROLL

For more of a chocolaty version, use:

- 1 shot (1½ ounces / 45 ml) coffee liqueur, chilled
- ½ shot (¾ ounce / 22 ml) orange juice, chilled

- 1 shot (1½ ounces / 45 ml) coffee liqueur (Kahlúa), chilled
- 1 shot (1½ ounces / 45 ml) pasteurized orange juice (Minute Maid Original), chilled

In 60 seconds or less

Mix together a shot of cold **Kahlúa** + a shot of cold **Minute Maid OJ** and toss it back. Now the real fun begins: experimenting with finding the perfect ratio of orange-y goodness to chocolate-y sensations.

THE GREATEST DROP OF ALL TIME . . . DESSERT!

Or as we like
to call them,
twenty-four-hour
Snacks.

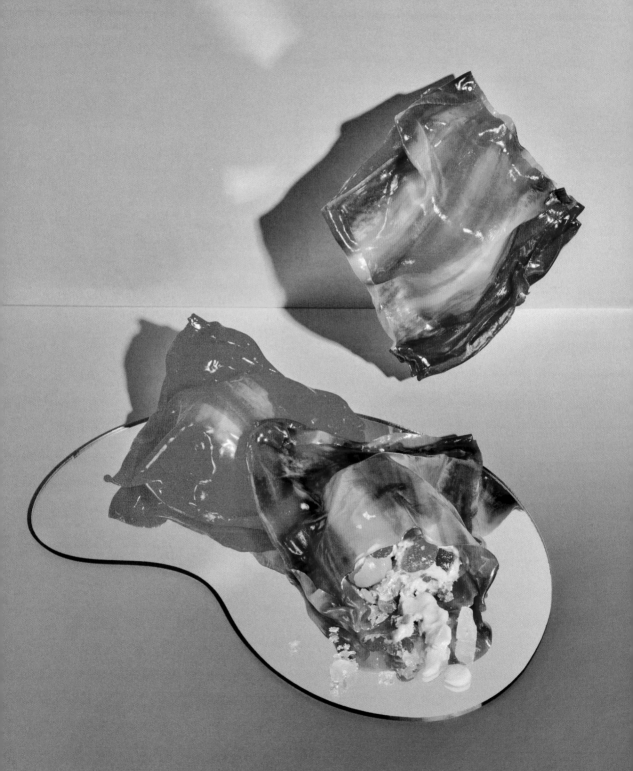

Fruit Roll-Up Ravioli

There are so many Snacks using Fruit Roll-Ups, the one-and-only fruit leather (there is no substitute!) could probably sustain its own video-sharing platform. One of the absolute best combos we've tried is when you put some ice cream or sherbet in the middle of one of the squares and fold it up into a little pocket that sorta looks like a stuffed ravioli. When the Fruit Roll-Up freezes, it almost shatters (in a really Incredible way) in your mouth like a super thin candy coating, then you get to that creamy ice cream filling. Some of the simplest roll-up and ice cream combinations have been the best but there's so much more you can do with these: add mix-ins to the ice cream before you fill the ravioli and maybe a fruity sauce (jam, chamoy, stuff like that) or candies, or even roll the outside of the ravioli in unsweetened Kool-Aid to get that sour candy vibe.

Makes 2 ravioli; 1 Snack

Unwrap the roll-ups, remove the paper beneath them, and spread them out on a large plate so they lay flat. Put 1 generous spoonful (2 tablespoons) ice cream or sherbet in the middle of each, and if you want, one small dollop (1 teaspoon) of whatever filling you're using. Quickly (don't delay or the roll-up will harden!) fold the top, bottom, and both sides of the roll-up over the ice cream or sherbet to enclose it completely.

Put the plate in the freezer and freeze the ravioli until the fruit leather has fully hardened, 15 minutes or up to 2 hours. Now prepare for a whole new ice cream sandwich experience!

Fact! Most fruit strips and fruit leather made by other manufacturers are not the right texture for this. Even Fruit-by-the-Foot (thin, extra long Fruit Roll-Ups) does not get as crunchy as Fruit Roll-Ups. Stick to the original!

- 2 Fruit Roll-Ups, any flavor
- 2 generous spoonfuls (4 tablespoons) ice cream or sherbet, any flavor
- 2 small dollops (2 teaspoons) filling, if you want: jam, fresh berries, chamoy, candies, or similar

CHEAT SHEET

One 1.5-quart (1.4-liter) tub of ice cream or sherbet will make about 4 dozen. Line a dish or baking sheet that fits in your freezer with plastic wrap or foil and freeze the ravioli in a single layer as they come off the assembly line. If you stack them, put a piece of plastic wrap between layers.

In 60 seconds or less
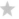

Lay a coupla **Fruit Roll-Ups** out flat, and put a small scoop of **ice cream or sherbet** in the middle of each and **a filling of some kind if you want**. Fold up the roll-ups to cover the ice cream, pop them in the freezer until the outside is crunchy, and you're set.

Recipe continued

Frozen Ravioli Hall of Fame

In one video, we invited our friend and epic record producer/songwriter Benny Blanco over to make these. The ravioli we made that day with butter pecan ice cream is still one of the best ever. Here are our other flavor combo winners . . . so far.

TROPICAL TIE-DYE + RAINBOW SHERBET

Ivy: Even though the strawberry roll-ups are usually my favorite, I'm going with Tropical Tie-Dye and rainbow sherbet. It really makes these taste like frozen candy. I might also throw a Gusher in there. They get kinda hard on the outside when they freeze up but I still love them!

STRAWBERRY + VANILLA OR STRAWBERRY ICE CREAM

X: I'm actually usually the one who eats the Tie-Dye roll-ups out of the box first, but I stand by what I said in the video and still think strawberry with vanilla ice cream is Incredible. (Strawberry ice cream would also be dank!) It really does taste like a strawberry milkshake.

CHERRY FRUIT ROLL-UP + BUTTER PECAN GELATO (TALENTI)

Benny: I'm wrapping my body in this!!

CHEAT SHEET

The fruit leather-to-hard candy transformation begins as soon as the ice cream hits the roll-up, so you need to fold in the edges of the fruit leather quickly so the whole thing doesn't break apart. Once they're out of the freezer, the transformation will soon head back the other direction, to chewy fruit leather territory, so eat them right away. And even if they get a little chewy, they're still really great.

*

You can keep these in the freezer for an hour or two but the fruit leather will eventually start to soften up again even though it's frozen because of the moisture from the ice cream.

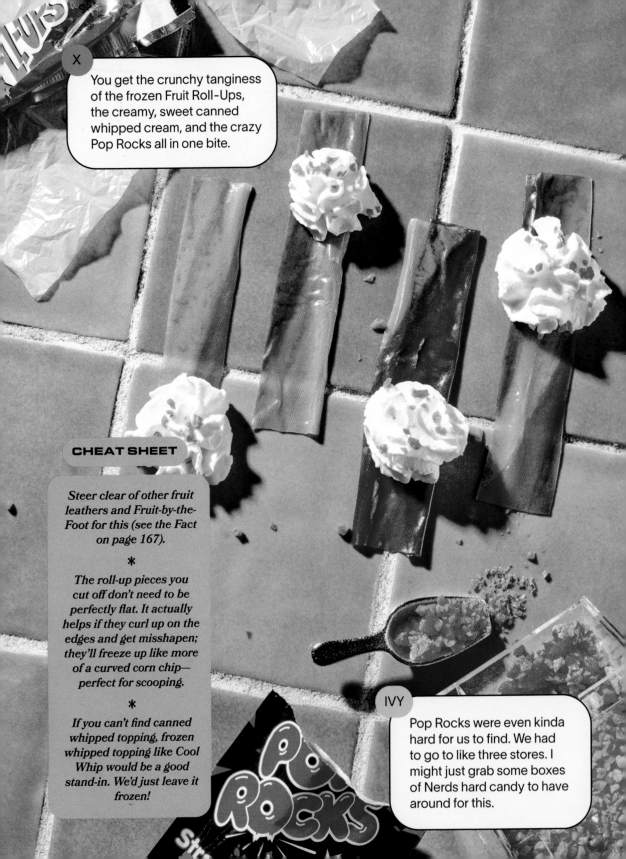

X

You get the crunchy tanginess of the frozen Fruit Roll-Ups, the creamy, sweet canned whipped cream, and the crazy Pop Rocks all in one bite.

CHEAT SHEET

Steer clear of other fruit leathers and Fruit-by-the-Foot for this (see the Fact on page 167).

*

The roll-up pieces you cut off don't need to be perfectly flat. It actually helps if they curl up on the edges and get misshapen; they'll freeze up like more of a curved corn chip— perfect for scooping.

*

If you can't find canned whipped topping, frozen whipped topping like Cool Whip would be a good stand-in. We'd just leave it frozen!

IVY

Pop Rocks were even kinda hard for us to find. We had to go to like three stores. I might just grab some boxes of Nerds hard candy to have around for this.

Fruity Chips with Poppin' Whipped Cream

Before we tried our first Fruit Roll-Up Ravioli, we tried that trick where you stack up several Fruit Roll-Ups and freeze them together. The texture of the Fruit Roll-Ups is Incredible when they're frozen, almost like a hard candy, and as they thaw out, the roll-ups get chewy again (and the fruity coating gets all over your fingers—messy, but worth it). Here, we've combined that straight-up frozen Fruit Roll-Up trick with another Snack revelation: Reddi-Wip with Pop Rocks. The first time we tried that combo on **Snack or Yack?**, we ate it with a spoon, but here frozen cut-up sheets of roll-ups serve as Fritos-like dipping chips. These two belong together!

Makes 2 fruity chips; 1 Snack

Unwrap the roll-ups (don't remove the paper beneath them) and use scissors to cut each into 2- to 3-inch (5 to 7.5 cm) strips. Lay the strips along with the paper beneath them on a large plate so they're not overlapping. (If you lose some of the paper, it's fine.) Put the plate in the freezer and freeze the roll-ups until they're crunchy, about 10 minutes or up to 2 hours.

Shake the can of whipped topping really well and spray the topping into a small bowl. Scatter the popping candy all over the whipped topping, grab a few roll-ups strips from the freezer (leave the rest in the freezer until you're ready to eat them), and scoop up that loud, creamy, crunchy goodness!

- 2 Fruit Roll-Ups, any flavor
- About one-third of a 6½-ounce (185 g) can whipped topping (Reddi Wip), chilled
- 1 (0.37-ounce / 10½-g) package popping candy (Pop Rocks), any flavor

In 60 seconds or less

Get a coupla **Fruit Roll-Ups** and spray some **canned whipped topping** on a plate. Throw some **Pop Rocks** on top of the whipped cream and hurry up and get to dippin' while the candy is still popping.

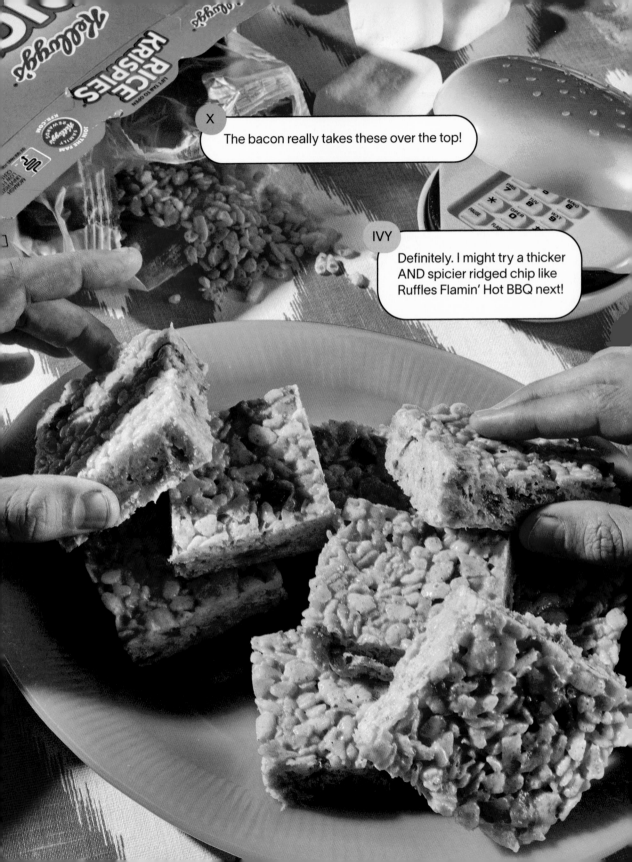

BBQ Rice Krispies Treats

When we heard that Rice Krispies treats with potato chips was a thing, the question was not if it's a Snack, but how could we make it even better? Any chip, cheese puff, or similar delicacy covered in a delicious powdery coating is going to win our votes! Barbecue chips won the final taste test; throw in some meaty bacon, and you're right there in the actual real barbecue flavor range. This is definitely the kind of show-stopping Snack that would be perfect for the Super Bowl or a Fourth of July cookout, and would probably even bring down the house if we ever get to DJ at a retirement home again. (Toughest crowd EVER . . . and it turned out to be one of our best shows to date!)

Makes 8 large bars/Snacks

Lightly coat a 9-inch (23 cm) square baking pan with cooking spray.

Crumble the chips over a large bowl so each chip is broken into 3 or 4 pieces (some small crumbs are also great), add the cereal, and use your hands to toss them together.

In a large skillet, heat the butter over medium heat until melted, add the marshmallows, and cook, stirring regularly, until the marshmallows are almost completely melted, 3 to 4 minutes. Turn off the heat, add the bacon, and stir the marshmallows until smooth.

- Nonstick cooking spray or vegetable oil, for coating the baking pan and your hands
- 4 large handfuls (4 cups / 85 g) classic or kettle-style BBQ-flavored potato chips (BBQ Lay's, Kettle Backyard BBQ; about half of an 8-ounce / 225-g bag)
- 4 large handfuls (4 cups / 110 g) puffed rice cereal
- 3 tablespoons unsalted butter or margarine
- 1 (12-ounce / 340-g) bag marshmallows, any size
- 4 to 5 slices bacon, any thickness, fried until crispy and crumbled

In 60 seconds or less

Crush up several handfuls of **BBQ Potato Chips** and mix them up in a bowl with the same amount of **Rice Krispies**. Melt some **butter** + **marshmallows** together, add crumbled **bacon**, and mix that into the chips and cereal. Press the mixture into a greased baking pan, bake the bars, let the whole thing cool, and dive in!

Recipe continued

CHEAT SHEET

A classic potato chip like Lay's is more subtle and results in more of a traditional Rice Krispies texture; a thicker kettle-style chip is great for more of a crunchy contrast.

The chips have plenty of salty goodness on their own so unsalted butter or margarine is best.

Immediately pour the hot marshmallow cream over the potato chip–cereal mixture and use a rubber spatula to gently but quickly fold the two together until just combined. Scrape the mixture into the prepared baking pan and lightly press the bars into the pan with the spatula the best you can (it's gonna be sticky).

When the bars are cool enough, rub your hands lightly with the cooking spray or oil and use your hands to press down on the bars to flatten them slightly.

Let the treats cool completely, cut them into 8 bars, and have at them! To save the bars for later, store them in a large zip-top food storage bag or airtight container for up to 2 days or freeze for up to 1 month.

Chocolate Ramen Crunchies

Australian spiders, called haystacks in the U.S, are a brilliant one-bowl candy combination made with crispy chow mein noodles, chocolate, and in our version at least, a little peanut butter that hardens. Wait! If you don't like peanut butter, don't turn the page just yet! Nutella would also be great in these hard chocolate candies. Another brilliant invention: instant ramen! Far easier to find these days than fried chow mein noodles, a package of ramen noodles is probably (or should be) in your pantry right now. It's the simplicity that makes these candies great. But if you want to sprinkle a little shredded coconut on top of some for a taste test, we're here to tell you that's pretty Incredible, too.

Makes 10 candies; 3 to 4 Snacks

Line a large baking pan or even a large plate with parchment paper or foil.

Crush the ramen noodles over a medium bowl into small pieces about the size of coffee beans; it's fine if there are some larger chunks and smaller bits. (Save the seasoning packet for something else delicious!)

In a small saucepan, heat the chocolate chips or bars and peanut butter or chocolate hazelnut spread over low heat, stirring constantly, until the chocolate is almost completely melted, 3 to 4 minutes. Turn off the heat and stir the chocolate until smooth.

- 1 (3- to 3.5-ounce / 85- to 100-g) package instant ramen, any flavor
- 1 large handful (1 cup / 6 ounces / 170 g) milk, semisweet, or dark chocolate chips or 1¾ (3.5-ounce/ 100-g) chocolate bars, broken into small pieces
- 1 generous spoonful (2 tablespoons) peanut butter or chocolate hazelnut spread (Nutella)
- 1 generous spoonful (2 tablespoons) sweetened shredded coconut, if you want

In 60 seconds or less

Melt some **chocolate** + a little **peanut butter or chocolate hazelnut spread** together. Crush up some **(uncooked) ramen noodles** and mix them into the chocolate sauce. Drop the candy by the spoonful onto a lined baking sheet, sprinkle some **coconut flakes** on top if you want, and pop them in the freezer for a bit to firm up.

Recipe continued

X
I actually like these better than the ones with chow mein noodles. It's a different texture, almost a finer crunch with the thinner ramen noodles, and more chocolaty.

IVY
The finely shredded coconut works perfectly here; you get just a taste of the coconut on top before you hit the chocolate.

Pour the hot chocolate mixture over the ramen and use a rubber spatula to gently fold the two together until well combined. Drop the mixture by generous spoonfuls (about 2 tablespoons) onto the prepared pan or plate and sprinkle the coconut over all or some of the candies, if you're going that direction. Press down lightly on the tops of any that have coconut so the flakes adhere.

Freeze the candies until the chocolate has hardened, about 20 minutes, and have at them right away. Or store the spiders in a large zip-top bag or airtight container in the refrigerator for up to 1 week or freeze for up to 1 month. If frozen, let the candies sit at room temperature for a good 15 minutes before you eat them.

Using the classic Aussie choice, milk chocolate (it must be Cadbury!) will give you the sweetest candies; a semisweet or dark chocolate is gonna give you more of that classic American haystack candy vibe. If you're using sweet chocolate hazelnut spread, go with a darker chocolate chip or bar (semisweet or even better, 65% chocolate or higher) instead of milk chocolate.

✳

To melt the chocolate in the microwave, put the chocolate and peanut butter or chocolate hazelnut spread in a medium microwave-safe bowl and cook, uncovered, on High for 45 seconds. Stir the chocolate and cook on High for another 30 seconds or until almost completely melted, then stir until smooth.

✳

Once they've firmed up in the freezer, the candies aren't gonna melt if you leave them at cool room temperature for a few hours. Leave them in the car on a hot day, and yeah, you'll end up with a melted chocolate mess.

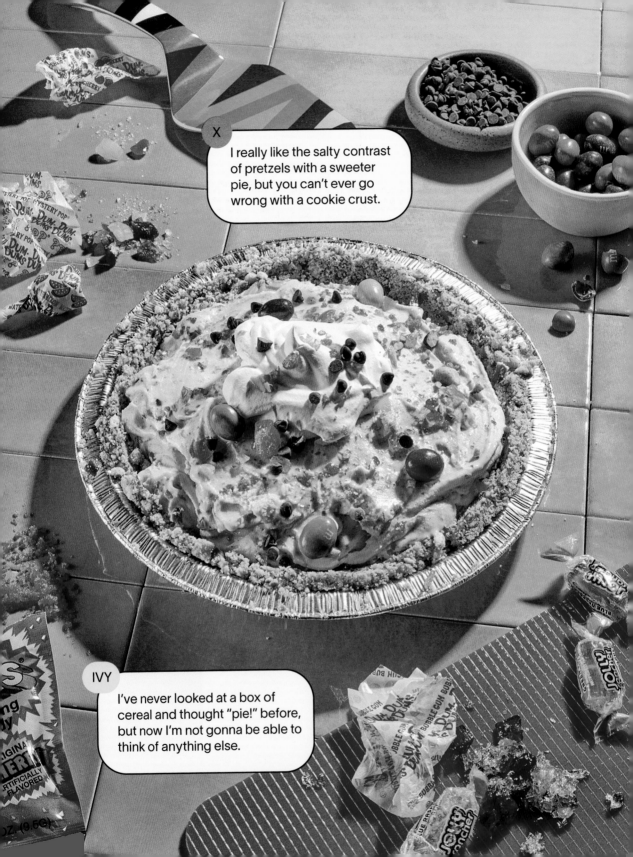

Next-Level Pie Crust

For those times in life when you have far too many bags of pretzels, cookies, or sugary cereal than you could possibly eat before they go stale, we bring you a pie crust solution that promises to downsize your pantry shelves efficiently and deliciously! It's like a graham cracker crust (crushed-up dry ingredients + butter), only with larger crumbs so you get a crunchier texture. That also means a few crumbs are likely to fall off as you slice whatever pie you've decided to make (fair game for whomever lays eyes on them first!)

Makes one 9-inch (23 cm) pie crust

Put the cookies, pretzels, or cereal in a large zip-top bag, close the bag, and gently crush them with a meat mallet, hammer, or rolling pin, or stomp on them so you have mostly fine crumbs with a few larger pieces in the mix.

Add 5 tablespoons (70 g) of the melted butter to the dry ingredients and give the bag a nice massage to incorporate the butter.

If you're using cookies or pretzels, pick up a small handful of the crust mixture and gently squeeze it; the ingredients should loosely clump together. If not, add more butter, 1 tablespoon at a time, until the mixture clumps. If you're using sweetened puffed cereal, add the remaining 2 tablespoons melted butter and mix well. The cereal isn't going to clump together like a typical crumb crust but it will be fine.

- 4 large handfuls (4 cups / weight varies) cookies or pretzels (plain or dipped) or 3 large handfuls (3 cups / weight varies) sweetened puffed cereal
- 5 to 7 tablespoons (70 to 100 g) salted or unsalted butter or margarine, melted

In 60 seconds or less

Smash up some **cookies, pretzels, or sweetened puffed cereal** in a bag and mix in some melted **butter**. Press the crust in a pie plate and freeze it for 15 mins or so.

Recipe continued

If you want more of that classic graham cracker–like crust, go with cookies or pretzels for a similar texture. Sweetened puffed cereals make a lighter-textured crust (that doesn't hold together quite as well) but can provide a rainbow of color and flavor opportunities.

✳

The amount of butter you need to bind the crust together will vary depending on type of ingredient (say, a light, puffy cereal or a thicker cookie) and whether there's something else in the mix, like a creamy cookie filling (Oreos, Nutter Butters) that will act like a binder. With pretzel crusts, the sodium levels are already deliciously high, so unsalted butter or margarine is probably the way to go.

Pour the crust into a 9-inch (12 cm) pie plate and spread out the crust on the bottom and roughly 1½ inches (4 cm) up the sides. If you have another pie plate, lay it on top of the crust and press down firmly to help set the crust, or just use the bottom of a drinking glass.

Freeze the crust for at least 15 minutes and you're good, or you can cover it with plastic wrap and freeze it for up to 1 month before you use it.

Cookie, Pretzel, and Cereal Amounts for One Next-Level Crust!

We're sticking to measuring out our pie crusts by the handful, but for those who like to be precise, here are some approximate ingredient measurements for your crust experiments.

SANDWICH COOKIES

25 Oreos or 20 larger sandwich cookies (Nutter Butters)

Go for those with an even filling-to-cookie ratio like Oreos (the original cookies, not those with extra filling) and Nutter Butters. If you're making a pie that's already loaded up with tons of other sweet flavors, take the filling out of half the cookies (and eat it!).

NILLA WAFERS, SHORTBREAD, OR COATED WAFER COOKIES

60 Nilla Wafers, 20 Walkers "fingers," 12 individual "petticoat tails" (triangle-shaped cookies), or 32 coated wafer cookies (one 9-ounce/255-g box of Girl Scouts Thin Mints)

Both Nilla Wafers and shortbread make a more classic graham cracker–like pie crust, while chocolate-coated wafer cookies are great for chocolaty crusts.

PRETZELS

100 mini (classic) pretzels or 45 mini yogurt- or chocolate-covered pretzels

Thinner hard pretzels (mini classic twists, sticks, and similar) give you a solid, salty crust to contrast any really sweet, creamy fillings; add 2 to 3 tablespoons sugar if you want a touch of sweetness in the crust. Dipped pretzels (white or dark chocolate, yogurt) already have that sweet-salty thing on their own.

SWEETENED PUFFED CEREAL

3½ (100 g) to 4 ounces (115 g) Fruit Loops, Corn Pops, Cocoa Puffs, Reese's Puffs, and similar

The amount of cereal you need depends on the size of the cereal pieces; start with less and add more as needed.

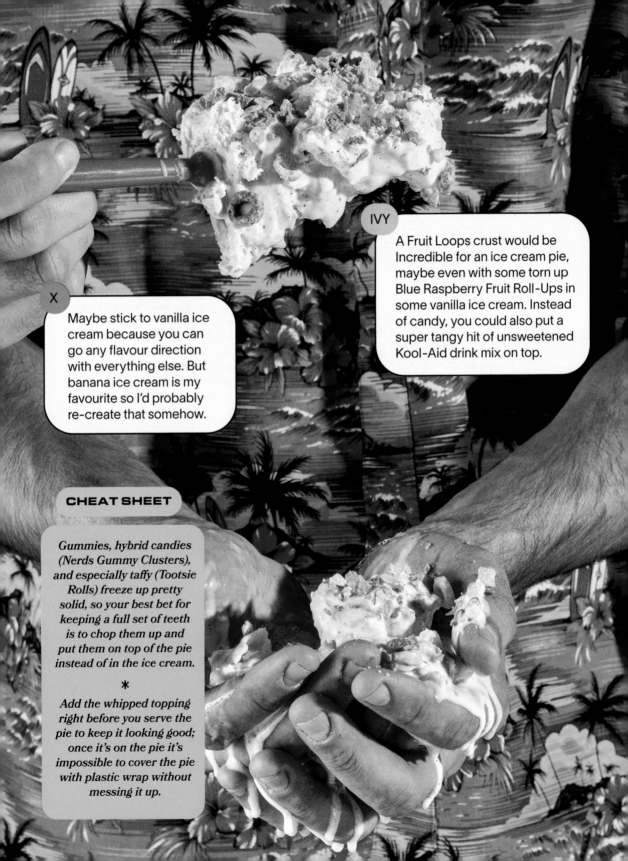

IVY

A Fruit Loops crust would be Incredible for an ice cream pie, maybe even with some torn up Blue Raspberry Fruit Roll-Ups in some vanilla ice cream. Instead of candy, you could also put a super tangy hit of unsweetened Kool-Aid drink mix on top.

X

Maybe stick to vanilla ice cream because you can go any flavour direction with everything else. But banana ice cream is my favourite so I'd probably re-create that somehow.

CHEAT SHEET

Gummies, hybrid candies (Nerds Gummy Clusters), and especially taffy (Tootsie Rolls) freeze up pretty solid, so your best bet for keeping a full set of teeth is to chop them up and put them on top of the pie instead of in the ice cream.

Add the whipped topping right before you serve the pie to keep it looking good; once it's on the pie it's impossible to cover the pie with plastic wrap without messing it up.

Party Shirt Ice Cream Pie

This is our kind of dessert. You can throw whatever you've got around into a pie crust and you're done. We can't think of a single cookie or crunchy/chocolaty/gooey/anything candy that wouldn't be great to mix in to the ice cream or sprinkle on top.

Makes 1 pie; 8 Snacks

In a large bowl, use a rubber spatula or large spoon to fold the mix-ins into the ice cream until well combined. Spoon dollops of the filling evenly over the chilled crust and gently spread it out to the edges. If some of the crust gets messed up you can patch it up if you want but the ice cream or sherbet will firm up enough to cover a few holes.

Cover the pie with plastic wrap and freeze until firm, at least 2 hours or up to 2 days. Just before serving, mound the whipped topping in the center of the pie and spread it out to the edges. (If you want it to look fancy, leave more whipped topping in the center than on the edges.) Now sprinkle any toppings you want over the pie and then a sauce, if you're going there, grab some spoons, and dive in!

If you have any leftovers, cover the pie remnants with plastic wrap and freeze it for up to 3 days.

- 1 (1.5 quart / 1.4-liter) tub ice cream, slightly softened
- 1 large handful (1 cup / weight varies) mix-ins: candy, cereal, cookies, berries (fresh or frozen), or that kind of thing, crushed or roughly chopped
- 1 Next-Level Pie Crust (page 179), any flavor, pressed into a pie pan and chilled
- 1 (8-ounce / 225-g) tub frozen whipped topping (Cool Whip), thawed (about 3 cups)
- 1 small handful (⅓ cup / weight varies) toppings: candy, nuts, sweetened cereal, chocolate, or similar, crushed or roughly chopped if large
- 1 to 2 generous spoonfuls (2 to 4 tablespoons) sauce, if you want: chocolate, caramel, chamoy

In 60 seconds or less

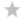

Mix together your **favorite ice cream** + **mix-ins**, spread that into a **Next Level Pie Crust**, and freeze. Top the pie with thawed **Cool Whip** + **any toppings you like**. Eat!

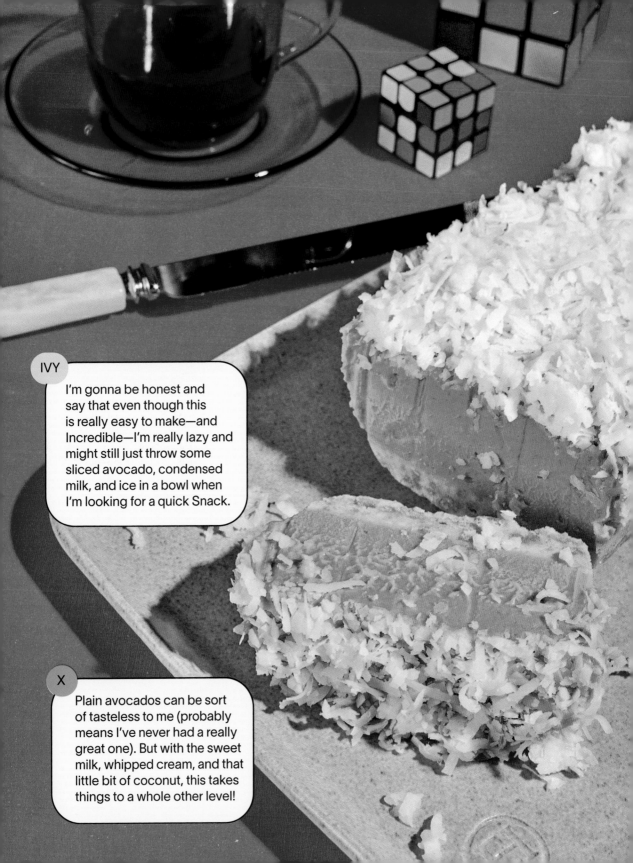

IVY

I'm gonna be honest and say that even though this is really easy to make—and Incredible—I'm really lazy and might still just throw some sliced avocado, condensed milk, and ice in a bowl when I'm looking for a quick Snack.

X

Plain avocados can be sort of tasteless to me (probably means I've never had a really great one). But with the sweet milk, whipped cream, and that little bit of coconut, this takes things to a whole other level!

Coconut-Avocado Semifreddo

When we heard about the three-ingredient Snack made with just avocados, sweetened condensed milk, and ice that's popular in the Philippines, we thought it was gonna be a complete waste of an avocado. We are happy to report we couldn't have been more wrong! As we both have Italian roots, here we turned that combo into a fancy Italian-style semifreddo that's super easy to make. You could eat this semifreddo on its own and be very happy, but pour the avocado base over a Next-Level Pie Crust (page 179) made with yogurt- or white chocolate-covered pretzels, and it's Next Level!

Makes 1 semifreddo; 8 Snacks

- About half of a Next-Level Pie Crust (page 179) with yogurt- or white chocolate-covered pretzels (not pressed into a pie pan)
- 1 cup (8 ounces / 225 g) ripe avocado flesh (about 2 medium avocados)
- 1 (14-ounce / 400-g) can sweetened condensed milk
- 1½ small spoonfuls (1½ tablespoons) fresh lemon juice
- Pinch salt
- 1½ cups (360 ml) heavy whipping cream
- 2 small handfuls (⅔ cup / 55 g) sweetened shredded coconut

Line a standard glass or metal loaf pan (about 9 by 5 inches or 23 by 12 cm) with several sheets of plastic wrap so the bottom and all the sides are covered: Lay one long strip of plastic wrap lengthwise so some of the plastic wrap hangs over both ends, then lay two more strips width-wise so an inch or two (2.5 to 5 cm) of plastic wrap drapes over the sides of the pan. Press enough of the pie crust mixture into the pan to make roughly a ½-inch-thick (11-mm) bottom layer.

In a blender, puree the avocado flesh, condensed milk, lemon juice, and salt until smooth.

Recipe continued

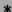
In 60 seconds or less

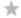

Start with half a **Next Level Pie Crust** (yogurt or white chocolate pretzel) in a lined baking pan. Puree some **avocados** + **sweetened condensed milk** + **lemon juice** + a pinch of **salt** in a blender or food processor. Whip up some **heavy whipping cream**, fold that into the avocado mixture, and pour it over the crust. Top everything off with **toasted coconut**, freeze, slice, and eat!

In a large bowl using a hand mixer or a stand mixer fitted with the whisk attachment, whip the heavy cream on high speed until soft peaks form, about 90 seconds. Add the avocado mixture to the bowl, remove the beaters or whisk attachment from the mixer, and use them to fold the avocado cream into the whipped cream by hand until just combined. There should be a few streaks of green from the avocado in the custard base.

Pour the custard into the prepared pan, sprinkle the toasted coconut on top, and gently press the coconut onto the surface of the custard. Fold the plastic wrap overhang over the semifreddo and freeze it for at least 6 hours or overnight.

When you're ready to impress, let the semifreddo thaw at room temperature for about 10 minutes so it's easier to remove from the baking pan. Unwrap the plastic wrap covering the top of the semifreddo and use the plastic wrap to lift the semifreddo out of the pan. (If it breaks, just use a spatula to pry the semifreddo out of the pan and onto a cutting board. Remove all of the plastic wrap, flip the semifreddo right side up so the coconut is on top, and slice it into 8 pieces.

Serve that deliciousness right away! If you have any leftovers, pile them back in the loaf pan, cover the top with plastic wrap, and freeze the semifreddo for up to 5 days.

The Ultimate Lazy PB Banana Cream Pie

We both love banana desserts, so this pie was inevitable. With a Nutter Butter crust, instant pudding mix, bananas, and whipped topping, it's as easy to eat as it is to make. Easy as pie, you could say. (Hahaha!) While the caramelly dulce de leche on top may sound like sugar overload, it's what makes this Incredible.

Makes 1 pie; 8 Snacks

Make the pudding according to the package directions but reduce the quantity of milk by about one-fourth. If you're using a large box, you'll need about 2¼ cups (540 ml) milk; for two smaller boxes, use 3 cups (720 ml).

Arrange about three-fourths of the banana slices over the bottom of the crust, pour the filling on top, and use a spatula or spoon to smooth out the pudding. Cover the pie with plastic wrap and refrigerate until the pudding is chilled, at least 3 hours or for up to 2 days.

Just before serving, mound the whipped topping in the center of the pie and spread it out to the edges if you want (or just leave it all piled up in the center). Arrange the rest of the bananas on top of the pie and drizzle the dulce de leche over the whole thing, if you're using it. Take a moment to admire your Incredible creation, then let everyone have at it.

If you have any leftovers, cover the pie with plastic wrap and refrigerate it for up to 3 days.

- 1 large 5- to 5.9-ounce (140 to 165g) box or 2 smaller 3.4- to 3.9-ounce (95 to 110 g) boxes regular or instant vanilla pudding mix
- 2¼ to 3 cups (540 to 720 ml) whole milk
- 2 small very ripe bananas, sliced
- 1 Next Level Pie Crust made with peanut butter sandwich cookies (Nutter Butters), pressed into a pie tin and chilled
- 1 (8-ounce / 225-g) tub frozen whipped topping (Cool Whip), thawed
- 2 generous spoonfuls (4 tablespoons) store-bought dulce de leche or DIY Dulce De Leche (page 198), if you've got some around, for drizzling

In 60 seconds or less

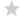

Make some **regular or instant vanilla pudding** with **milk**. Lay some **sliced bananas** all over the bottom of a **Next Level Pie Crust** made with peanut butter sandwich cookies, then fill it with the pudding. Chill the pie and pile on the **Cool Whip** + **more bananas** and finish off that beauty with **dulce de leche**.

Recipe continued

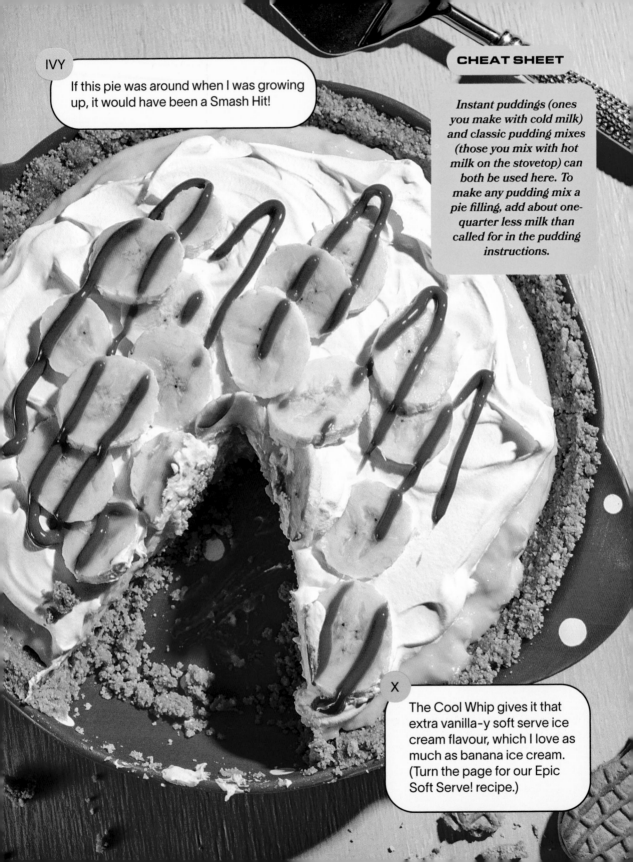

IVY

If this pie was around when I was growing up, it would have been a Smash Hit!

X

The Cool Whip gives it that extra vanilla-y soft serve ice cream flavour, which I love as much as banana ice cream. (Turn the page for our Epic Soft Serve! recipe.)

Magical Chocolate Shell

The chocolate hard shell topping that comes in those squeeze bottles that every kid loves to pour over ice cream is still just as exciting to see in action as an adult. The only thing is they never taste that chocolaty. Problem solved: With just two ingredients you can make it with whatever kind of chocolate you like! And it's yet another excuse to throw together some Epic Soft Serve (the recipe right before this one, if you missed it).

Makes about ⅔ cup (165 ml)

In a small saucepan, heat the chocolate chips or bars and coconut oil over low heat, stirring constantly, until the chocolate is almost completely melted, 3 to 4 minutes. Turn off the heat and stir the chocolate until smooth.

Let the sauce cool for a few minutes before pouring it over ice cream; it should be warm but not hot when you put your finger in it. It's ready for ice cream now, or you can pour it into a large porcelain (meaning everyday) mug or ramekin so it's easy to reheat later; cover and refrigerate it for up to 2 weeks.

To rewarm refrigerated chocolate shell topping that has hardened, put the mug or ramekin with the cold sauce in a small saucepan, fill the pan partway with water (the water should go roughly halfway up the sides of the mug), and bring the water to a simmer. Once the chocolate starts to melt, stir it a few times until it's fully melted, and you're good to go!

Fact! Chocolate hard shell was invented in Australia by Cottees, where it's called Ice Magic. In the U.S., Smucker's Magic Shell and Hershey's Shell Topping are the ice cream topping mainstays.

- 1 large handful (1 cup / 6 ounces / 170 g) milk, semisweet, dark, or white chocolate chips, or 1¾ 3.5-ounce (100 g) chocolate bars, broken into small pieces
- 1 generous spoonful (2 tablespoons) refined coconut oil

CHEAT SHEET

Use refined coconut oil for the purest chocolate flavor. The unrefined oil tastes more coconutty. If you don't have either, vegetable shortening works but the hard shell topping won't firm up quite as much.

In 60 seconds or less
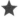

Melt some **chocolate** + **refined coconut oil** in a small saucepan over low heat, stirring while it melts. Turn off the heat and let the sauce cool a few minutes, pull out the ice cream, and enjoy!

CHEAT SHEET

For a classic soft serve flavor, use vanilla bean or "natural vanilla" (ice cream flavored with vanilla extract), not French vanilla ice cream.

✳

Wanna just make a single serving? Mix 2 scoops (1 cup / 150 g) ice cream with 1½ scoops (¾ cup / 2 ounces / 55 g) frozen whipped topping. You'll end up with about 3 scoops (1½ cups / 135 g). Trust us, you're gonna want that much when you make that Fruit Loops–White Chocolate Soft Serve Sundae on page 193.

X

This is Incredible, it really does taste like soft serve! The texture is a little different, not quite as fluffy, but it's all really there.

IVY

How did we not know about this before?

Epic Soft Serve!

We never thought there could truly be a decent stand-in for the pillowy soft serve ice cream that's the mainstay of every fast food restaurant's dessert menu. You need one of those soft serve machines, right? This two-ingredient method only requires a bowl and a fork. Warning: Once you make it, you're gonna want to grab a tub of Cool Whip every time you hit the freezer aisle at the grocery store.

Makes about 1½ quarts (1.4 L); 6 Snacks

In a large bowl, break up the ice cream into chunks and let it soften until it's easier to mash up, about 10 minutes. (Eat the rest of the ice cream in the container while you wait.)

Add the frozen whipped topping to the bowl and use the back of a fork or a potato masher to really get in there and smash the two ingredients together until smooth. Pile the soft serve back into the ice cream container or cover the bowl with plastic wrap and freeze the soft serve until it firms back up, a solid 2 to 3 hours; it won't get as hard as regular ice cream.

Now pile that ice cream into a bowl—or just eat it straight out of the tub!—or cover it with plastic wrap and freeze for up to 5 days

Fact! Those 1½ quart (1.4 liter) cardboard tubs of Dreyer's, Breyers, and other freezer aisle staples are the perfect size for storing your homemade soft serve and better than a big bowl at keeping out air that makes ice cream crystalize (and more space friendly in a packed freezer). The catch: You have to eat the ice cream you don't use for the recipe, but you've got several hours before the soft serve firms up. A Snack will be required!

- Two-thirds of a 1.5-quart (1.4 liter) tub vanilla bean or "natural" vanilla ice cream (4 cups / 960 ml)
- 1 (8-ounce / 225-g) tub frozen whipped topping (Cool Whip; about 3 cups)

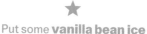

In 60 seconds or less
★

Put some **vanilla bean ice cream** in a bowl, let it thaw out for 10 minutes, then use a fork to mash in plenty of frozen **Cool Whip**. Throw the soft serve base in the freezer, and you can get back to "rinsing" the house music (playing a song SO much you're getting every single drop out of it!) while it freezes up.

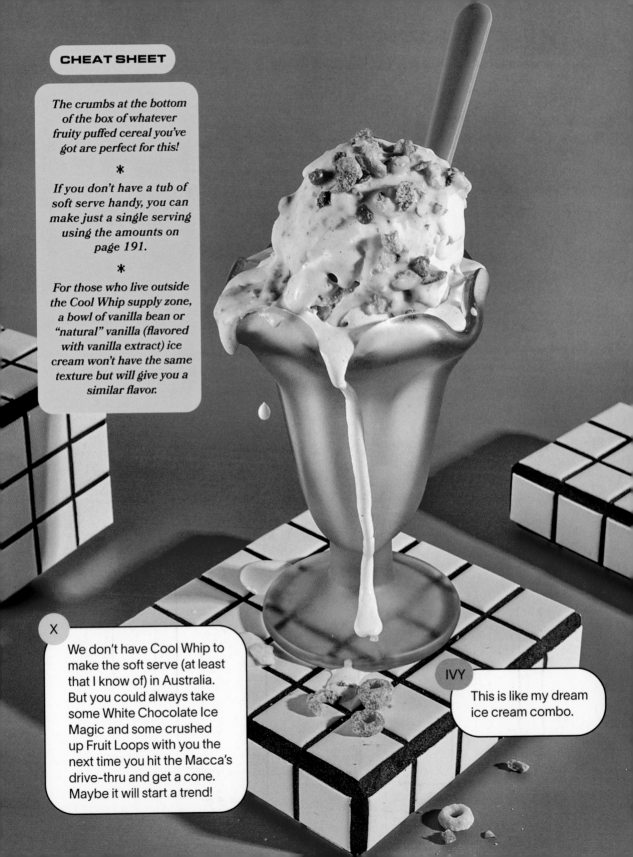

CHEAT SHEET

The crumbs at the bottom of the box of whatever fruity puffed cereal you've got are perfect for this!

*

If you don't have a tub of soft serve handy, you can make just a single serving using the amounts on page 191.

*

For those who live outside the Cool Whip supply zone, a bowl of vanilla bean or "natural" vanilla (flavored with vanilla extract) ice cream won't have the same texture but will give you a similar flavor.

X

We don't have Cool Whip to make the soft serve (at least that I know of) in Australia. But you could always take some White Chocolate Ice Magic and some crushed up Fruit Loops with you the next time you hit the Macca's drive-thru and get a cone. Maybe it will start a trend!

IVY

This is like my dream ice cream combo.

Fruit Loops–White Chocolate Soft Serve Sundae

For those who don't live near a Wienerschnitzel (and even if you do), we present a homemade version of one of our favorite drive-thru desserts! At one point the hot dog chain had a special-release soft serve cone that was dipped in a white chocolate shell topping with crushed-up Fruit Loops IN the hard shell. Maybe it was a bit of sugary cereal nostalgia, the white chocolate, or both, but we couldn't get enough. This is our tribute to that bit of ice cream greatness.

Makes 1 sundae/Snack

Stir about half the crushed cereal into the white chocolate shell topping.

Grab the soft serve from the freezer, pile it into a bowl, and pour the shell topping over the ice cream. Scatter the rest of the crushed cereal on top and have at it!

Fact! If you're using homemade chocolate shell topping, you'll need to rewarm it if it's been in the fridge (for how to do this, see page 18). If you're using store-bought shell topping, the Australian brand Cottee's makes White Chocolate Ice Magic and if you're in the States, Smucker's Unicorn Magic Shell, a "white cupcake" flavor (pretty much what white chocolate tastes like!) that also has sprinkles (more candy is never a problem for us) works. Or, just make your own!

- 3 small spoonfuls (3 tablespoons) finely crushed fruity puffed cereal (Fruit Loops, Fruity Pebbles)
- 2 generous spoonfuls (4 tablespoons) Magical Chocolate Shell made with white chocolate (page 189), warm, or store-bought white chocolate shell topping (Magic Shell, Ice Magic)
- 3 scoops (1½ cups / 135 g) Epic Soft Serve! (page 191)

In 60 seconds or less

Pull out that tub of **soft serve** you probably already made (page 191). Mix some crushed up **Fruit Loops** into **white chocolate shell topping** and pour that over the soft serve. Throw some more crushed **Fruit Loops** on top and experience the drive-thru at home!

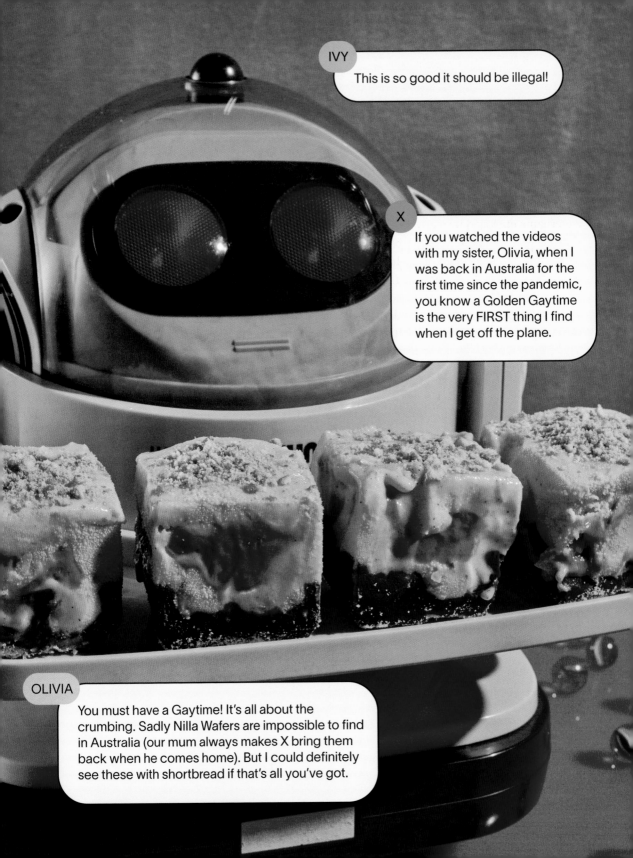

Golden Party Bars

If you have not had a Golden Gaytime, we know where you don't live—and now you officially have another reason to go to Australia! This is not merely an ice cream bar, it's a culinary masterpiece with the perfect ratio of toffee and vanilla ice creams enclosed by a crunchy chocolate shell topping that's coated with cookie crumbs. You will never look at an ice cream bar the same! Anything this iconic will never be precisely replicated, but we assure you this version has all the very best elements with a few helpful shortcuts. A gooey dulce de leche center stands in for the creamy toffee ice cream, which can be tricky to find (most we've seen are simply tubs of vanilla with smashed up bits of toffee or praline or they go more the salted caramel flavor route). And we assemble the layers in giant silicone ice molds (the ones that make mega-size square ice cubes for whatever bottle of liquor you're drinking on the rocks) or short of that, a DIY version from an empty milk carton makes layering up the ingredients and molding the bars easy (get the how-to below).

Makes 4 large ice cream bars; 4 Snacks

Pull out an extra-large square silicone ice mold with at least four 2- to 2½-inch (5 to 6 cm) cavities. Finely crush 4 vanilla wafers or half of the shortbread over the four silicone ice molds. Crumble the remaining 4 vanilla wafers or shortbread into a small bowl.

Drizzle about 1 small spoonful (1 tablespoon) chocolate shell topping over the wafer cookies or shortbread in one cavity, covering as much of the crumbs as you can. Now do the same in the other three cavities.

- 8 Nilla Wafers or 1½ ounces (40 g) shortbread cookies
- About 4 generous spoonfuls (8 tablespoons) Magical Chocolate Shell made with semisweet or dark chocolate (page 189), warm, or store-bought chocolate shell topping (Magic Shell, Ice Magic)
- 2 scoops (1 cup / 150 g) vanilla bean or "natural" vanilla ice cream, slightly softened
- 1 generous spoonful (2 tablespoons) store-bought dulce de leche or DIY Dulce De Leche (page 198)

In 60 seconds or less

Layer crumbled **Nilla Wafers** + **chocolate shell topping** + a spoonful of **vanilla bean ice cream** + a dollop of **dulce de leche** + another spoonful of **ice cream**. Top it off with more **chocolate shell topping** + **Nilla Wafer crumbs**. Freeze those up and get ready for a life changing ice cream bar experience!

Recipe continued

Rip off a piece of plastic wrap about the size of a small plate and put it on the counter. Scoop up 1 generous spoonful (2 tablespoons) ice cream, put it on the plastic wrap, fold the plastic wrap over the top, and use your hands to shape it into a square roughly the size of a cavity. Remove the plastic wrap and plop the ice cream into a cavity, and make 3 more ice cream squares for the rest of the molds.

Now put a small dollop (1 teaspoon) dulce de leche in the center of each ice cream square, then make 4 more squares of ice cream (1 generous spoonful / 2 tablespoons each), drop them in the molds, and use your finger to smooth out the ice cream to the edges of each cavity. If the ice cream is melting really quickly, pop the mold in the freezer for 10 minutes or so.

Grab the rest of the cookie crumbs you put in the bowl so they're nearby. Drizzle about 1 small spoonful (1 tablespoon) chocolate shell topping over one ice cream square and right away (like, really fast!) sprinkle about one-fourth of the crumbs on top, pressing down slightly to adhere the crumbs to the chocolate and ice cream. (Work quickly! The shell hardens fast now that it's on top of ice cream. If some crumbs don't adhere, it's fine.) Do the same with the other ice cream squares.

Freeze the bars until the ice cream firms up a little, a solid 15 minutes, pop the bars out of the silicon molds to unveil your masterpiece, and enjoy! If you have any leftovers, you can cover and freeze the bars a day or two, but the longer they sit, the less crunchy the cookie crumbs will be.

DIY Milk Carton
Ice Cream Bar Mold!

If you don't have one of those giant silicone ice cube molds, you can build one from an empty milk container.

Use scissors to cut an empty half-gallon (2.3 liter) paperboard milk container in half crosswise and discard the top half of the container. Starting at the new "top" of the container, make 4 vertical cuts down each corner approximately 2 inches (5 cm) long. Fold the top of each side down toward you to make 4 flaps and cut off each flap at the crease to make 4 rectangular pieces of paperboard.

Cut a slit in one rectangle at the very center almost all the way through to the other side. Line up the other 3 rectangles side by side and lay the cut rectangle over them; the slit in the center will loosely hold the other 3 rectangles together and form a cross shape. Put the paperboard cross in the bottom of the container to divide the container into 4 separate chambers. You may need to adjust the flaps by bending them back and forth a bit so they stay in place more easily (adding the ice cream bar ingredients will also help). Voilà . . . you have a four-chamber ice cream mold!

DIY Dulce de Leche

- 1 (14-ounce / 400-g) can sweetened condensed milk, unopened

CHEAT SHEET

You can caramelize more than one can of condensed milk in the pot at a time, as long as the water level stays above them. (If you stand the cans upright instead of on their sides, you can sandwich even more in the pot.)

In 60 seconds or less

Put a can of **sweetened condensed milk** (unopened!) in a high-sided pot, cover it completely with **water**, and cook it at a nice simmer for 2½ hours. Keep topping off the water to keep it above the top of the can. Let that cool a good while, then open the can and behold the greatest food science transformation ever!

Once we watched a video of someone making dulce de leche and thought about doing it as one of our **Fact or Cap?** (does it really work or not?) experiments. To think you could just cook a can of condensed milk in boiling water, and when you opened the can you would be rewarded with the thick, sweet, glorious caramel goop known as dulce de leche sounded Incredible. (We had no idea it was an actual thing people have been doing forever.) Then we saw how long it took: 2 to 3 hours. We didn't have that kind of patience! But this is a cookbook, the perfect place for that kind of thing. It's as easy to make as it sounds, but the one thing to remember is to keep your eye on the water level in the pot. If you don't keep the can covered with water at all times, you could end up with a major, and very dangerous, mess. We hear the can acts like a pressure cooker and could explode if it gets too hot; the water keeps it cooler. Fact or Cap? That's one experiment none of us needs to try!

Makes about 1 cup (240 ml)

Put the can in a tall pot like a Dutch oven or pasta pot. The type of pot doesn't matter, it's the height that's key. You need to be able to add enough water to cover the can by a solid 2 to 3 inches (5 to 7.5 cm).

Add the water, bring it to a low boil, and if you want, use tongs to remove the label from the can when it boils off. (Or just leave it, it doesn't matter.) Reduce the heat to a low simmer and cook the condensed milk for 2½ hours; don't cover the pot. Check the water level every 30 minutes or so and add more if the water ever gets close to the level of the can.

Let the dulce de leche cool for at least 1 hour before you open the can, or you can refrigerate the dulce de leche in the can (unopened) for up to 3 months. Put any leftovers from an open can in a clean, non-metal container, cover, and now you can also refrigerate that, but only for like 2 weeks.

198

OREOS: THE COOKIE!

Oreos are pantry legends! They've been around longer than Don Johnson's linen blazer and are still just as epic. Perfection on their own, Oreos can also be dunked, deconstructed, smashed, and paired with endless partners.

If you've made it with us through all of the recipe playlists in this book, you've probably already checked out that Next-Level Oreo Butter (page 148). We've included more of our favorite dessert-worthy (or anytime, really) Oreo variations on the next few pages: The Easiest, Cheesiest Oreo Cheesecake (page 201; the chocolate-dunked frozen version is Incredible!), Oreos with Queso (page 202), a new-and-improved Chocolate Lava Mug Cake (page 207), and the latest invention, the Double-Crunch Pickle Ice Cream Sandwich (page 209)!

Here are a few of our other tasting recaps to inspire your own experiments, along with the essential information everyone needs to know: the number of Original Oreos in a pack.

- 6 / single pack (2 ounces/ 55 g)
- 36 / regular pack (14.3 ounces/ 405 g)
- 48 / family pack (19 ounces/ 540 g)
- 64 / party pack (1 pound 9.5 ounces/ 725 g)

WHOLE OREOS

DIPPED IN PREPARED PANCAKE MIX AND AIR FRIED

X: It was great with powdered sugar, but for breakfast I'd go with syrup!

DUNKED IN CARROT JUICE

Ivy: I spit this out.

DUNKED IN DILL PICKLE JUICE

X: Hits the spot!

+ BALLPARK MUSTARD

Ivy: I'm not going to say it's a Snack, but everyone should mark this one off their bucket list.

+ DILL PICKLE SLICE

Ivy: I love pickles, I love Oreos, I LOVE this. Perfect.

REPLACE OREO FILLING WITH

BUTTER

X: Enough with the butter! Save yourself the calories.

+ SOUR CREAM

Ivy: Now THIS is how you make Oreos a breakfast food! It tastes even better than those yogurt cups with Oreos because it's not as sweet.

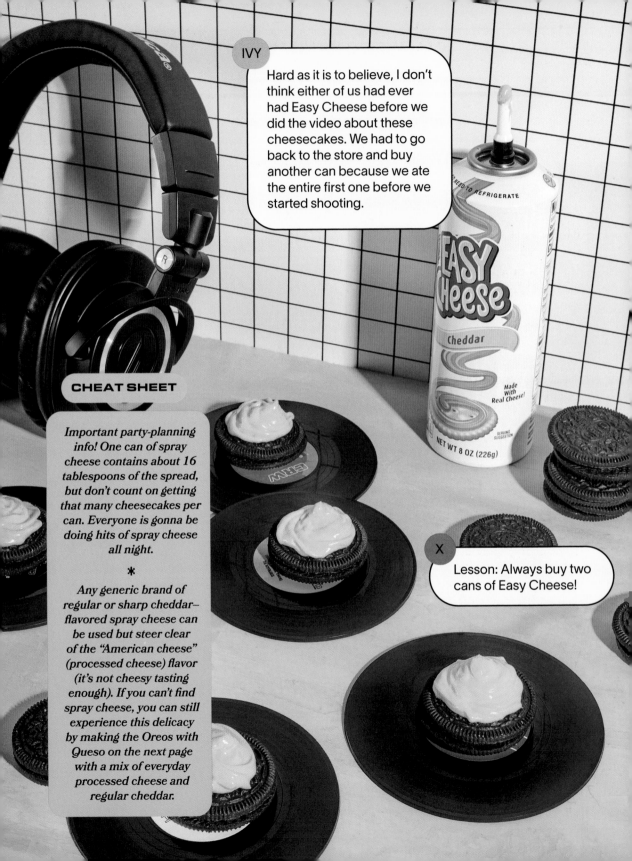

IVY

Hard as it is to believe, I don't think either of us had ever had Easy Cheese before we did the video about these cheesecakes. We had to go back to the store and buy another can because we ate the entire first one before we started shooting.

CHEAT SHEET

Important party-planning info! One can of spray cheese contains about 16 tablespoons of the spread, but don't count on getting that many cheesecakes per can. Everyone is gonna be doing hits of spray cheese all night.

*

Any generic brand of regular or sharp cheddar–flavored spray cheese can be used but steer clear of the "American cheese" (processed cheese) flavor (it's not cheesy tasting enough). If you can't find spray cheese, you can still experience this delicacy by making the Oreos with Queso on the next page with a mix of everyday processed cheese and regular cheddar.

X

Lesson: Always buy two cans of Easy Cheese!

The Easiest, Cheesiest Cheesecake

If there is one recipe in this book the biggest **Snack or Yack?** skeptics in your life must try, this is it! Make them close their eyes, eat one of these Oreos with Easy Cheese, and they will tell you it's cheesecake. We have no idea why it works, but the combo gives a whole new meaning to Oreo cheesecake . . . and potentially threatens the Cheesecake Factory's entire existence.

If you must mess with perfection, simply scroll through the aforementioned chain restaurant's menu for cheesecake topping ideas.

Makes 4 mini cheesecakes; 1 Snack

Lay out the Oreos on your counter and pile enough spray cheese on top of each to cover the cookie surface generously while still allowing you to eat the cheesecake in one glorious bite. If you've gotta be precise, you want about 1 small spoonful (1 tablespoon) spray cheese per cookie.

You can either pop back the mini cheesecakes now, or freeze them until firm, about 15 minutes, for a chilled flavor sensation

- 1 (8-ounce / 225-g) can cheddar spray cheese (Easy Cheese)
- 4 original Oreos

In 60 seconds or less

Grab a can of **Easy Cheese** (cheddar flavor) and a bag of **Oreos**. Now do shots of Oreos and spray cheese all afternoon!

Oreos with Queso (a.k.a. The Best-Ever Party Cheese Plate!)

- 12 slices (8 ounces / 225 g) processed (American) cheese
- 1 large handful (1 cup / 4 ounces / 155 g) shredded sharp cheddar cheese
- 1 generous spoonful (2 tablespoons) milk, any percentage
- About 20 original Oreos

In 60 seconds or less

Melt some **processed cheese** + **sharp cheddar** + a splash of **milk** together on the stovetop. Let the queso cool, chill it in the fridge until firm, and pull out a bag of **Oreos!**

Fact! Most jarred quesos have added ingredients like onions, garlic, and tomatoes (that's why they're often called salsa con queso). They also are usually more sauce-like and don't typically firm up fully like homemade versions, the very quality that makes the cheese spreadable in this recipe and firm enough to make the chocolate-dipped cheesecakes on the next page.

This recipe started out as an alternative for those who will never be able to experience the pleasures of the Easiest, Cheesiest Cheesecake (on the page right before this) due to the limited reach of such all-American Big Snack novelties as spray cheese. But even if you do get your hands on a can of the whipped processed cheese, it's still worth trying this version with a plain (no onions or spices!), extra-cheesy homemade queso in the interest of comparative research. It's guaranteed to shock and delight tasters at any party. It works like this: When traditional homemade queso (the kind you eat with tortilla chips) is hot, it's a sauce-like dip. But when chilled, the processed cheese–sharp cheddar dip becomes a thick spread that's perfect for spreading on Oreos to mimic the cheesecakes we both love. Put out a bowl of this with a bag of Oreos and everyone is gonna be dipping all night!

Makes about 1¼ cups (300 ml) queso, enough for about 20 Oreos

In a medium saucepan, heat the processed cheese, cheddar, and milk over medium-low heat, stirring occasionally, until the cheese has melted and the sauce is creamy, about 5 minutes. It will be very thick.

Let the queso cool until it firms up, about 15 minutes, then cover and refrigerate it for at least 1 hour or up to 3 days.

When you're ready to experience a culinary revelation, mound 1 small spoonful (1 tablespoon) of the queso on top of each Oreo. Or, let everyone dig in on their own!

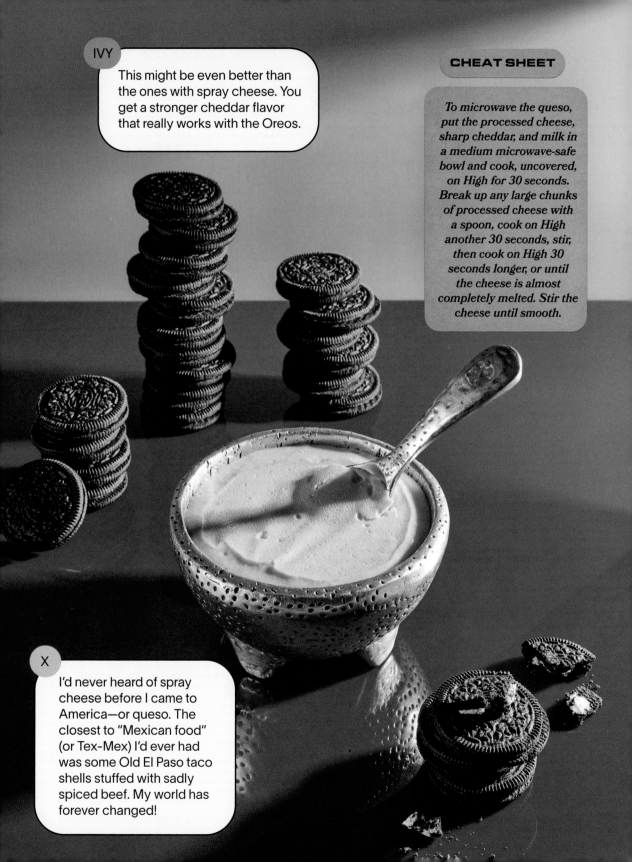

IVY

This might be even better than the ones with spray cheese. You get a stronger cheddar flavor that really works with the Oreos.

X

I'd never heard of spray cheese before I came to America—or queso. The closest to "Mexican food" (or Tex-Mex) I'd ever had was some Old El Paso taco shells stuffed with sadly spiced beef. My world has forever changed!

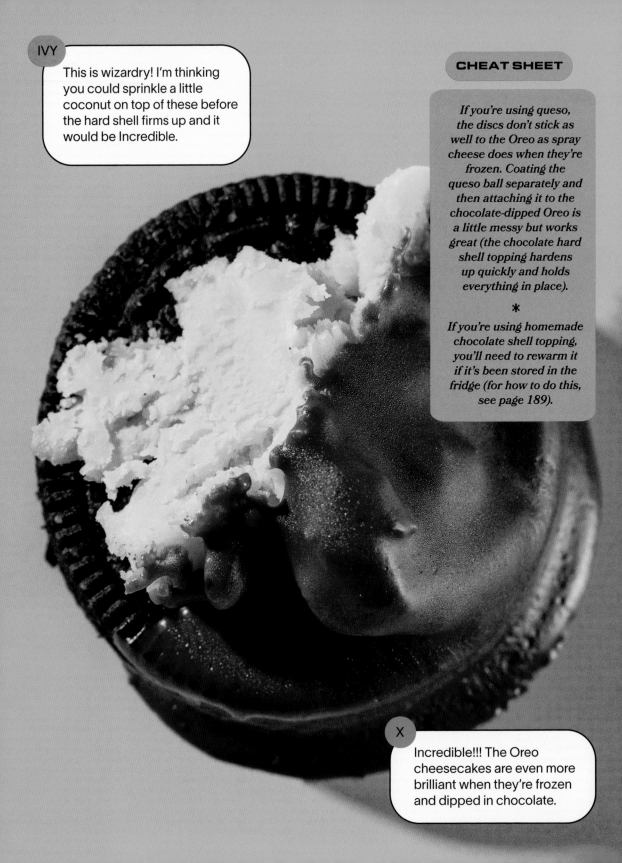

IVY

This is wizardry! I'm thinking you could sprinkle a little coconut on top of these before the hard shell firms up and it would be Incredible.

CHEAT SHEET

If you're using queso, the discs don't stick as well to the Oreo as spray cheese does when they're frozen. Coating the queso ball separately and then attaching it to the chocolate-dipped Oreo is a little messy but works great (the chocolate hard shell topping hardens up quickly and holds everything in place).

✳

If you're using homemade chocolate shell topping, you'll need to rewarm it if it's been stored in the fridge (for how to do this, see page 189).

X

Incredible!!! The Oreo cheesecakes are even more brilliant when they're frozen and dipped in chocolate.

Frozen Chocolate-Dipped Cheesecake Bites

The idea to make these came about when there was both homemade Magic Shell (page 189) and some queso left-over in the fridge (from the recipe right before this one). It's basically a cheap hack for those chocolate-covered frozen cheesecakes in the freezer aisle that turn an already loved classic into a frozen Big Snack novelty. AND it tastes way better!

Makes 4 mini cheesecakes; 1 Snack

Line a small baking pan or food storage container with parchment paper or foil. Put the cheesecakes on top of the paper or foil and freeze until firm, a solid 15 to 20 minutes.

Dip each cheesecake upside down in the chocolate shell topping so the spray cheese and the sides of the Oreo are covered with chocolate but not the bottom. If you're using the queso-topped Oreos, pop off the frozen disc of cheese and dip it in the chocolate shell topping first. Then, dip the top and sides of the Oreo in the chocolate shell topping and put the chocolate-covered queso disc back on the Oreo.

Arrange the cheesecakes in the baking pan or storage container so none of the chocolate-covered sides are touching, freeze until the chocolate has fully hardened, about 5 minutes. Incredible, no?!

Fact! One batch of Magical Chocolate Shell (page 189) is enough to make about 16 Oreo cheesecakes. Store-bought chocolate shell topping is usually a little thinner, so you might get a few more cheesecakes out of a bottle.

- 1 batch (4 cookies) of the Easiest, Cheesiest Oreo Cheesecake (page 201) or 4 assembled Oreos with Queso (page 202)
- 1½ to 2 generous spoonfuls (3 to 4 tablespoons) Magical Chocolate Shell, any flavor (page 189), warm, or store-bought chocolate shell topping (Magic Shell, Ice Magic)

In 60 seconds or less

Take those **Oreo cheesecakes** (or the ones with spray cheese or queso) and dunk them in **chocolate shell topping**. Freeze them for a few minutes, and you're ready to experience a whole new frozen cheesecake!

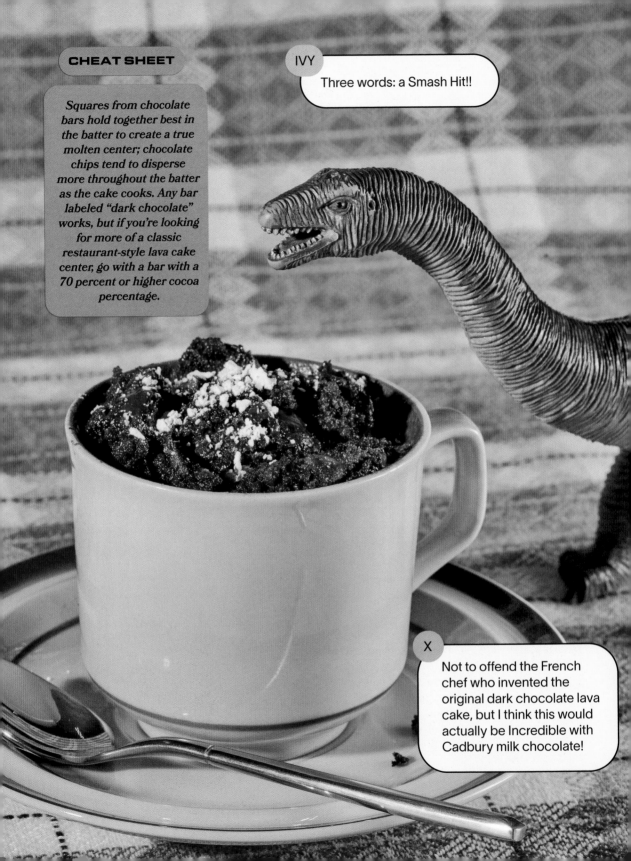

THE Chocolate Lava Mug Cake

It's time for a delicious late-night munchie delight microwave devotees everywhere have come to love: the five-minute mug cake. This Oreo version combines that easy cake hack with a lava cake. [Ivy: Chocolate lava cakes are my FAVORITE, and arguably THE BEST item on the Domino's menu. No questions asked!] The problem with many mug cakes is that they can be on the dry side, like one we tried that was made up almost entirely of ground-up Oreos (brilliant idea!). It needed something more . . . a little more milk, cocoa powder, and most of all, a deliciously hot, oozy chocolate center!

Makes 1 mug cake/Snack

Put the butter or margarine in a large microwave safe mug and microwave on High for 10 seconds. Use a fork to stab the softened butter and wipe it all over the sides of the mug.

Add the milk to the mug and microwave on High for another 20 seconds, or until the milk is warm and the butter has melted. Add the sugar, cocoa powder, flour, and baking powder to the mug and stir with the fork to make a clumpy pancake-like batter. Crush the Oreos over the mug into 5 or 6 pieces, give the batter another stir, and push the chocolate squares into the middle of the batter.

Microwave the cake on High until the batter is firm just along the top edges, about 45 seconds; the center will continue to cook as it cools. Let the cake rest for 5 minutes to cool (it will be super hot!) and finish cooking. Sprinkle a little powdered sugar over the top and we don't even need to say it, but ENJOY!

- 2 tablespoons unsalted or salted butter or margarine
- 3 small spoonfuls (3 tablespoons) milk, any percentage
- 1 generous spoonful (2 tablespoons) granulated sugar
- 1 small spoonful (1 tablespoon) regular or Dutch process cocoa powder
- 1 generous spoonful (2 tablespoons) all-purpose flour
- ¼ teaspoon baking powder
- 2 original Oreos
- 1½ squares (15 g) from a 3½-ounce (100 g) dark chocolate bar (Lindt 70% cocoa or higher)
- Powdered (confectioners') sugar for sprinkling

In 60 seconds or less

Microwave some **butter** in a mug and rub the softened butter all over the sides. Add some **milk**, zap it again, then add a little **sugar** + **cocoa powder** + **flour** + **baking powder** and mix it up so you have a batter. Crumble a coupla **Oreos** on top, stir, then shove some **dark chocolate squares** in the middle. Microwave the batter until it transforms into a cake and let it cool a little (that shit is hot!). Sprinkle some **powdered sugar** on top and go for it!

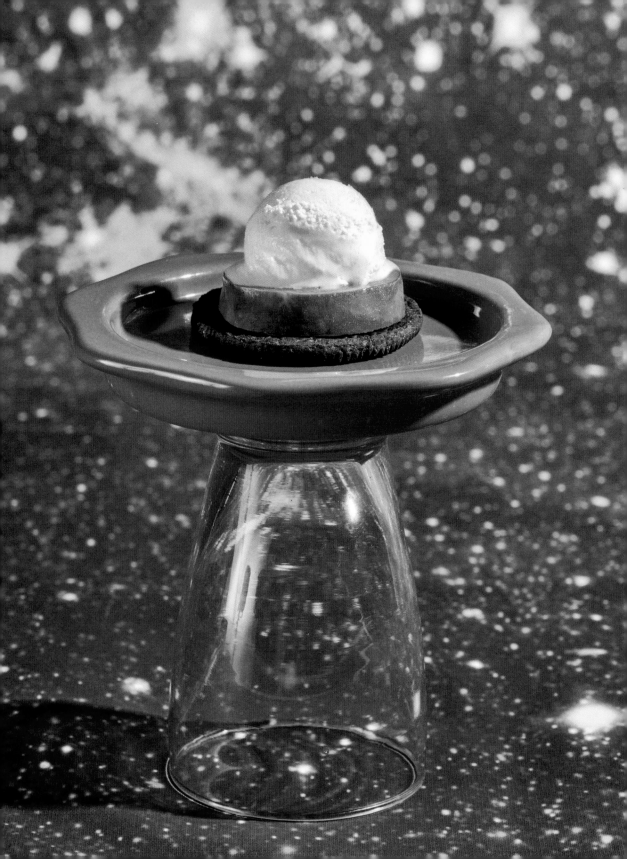

Double-Crunch Pickle Ice Cream Sandwiches

This idea for this recipe came from tasting some of the Oreo and pickle combos that people were doing on TikTok. One of the best was dunking the whole cookies in pickle brine. There was definitely something there, but it wasn't a true Smash Hit. BUT replace the Oreo filling with a spoonful of vanilla ice cream and add a dill sandwich slice in the middle (instead of dunking the cookie in brine), and now you've got a winner!

Makes 4 mini ice cream sandwiches; 1 Snack

Open the Oreos, remove the filling (eat it!), and lay the cookies out on the counter.

Cut the sandwich slice into 4 equal pieces, or if you're using part of a whole dill, cut it into 4 pickle chips each about ¼ inch (6 mm) thick.

Lay 1 pickle chip on top of 1 chocolate wafer cookie and top it with 1 small spoonful (1 tablespoon) ice cream. Pop your fancy nouvelle dessert into your mouth while you work on building (and eating!) the other 3 ice cream sandwiches.

- 2 original Oreos
- 1 Claussen's dill sandwich slice or about one-third of a whole dill pickle
- 2 generous spoonfuls (4 tablespoons) vanilla bean or "natural" vanilla ice cream

CHEAT SHEET

Don't try to freeze these to eat later; the pickle slice makes the Oreo soggy.

To make more of a classic ice cream sandwich (two wafer cookies with ice cream in between them) that you can make ahead, chop up the pickles and fold them into the ice cream, then assemble the sandwiches. As they sit in the freezer, the Oreo wafers will soften up like a classic ice cream sandwich "cookie" but won't get soggy.

In 60 seconds or less

We don't need to tell you this, do we?

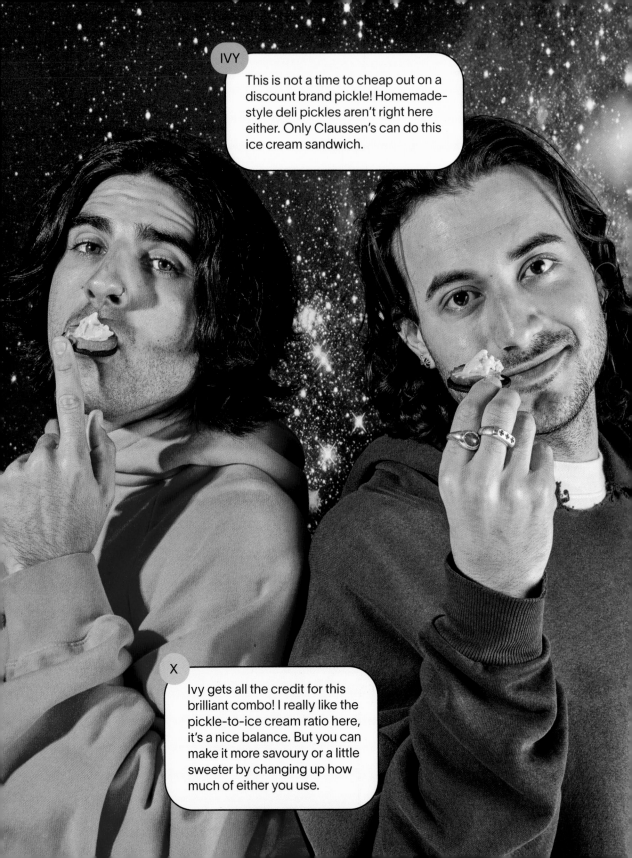

Banana-Coconut Doughnuts

For centuries, humans have tried to incorporate bananas into desserts with little to no avail (our metric being how many are in the grocery store freezer aisle today, naturally). Probably the biggest success story is the all-American banana split, but even that lost much of its appeal somewhere along the way. Social media has yet again saved the day and continues to provide us with some of the greatest recipe ideas and innovations in culinary history! A prime example is these Incredible fried banana sandwiches covered in shredded coconut. It's the perfect cheeky after-dinner delight or late-night bite—not too sweet but it hits the spot. If you like sweets for breakfast, simply change the name to Banana-Coconut French Toast, maybe sprinkle a little cinnamon and powdered sugar on top, and you're good. Need more reasons to make a few? Add a few chocolate chips to the filling for a hot melted chocolate-banana delight. Warning: Make these at your own risk!

Makes 2 doughnuts; 1 Snack

Line a plate with paper towels.

Pour enough oil into a large frying pan or Dutch oven to come roughly 2 inches (5 cm) up the sides. Heat the oil over medium-high heat until very hot, about 350°F (175°C).

Meanwhile, set up your assembly line: Smash the banana with the back of a fork on a cutting board or plate. Put the chocolate chips on another plate, if using. In a small bowl (even a soup bowl works), lightly beat the eggs with a fork. Put the coconut in another bowl.

- Vegetable oil, for deep-frying
- 1 small overripe banana
- 10 to 12 semisweet or dark chocolate chips, if you want
- 2 large eggs
- 2 small handfuls (⅔ cup / 55 g) sweetened shredded coconut
- 4 slices classic white or wheat sandwich bread
- 2 pinches salt

In 60 seconds or less

Make a coupla mini banana sandwich pockets (**white bread** + **mashed banana filling** + a few **chocolate chips**, if you want). Dip the sandwiches in **eggs** then **shredded coconut**, and deep-fry them in hot **oil** until golden brown. Let the sandwiches cool a bit, sprinkle them with a pinch of **salt**, and enjoy!

Recipe continued

To make the sandwiches, lay 2 slices of sandwich bread on the counter. Scoop up about half of the mashed banana and mound it in the center of each slice of bread. Both slices should have about 1 generous tablespoon filling. Top the filling with 5 to 6 chocolate chips, if you're using them, and lay another slice of bread on top of each. Put a roughly 3-inch (7.5 cm) wide drinking or rocks glass, rim facing down, in the middle of each sandwich, press down firmly on the glass to seal the edges of the bread, and peel away the excess bread to make a sandwich round. The filling should be completely enclosed by the bread; if not, crimp down the edges by pressing on them gently. (Discard the bread scraps.)

When the oil is hot, dip both sides of one sandwich into the eggs, shake off the excess, then roll the sandwich in the shredded coconut. Gently drop the sandwich into the oil and fry until golden brown on the bottom, about 45 seconds. Use tongs to flip the sandwich and fry until golden brown on the opposite side, about 30 seconds longer, then transfer the sandwich to the paper towel–lined plate. (Resist the urge to do a taste test! It will be piping hot and needs a solid 5 minutes to cool.)

Reheat the oil to 350°F (175°C), if needed, and use a small strainer or a slotted spoon to scoop up any excess coconut in the oil, then batter and fry the second sandwich the same way.

Sprinkle a pinch of salt over the banana bites and eat the first one while you wait for the second one to cool. Incredible, no?!

CHEAT SHEET

Don't go all health-nut on the bread. This recipe requires good old American-style white sandwich bread, or wheat if you must. And don't batter the bread before the oil is hot as the sandwiches will get soggy.

✳

If you've never made pocket sandwiches, check out the PB&J version (page 60) for tips on cutting out the bread so the edges are sealed.

✳

If you don't have a frying thermometer, test the temperature of the oil by adding a few flakes of shredded coconut. They should sizzle and quickly brown.

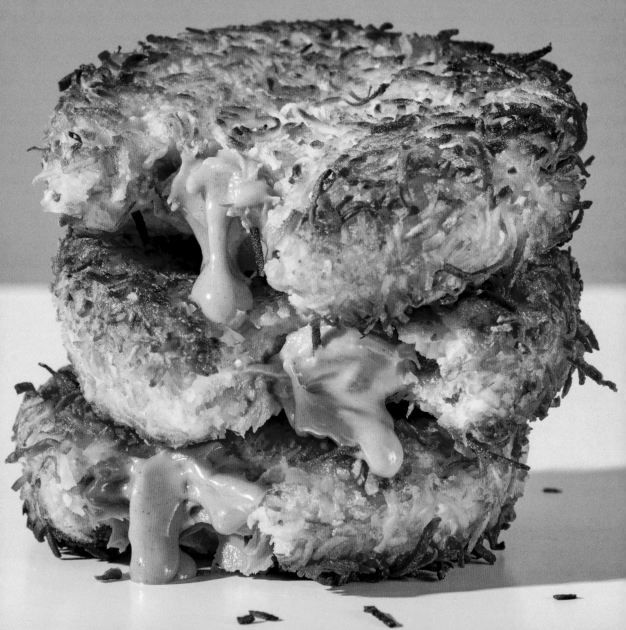

X

Americans have waaay more of a thing for banana desserts than Australians (though I do love a good banana ice cream), and peanut butter is not something I grew up eating. But the King has it nailed on this!

The Elvis

Throw in a little peanut butter and put some powdered sugar on top, and now you've got a sandwich the King would get behind!

Makes 2 doughnuts; 1 Snack

Make the doughnuts as instructed but spread the peanut butter in a circular shape in the middle of the bottom slices of bread before adding the mashed bananas. After battering and frying the doughnuts, let the sandwiches cool a few minutes, dunk them in the powdered sugar, and enjoy!

- 1 batch Banana-Coconut Doughnuts (page 211), without chocolate chips
- 1 small spoonful (1 tablespoon) creamy peanut butter spread (Jif, Bega)
- Powdered (confectioners') sugar, for dunking

In 60 seconds or less
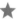

Make the **Banana-Coconut Doughnuts**, only leave out the chocolate chips and slather some **peanut butter** on the bread in honor of The King's favorite PB & Banana sandwich combo. Batter and fry them up and dunk them in **powdered sugar**.

Double-Stuffed Air-Fried Twinkies

Twinkies might be the most recognized grocery store cake—even if, like us, you don't even really love them. It's not that they're bad, they just fall into that gray area. Is it a breakfast pastry, a dessert, an anytime-of-day Snack? The cream filling is essential, or it's nothing more than a cake without icing. But air fry Twinkies, and you will behold a transformation worthy of the greatest before-and-after pics! They get warm and slightly crispy on the outside with a marshmallow-y center. You'll never eat them straight from the package again. The first time we made these for the video, we coated them in powdered sugar, which was solid. Our first thought to elevate this Snack even more was to add a dipping sauce (chocolate syrup, perhaps?), but then we heard an even better idea: Why not cut the Twinkie open, stuff it with a few candies, and then put it in the air fryer? That Next-Level idea came from a kid who had the difficult job of taste-testing many of the recipes in this book. (Thank you, Joseph!) That got us to another idea: roll the stuffed Twinkies in Tangy Candy Coating (what we call unsweetened Kool-Aid and sugar mixed together) before you fry them, and it's a whole other sour-sweet experience. The lesson: Listen to kids! If anyone knows a good Snack, they do.

Makes 1 fried Twinkie; 1 Snack

- Nonstick cooking spray or vegetable oil, for coating the air fryer rack
- 1 Twinkie
- 2 small dollops (2 teaspoons) Next Level Fillings (see below), roughly chopped or crushed if large
- 1 teaspoon Instant Tangy Candy Coating (page 38), any flavor

In 60 seconds or less

Slice open the bottom of a **Twinkie** just enough to expose the filling, stuff it with your **filling of choice**, and roll it in **Instant Tangy Candy Coating**. Air-fry that beauty until it's just beginning to turn golden brown and let cool for a min or two, and dive in!

Recipe continued

Lightly coat 1 air fryer rack with oil.

Put the Twinkie on the counter, bottom side facing up, and make a lengthwise slice that starts about ½ inch (12 mm) from each end. You should be able to see the filling, but don't slice all the way through to the bottom of the cake.

Gently squeeze both ends of the cake to expose the icing, insert your fillings evenly throughout, and partly close the Twinkie. (It won't close completely.) Sprinkle the powdered drink mix coating on a plate and roll the outside of the Twinkie in the powder to coat.

Set an air fryer to 350°F (175°C), put the Twinkie on the rack, stuffed side facing up, and cook until the edges are golden brown, about 2 minutes. Use tongs to remove the Twinkie from the air fryer and let it cool a minute or two.

Let's say it one last time. . . . INCREDIBLE!

Next Level Fillings

The Twinkies aren't in the air fryer long, so candies that melt quickly work best. Anything on the larger or denser (gummy!) side of the candy world should be chopped; hard candies need to be finely crushed. And if you're using chocolate or caramel candies or sauce/spreads (Nutella, dulce de leche) as fillings, you might want to forego the Tangy Candy Coating and roll that Twinkie in a little powdered sugar after you fry it instead. But hey, it's your Snack. If you think Milk Duds and Kool-Aid Ice Blue Raspberry Lemonade drink mix is gonna work, go for it!

CHOCOLATE CANDIES (CHOPPED)

Chocolate chips, chocolate-covered candies (M&M's, Reese's Peanut Butter Cups, Snickers, Health bars, Milk Duds)

SOUR/TART CANDIES (CHOPPED)

Gummies (gummy bears or worms, Nerds or Nerds Gummy Clusters)

HARD CANDIES (CRUSHED)

Jolly Ranchers, butterscotch, peppermints

FRESH OR CANDIED FRUIT (WHOLE, IF SMALL, OR CHOPPED)

Berries, mango, pomegranate, bananas

SAUCES (THICK!) AND SPREADS

jam, chocolate-hazelnut spread, DIY Dulce de Leche (page 198)

A HUGE THANK-YOU!

We'd like to thank our parents, Steve and Venetta Di Petta and John and Gigi Iavarone, for being the reason we exist and therefore allowing us to being able to write this book. Without their love and support, we would just be two random people floating aimlessly in the universe. We'd also like to thank them for putting up with us when we were growing up and for not disowning us after we ruined the kitchen trying to make a Snack. Thank you, Mom and Dad, we love you!

We also want to thank our siblings, Olivia Di Petta and Gianna and Johnny Iavarone, for putting up with our countless late nights in the kitchen, never complaining about the smell of burnt microwave popcorn, and last but definitely not least, for always being there to taste test our creations . . . even when they were less than appetizing. Without their support and open mouths, this book would not have been possible.

Thanks to the Academy for teaching us what traditional institutes can't, and for everyone at Abrams (especially our editors Holly Dolce and Sam Weiner and art director Diane Shaw, along with the rest of the team: Sarah Masterson Hally, Asha Simon, Sarah Scheffel, Glenn Ramirez, and so many others) for believing that two twenty-something DJs could put together the World's first Snack book (or, in the very least, the most unique!). A big thanks to Dan Milaschewski and Brandi Bowles at United Talent Agency for helping Abrams see that Snack world vision, and then there's Seth Jacobs and Michael Kaufman, both part of our great team, and Jon Polk, who we can't thank enough for everything he's done for us over the years (true fam!).

A big round of applause goes out to our amazing design and photo team: designer Heesang Lee, food photographer Lindsay Kreighbaum, and lifestyle photographer Dusty Heger; food stylist Jessica Boone and prop stylist Aimee Vredevoogd, along with set assistants Michelli Knauer and Kari Vredevoogd. They made the stories told in these recipes come to life in ways we never could have imagined.

And thanks to @everyone (see below) for your online food ideas and inspiration, which the amazing Jenn Garbee helped us turn into

221

the Incredible and original recipes included in this book. You've expanded our minds and challenged us to experiment with new ingredients and cooking techniques.

Lastly and most importantly, we'd like to thank Jenn. It may sound cliche, but without her, this book simply would not have been possible. We could not have found a better person to capture our voice and ideas and turn them into delicious, real Snacks. Even if we don't win a Pulitzer, we at least got to discover what a microwaved egg tastes like!

Thank you ALL for making this book possible. Now please go forth and enjoy our magnum opus (or at least pretend to enjoy it for the sake of our egos).

Sincerely,
X & Ivy

Special thanks to @everyone listed here (and everybody else who made Incredible TikTok videos that we featured on our series), including:

@wolfgangpuck
@nick.digiovanni
@itsbennyblanco
@olivia.dipetta
@nickuhas
@thecoreyb
@jillzfoodz_
@masterchefau
@trinhdoesthings
@butterrgirll
@thecaseyferguson
@danielle_kollander
@moemoney888
@ericgarcia6
@kyrannijjar
@thesalguerofam
@foodies
@jackcooper
@kirsten
@kylieminero
@purplepossum
@arnienegrete
@veronicareign
@onebigpike
@judgiespod
@tessthereckxxo
@columbiancraker
@schoollunchboxdad
@anayal8ter_
@pitbossgrills
@kaykayaye
@cardiB

@veronicareign
@clintonsvatos
@maddiegoetzzzzz
@alonzo_lerone
@37yroldgrandpa
@itslisanguyen
@callmebelly
@pebbles_573
@role_model_rl
@410dwill45
@weredos
@alonzo_lerone
@catfishvsthug
@richardeats
@stony_ley
@baybradyy
@mrhamilton
@louislevanti
@.chris_dolo
@pierzza
@angelsoriano004
@tommywinkler
@allrecipes
@ambitious_jess
@guitarman3245
@adrianghervan
@yourstrulylycette
@mohead_thanbody
@cookiterica
@mxriyum
@myrnanassar
@thepunguys

Editor: Holly Dolce
Designer: Heesang Lee
Managing Editor: Glenn Ramirez
Production Manager: Sarah Masterson Hally

Library of Congress Control Number: 2023933933

ISBN: 978-1-4197-6807-1
eISBN: 979-8-88707-024-7

Text copyright © 2023 Xavier Di Petta and Nick Iavarone
All photographs copyright © 2023 Lindsay Kreighbaum except pages 4–5, 6, 10–11, 12, 30–31, 220, and 223, which are copyright © 2023 Dustin William Heger

Cover © 2023 Abrams

Printed and bound in the United States
10 9 8 7 6 5 4 3 2 1

The author and publisher do not accept liability for any injury, loss, or incidental or consequential damages suffered or incurred by any reader of this book.

Abrams Image books are available at special discounts when purchased in quantity for premiums and promotions as well as fundraising or educational use. Special editions can also be created to specification. For details, contact specialsales@abramsbooks.com or the address below.

Abrams Image® is a registered trademark of Harry N. Abrams, Inc.

ABRAMS The Art of Books
195 Broadway, New York, NY 10007
abramsbooks.com